Aaron Siskind and Louis Sullivan:
The Institute of Design Photo Section Project

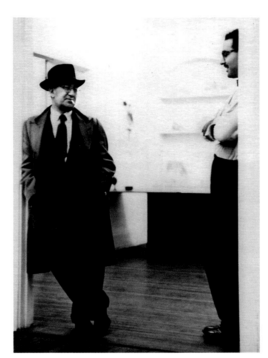

Figure 1. Aaron Siskind and unidentified Institute of
Design student, c.1953

Aaron Siskind and Louis Sullivan:
The Institute of Design Photo Section Project

Jeffrey Plank

William Stout
Publishers

Copyright © 2008 by Jeffrey Plank
Copyright © of photographs: see Illustration credits, page 11,
and Exhibit Photograph credits, page 87

Published in 2008 by
William Stout Publishers
530 Greenwich Street
San Francisco, CA 94133

Design by Robertz & Kobold, Inc., Chicago
Printed in China

ISBN 978-0-9795508-3-6

Library of Congress Control Number: 2008924594

For my parents, Martha Senft Plank (1920-2006) and Paul Wiley Plank

Table of Contents

Acknowledgments

Following Richard Nickel's untimely death in 1972 during the demolition of Louis Sullivan's Chicago Stock Exchange Building, Aaron Siskind, John Vinci, and Ben Raeburn, with the approval of Nickel's brother Donald, established the Richard Nickel Committee to preserve Nickel's photographs and research on Sullivan and other modern American architects, including the photographs made by Siskind and the student participants in the Institute of Design Sullivan project. Nickel's collection alone contains more than 4,000 negatives and prints of Sullivan buildings, building demolition, and ornament fragments. Under Vinci's direction, the Richard Nickel Committee has grown into an important independent resource and advocate for architectural history and architectural preservation; it is a magnificent cultural asset for Chicago. With Ward Miller's appointment in 2003 as Executive Director, the Richard Nickel Committee expanded its capacity and reach; in 2006 Richard Seidel completed the professional archiving of the Committee's collections. John Vinci first suggested that I consider the Institute project for extended study and provided access to all Committee materials; Ward Miller reviewed early text drafts and participated in every phase of image identification, analysis, and reproduction. Without their encouragement and assistance, and without the materials preserved in the Richard Nickel Committee Archive, this book would not have been possible.

Former Institute of Design students who participated in the Sullivan project also provided valuable information: James Blair, Asao Doi, Charles Estram (Casimir Estramskis), Len Gittleman, and Alvin Loginsky. I am grateful to them for sharing their recollections and hope that publication of their photographs, along with those of Paul Hassel, Leon Lewandowski, and Richard Nickel, will memorialize their important contributions to our understanding of Louis Sullivan in the mid-twentieth century.

For their help with other original materials, it is a great pleasure to thank Catherine Bruck, Paul V. Galvin Library, Illinois Institute of Technology; Leslie Calmes, Center for Creative Photography, University of Arizona; Helen Chillman, Art and Architecture Library, Yale University; Lew Purifoy, Alderman Library, University of Virginia; and Mary Woolever, Ryerson and Burnham Libraries, Art Institute of Chicago.

Hope Taylor, Victoria Taylor, Beth Taylor Fergon, and John Taylor provided information about Crombie Taylor and his tenure as Acting Director of the Institute of Design. Taylor's pioneering work on Louis Sullivan—he rediscovered Sullivan's treatment of interior space through restoration of several Auditorium Building rooms beginning in 1954—merits wider attention.

The Gwen and Morris Hirsh Foundation provided financial assistance for my research and this publication. Hirsh Foundation trustee Joel Rothman continues to provide wise counsel; it is my good fortune to work with him to realize the interests of Gwen and Morris Hirsh in Louis Sullivan scholarship that followed from their long association with Crombie Taylor.

Elaine Kobold and Bruce Baker designed and, along with Bill Stout, managed the production of this book with splendid sympathy for its content.

John Rowlett served as my primary reader; as always, I have relied on his intellectual rigor and breadth, his soaring enthusiasm, and careful eye for detail.

Not least, my heartfelt thanks to Astrid Henriksen, muse and confidante, for her constant support.

List of Illustrations

Figure 1. Aaron Siskind and unidentified Institute of Design student, c. 1953. *Photograph by Alvin Loginsky*

Figure 2. Aaron Siskind, c. 1953. *Photograph by Asao Doi*

Figure 3. Institute of Design building, 632 N. Dearborn Street, Chicago, 1950. *Photograph by Alma B. Robert*

Figure 4. Crombie Taylor. *Integral* (Illinois Institute of Technology yearbook), 1953

Figure 5. James Blair, 1954; Asao Doi, *Integral,* 1953; Len Gittleman, 1955; Leon Lewandowski. *Integral,* 1954; Alvin Loginsky, *Integral,* 1953; Richard Nickel, 1960

Figures 6-12. Aaron Siskind photographing Max M. Rothschild Flats, c. 1953. *Photographs by Richard Nickel*

Figures 13-15. Rothschild Flats. *Photographs by Aaron Siskind*

Figure 16. Entrance to exhibit. *Photograph by Richard Nickel*

Figure 17. Exhibit installation panels at corner. *Photograph by Richard Nickel*

Figure 18. Exhibit plan diagram. *Photographs by Richard Nickel*

Figures 19-26. Exhibit installation panels. *Photographs by Richard Nickel*

Figure 27. Exhibit installation panels with light box. *Photograph by Richard Nickel*

Figure 28. Exhibit announcement card. *Design by James Wood, Sullivan ornament photograph by Len Gittleman*

Figure 29. Knisely Store and Flats. *Photograph by Richard Nickel*

Figures 30-31. Ann Halsted Residence. *Photographs by Richard Nickel*

Figure 32. Aurora Watch Company Factory. *Photograph by Richard Nickel*

Figure 33. F. A. Kennedy and Company Bakery. *Photograph by Richard Nickel*

Illustration credits: 1, courtesy of Alvin Loginsky; 2, courtesy of Asao Doi; 3, by permission of the Chicago History Museum, Chicago (ICHi-26011); 4, by permission of University Archives, Paul V. Galvin Library, Illinois Institute of Technology, Chicago; 5, Blair photograph, courtesy of James P. Blair; Doi, Lewandowski, and Loginsky photographs, by permission of University Archives, Paul V. Galvin Library, Illinois Institute of Technology; Gittleman photograph, courtesy of Len Gittleman; Nickel photograph, courtesy of the Richard Nickel Committee, Chicago; 6-33, courtesy of the Richard Nickel Committee

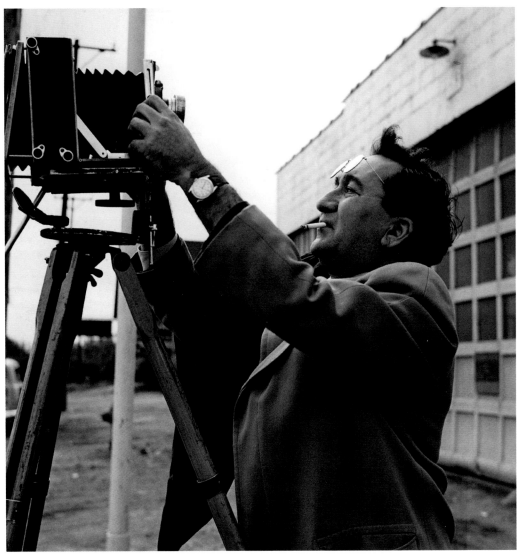

Figure 2. Aaron Siskind, c.1953

Louis Sullivan and Architectural Photography: Towards a New Architectural History

Introduction

This book publishes for the first time a 1954 exhibit of photographs of Louis Sullivan buildings directed by Aaron Siskind at the Institute of Design. In 1952 Siskind and his advanced photography students undertook a comprehensive photographic survey of Sullivan's architecture and by early 1954 had photographed more than 60 Sullivan buildings. From hundreds of photographs Siskind composed an exhibit of 126 photographs of 35 Sullivan buildings, noteworthy for its startling juxtaposition of ornament details and carefully composed building portraits. Siskind's exhibit was a documentation of Sullivan's architecture unlike any other—and one that could never be repeated, because so many of Sullivan's buildings were demolished shortly thereafter.

Siskind intended quick publication of the project photographs as part of a complete catalogue of the architecture of Adler and Sullivan, initially advertised for 1957. While unforeseen circumstances delayed the catalogue indefinitely, Siskind fortunately required that all negatives, including his own, remain with the project archives, so the exhibit can be reconstructed, even though most of the exhibit photographs have remained hidden from view for more than fifty years. If critics have commented on project photographs, they have isolated single images, from the exhibit series as well as from the exhibit format. Consequently, the full impact of Siskind's Sullivan project—both on Siskind's career and on architectural history—has gone unacknowledged until now.

A comprehensive survey of Sullivan's architecture, indeed of the work of any American architect, was unprecedented. While Sullivan worked closely with photographers to record his major buildings when they were built, lesser commissions went unrecorded. These early photographs are brilliant documents that capture pristine buildings from a point of view informed by close and longstanding personal relationships of architect and photographer. By the 1950s, however, Sullivan's buildings were no longer pristine. They were worn from hard use, vulnerable to urban renewal and the harsh Chicago climate. No small achievement of the Institute project is the sympathetic presentation of Sullivan's aged buildings as they approach the end of their lives, with powerful compositions that accept their present condition and resist the temptation to blame their owners and occupants.

Siskind conceived the Institute project as a group project, with the perspectives of many individuals, and the presentation of photographs as a whole series, with a very deliberate juxtaposition of print size and scale of subject matter. Indeed, with the exhibit format, Siskind used photographs of one building to stimulate closer or comparative inspection of photographs of other buildings. Most provocative, however, was Siskind's juxtaposition of print size and scale to manipulate the physical relationship between the viewer and the photograph and, by implication, between the viewer and Sullivan's buildings. Siskind's exhibit encourages an active and intimate investigation of Sullivan's buildings, from their bold mass and profile to the textures of their smallest and most hidden details.

In the exhibit we can read the Institute's educational philosophy and Siskind's pedagogical strategies. He provided models for his students, but he also encouraged his students to work independently, and the many series of photographs of single buildings show Siskind stepping back to afford the students greater authority. Siskind's decision to include so many photographs of buildings not previously photographed in the exhibit no doubt was as much related to the aim of a comprehensive survey as to the opportunities for student creativity: for these buildings, the students had no models and their photographs typically employ techniques taught in the Institute Foundation and early photography courses.

In the Institute Sullivan exhibit we also see an extraordinarily sophisticated approach to architectural photography at midcentury, informed by the documentative work of Siskind's contemporaries in the 1930s and 1940s such as Berenice Abbott. In 1934 Abbott accompanied architectural historian Henry-Russell Hitchcock on a summer tour of American cities to photograph Henry Hobson Richardson and other nineteenth-century urban buildings for his 1934 *The Urban Vernacular of the Thirties, Forties, and Fifties: American Cities before the Civil War* exhibit and his 1936 Museum of Modern Art *Exhibition of the Work of H.H. Richardson,* the first ever dedicated to a single architect (reprised in 1947, with enlarged Abbott photographs). Hitchcock and Phillip Johnson achieved widespread visibility for their 1932 *Modern Architecture: International Exhibition* at the Museum of Modern Art (said to coin the term "International Style"), and Hitchcock used their "International Style" criteria and Abbott's photographs to argue that Richardson was the first modern American architect. Hitchcock also assisted Hugh Morrison in shaping his pioneering 1935 *Louis Sullivan: Prophet of Modern Architecture* and selecting photograph illustrations.[1] Siskind's Sullivan is very different from Abbott's Richardson—and from Morrison's Sullivan—and the differences indicate an intelligent resistance to the conceptual aims of contemporary architectural historians.

Siskind's use of an innovative procedure to counter the prevailing treatment of Sullivan's buildings by architectural historians raises important questions about the relation of architectural photography to architectural history, that is, of visual to verbal treatments of fundamentally nontextual objects. At the exhibit opening, Siskind noted the Sullivan project aim to make "a complete documentary of Sullivan's work and to preserve it in published form for the history of architecture." In the context of Morrison, Hitchcock, and Abbott, Siskind's Sullivan exhibit and project photographs also become archival documents of architectural history. These documents preserve a turning point in Sullivan studies that was instigated by visual inspection, yet the procedures by which they are achieved do not serve documentative ends. Rather, as I will suggest in this essay, they serve interpretative ends. Siskind's procedures reinforce Frank Lloyd Wright's well-known reservations about the codified "International Style" as an adequate account of the origin and character of modern architecture, but they do so demonstratively in a visual rather than verbal medium, indeed in a manner Wright thought impossible.

More than fifty years later the exhibit and the exhibit photographs are still fresh, Sullivan's aged and worn buildings arrested in their decline, their darkened ornament luminous in Siskind's incomparable compositions. Publication of the exhibit and the photographs and the reconstruction of Siskind's distinctive perspective on the architectural photography of early modern American architecture will contribute, I trust, to architectural history and to the history of photography, for the Sullivan project is the missing piece in our understanding of Siskind's career and in his uses of architectural photography.

The Photographic Background: Early Sullivan Building Photographs

The association of Louis Sullivan with extraordinarily talented photographers began early in his career. From 1890 to 1920 Sullivan worked closely with three photographers— J. W. Taylor, Ralph D. Cleveland, and Henry Fuermann—to document many of his principal buildings, initially the Auditorium Building, then other buildings designed with Dankmar Adler through 1896, and finally his rural midwestern banks.[2] Sullivan's relationships with these photographers were so close and longstanding that their photographs of his buildings constitute authoritative representations of his architecture. Sullivan—or his clients—typically used these photographs to market newly-completed commercial buildings or to illustrate professional journal articles. Sullivan's contemporaries also used the photographs to illustrate his seminal role in the "Chicago School" of architecture, especially in the 1920 and 1924 annual exhibits of the Chicago Architectural Club. Sullivan retained copy negatives of these photographs, excepting Taylor's Auditorium Building series, until he closed his office in 1918. He then passed three boxes of negatives on to Fuermann, who supplied Hugh Morrison with prints for his *Louis Sullivan: Prophet of Modern Architecture* (1935), the first comprehensive account of Sullivan's life, his architecture, and his architectural writings. In 1942 Fuermann sold his Sullivan building photograph negatives to the Chicago Architectural Photographing Company.

It was fortunate for Morrison that Fuermann could supply so many Sullivan building photographs. For the Auditorium Building, which he did not photograph, Fuermann made copy negatives from a set belonging to Dankmar Adler's daughter, Sara Weil. For other Sullivan buildings for which Fuermann had no photographs Morrison was unable to afford a professional photographer. Instead, he commissioned a student, Joseph Barron, to photograph many additional Sullivan buildings.[3] Because Morrison's publisher limited the book size and required that he pay for engraving the photographs, Morrison was able to use only 15 of Barron's photographs. Thus, while he was able to provide the most comprehensive photographic survey of Sullivan's buildings to date, Morrison was forced to sacrifice image quantity and quality.

Despite the poor reproductions in Morrison's book, Taylor, Cleveland, and Fuermann made splendid photographs. They used films sensitive to few light waves and large format view-finder cameras with glass plate negatives that contact print sharp edges and capture a wide range of grey tones. While they made few photographs that isolated ornament from structural features or planar surfaces, their photographs clearly documented the three-dimensionality of Sullivan's carved and fretsawn wood, carved stone, cast terra cotta and plaster, and cast iron decorations. With his smaller scale images and halftone printing process, Morrison would have had to use ornament detail photographs if he had wanted to feature Sullivan ornament. But Morrison discounted Sullivan's ornament, arguing that Sullivan's "greatest achievement was his emancipation of architectural thinking from the dead forms of the past."[4] According to Morrison, Sullivan's ornament obscured this achieve-ment: "the bare logic of Sullivan's architectural thinking would have been more clearly apparent to his contemporaries if his buildings had not been adorned by such lyrical enrich-ments in the way of ornament" (p. 269). None of the additional Barron photographs that Morrison published are ornament details.

In 1940 Morrison's book had gone out of print, and his publisher W. W. Norton destroyed the plates. Morrison did no further research on Sullivan, and no other major Sullivan studies were published until Frank Lloyd Wright's *Genius and the Mobocracy* in 1949. When Peter Smith reissued Morrison's book in 1952, illustrations were reproduced from the printed pages of the first edition, with a significant loss of clarity and quality. Between 1935 and the 1952, no new photographs of Sullivan's buildings were published.

Frank Lloyd Wright's Case for Sullivan Ornament

In his 1949 *Genius and the Mobocracy* Frank Lloyd Wright makes claims for Sullivan's ornament that Morrison did not and, in denying the capacity of photography to capture the "truth" of "organic architecture," issued a challenge to photographers. With all the rhetorical power and authority of his early association with Sullivan and the continuing success of his own work, Wright insists that ornament is fundamental to Sullivan's architecture, repeating claims first made in his 1935 review of Morrison's book:

Louis H. Sullivan would have been the first to gleefully kick those self-styled function-eers—with their "A house is a machine for living" (but only if a human heart is a suction pump)—from his doorstep. In so far as his doorstep was mine I did it myself when they appeared with their dead-sea fruit, "the whited-sepulcher" (call it flat-bosomed façade), at the Museum of Modern Art about 1932....

For any wanton sect to understand Louis H. Sullivan at all is to know that not then was he, nor ever would he be, any such. His greatness for all lies in that at heart and in deed he was the great, human lyric poet whose creation out of himself of the poetic efflores-

cence of LOUIS H. SULLIVAN—great individual—was unique. Of course, he is best seen where happiest—seen in what he loved best: the primal plastic. Clay.

Although seeming at time a nature-ism (his danger), the idea is there: *of* the thing not *on* it, and therefore SULLIVANIAN self-expression contained the elements and prophesied organic architecture. To look down upon such efflorescence as mere "ornament" is disgraceful ignorance. We do so because we have only known ornament as self-indulgent excrescence ignorantly *applied* to some surface as a mere prettification. But, with the master, "ornament" was, like music, a matter of the soul—"of" the nature of man— inevitable to him: (natural) as leaves on trees or any fruit announced by the blossoms on the stems that carry both. It was this man that Louis H. Sullivan was and felt himself to be, that he expected me to write about someday: a far greater man than the functionalist he has been wishfully and willfully made to appear.[5]

With these claims about Sullivan's ornament, Wright also insists on the inadequacy of modern architectural history that for him dates to the 1932 *Modern Architecture: International Exhibition* (and catalogue) organized by Henry-Russell Hitchcock and Philip Johnson for the Museum of Modern Art (and their 1932 *The International Style: Architecture since 1922*). For Wright, neglecting Sullivan's ornament amounts to a misunderstanding of Sullivan's architecture and, by implication, a misunderstanding of the origins and character of modern architecture. By insisting on the fundamental importance of Sullivan's ornament, Wright reminds his midcentury readers that Sullivan's architectural successors chose to continue only parts of his procedures, that the unornamented style does not address important human needs, and, despite the hegemony in 1949 of an unornamented style, that ornament remained a compelling alternative, as Wright's own architecture continued to demonstrate. Wright's Sullivan thus stands for the continuous presence of an alternative to the International Style, an alternative not acknowledged by architectural historians. In *Genius,* Wright illustrates this argument with reproductions of drawings that Sullivan passed on to him on his deathbed in 1924.

Throughout his book, Wright also takes issue with Morrison on the relative value of Sullivan's drawings, writings, and buildings. For Wright, ornament drawings are the "perfect expression" of the "Sullivanian philosophy": "The Sullivanian philosophy, so far as it was personal to him, is written in that chosen language [drawings of ornament] of his most clearly, and if you are going to read *him* at all, it is there to be read at level best. Not in the remarkable buildings built by the firm nor in his own writings (so I felt then and now think) were the perfect expressions of Louis H. Sullivan to be found" (p. 56). For Wright, this position perhaps evokes and memorializes his private relationship with Sullivan, over the drafting table, in early moments of building design. In the context of Wright's argument with Morrison, however, it also is the architect's claim, against the architectural historian or the historian of ideas, for visual, over textual, evidence.

While Wright makes the unfashionable case for ornament and for visual evidence, he has little use for photography. For Wright, the "truth concerning the elusive depth-dimension involved in organic architecture defies the camera" (p.10). Wright's challenge to the photographer is exquisitely framed. As the leading exponent of Sullivan's "organic architecture," whose own early buildings were photographed by J. W. Taylor and Henry Fuermann and who carefully photographed Japanese architecture himself, Wright appears to set criteria for representation that only drawing can meet. This position about media may be an architect's special privilege: a drawing might be understood as the architect's personal signature, an abstract of his conception, the pure input of the his hand ("of" the architect, to use Wright's term for Sullivan's ornament), whereas the building photograph represents a product of many hands, the output of many compromises. However, Wright's argument with Morrison (and with Hitchcock and Johnson) and his reference to the various kinds of evidence available to architectural historians, I believe, point to the difficulty of appreciating Sullivan's architecture in the middle of the modern period. The medium in which the evidence appears—text, drawing, or building photograph—figures strongly in this difficulty. At midcentury, for Wright, textual treatments of Sullivan, including Morrison's book and Sullivan's own architectural writings, distort his architecture: by moving attention away from features such as ornament that can be seen in any adequate visual representation of his buildings, textual treatments can make Sullivan into a "functioneer," the "prophet of modern architecture," and simplify modern architectural history as a history of ideas rather than of forms.

Aaron Siskind, Sullivan Ornament, and Documentary Photography

Figure 3. Institute of Design building, 1950

The Institute of Design was founded (first as the New Bauhaus, 1937-38; the School of Design in Chicago, 1939-44; and the Institute of Design, 1944-present) by Lazlo Moholy-Nagy, a painter, photographer, and designer who taught the Foundation course at the Bauhaus in Dessau. Moholy-Nagy aimed to translate the Bauhaus integration of art, science, and technology and its experimental, problem-based pedagogy for a new American institution. He was so successful at recruiting artists and practitioners—the earliest Institute faculty members included Alexander Archipenko, Hugo Weber, Gyorgy Kepes, Marli Ehrman, George Fred Keck, Ralph Rapson, and Arthur Siegel, and visiting instructors Herbert Beyer, Buckminster Fuller, Siegfried Gideon, and Walter Gropius—that in October 1946, shortly after Moholy-Nagy's premature death at fifty-one from leukemia, Herbert Read declared that "the Institute of Design is the best school of its kind that exists anywhere in the world today."[6]

With Moholy-Nagy's example and leadership, photography became more central to the Institute's curriculum than it had been at the Bauhaus, and it quickly emerged as the strongest of the Institute's programs:

> Photography throughout the country was effectively revolutionized by what happened under Moholy: first, photography was taught as a basic understanding of light and the

manipulation of light; second, it was recognized as central to modern vision, a fundamental part of what Moholy believed it meant to say that someone was literate; third, photography was integrated into a complete art and design curriculum; and fourth, it was taught experimentally, not rigidly or dogmatically or commercially. In addition to these groundbreaking acts, what Moholy also set into motion in Chicago also altered the geography of photography: prior to the opening of the New Bauhaus, photography had been dominated by artists who worked in New York or in or near the San Francisco Bay Area, Moholy's new school changed that fact as well, and Chicago took its place among the great centers of photography.[7]

Figure 4. Crombie Taylor, c.1953

In 1946 Moholy recruited Harry Callahan to the Institute photography faculty, and in 1951, Crombie Taylor, who succeeded Moholy's successor director Serge Chermayeff, recruited Aaron Siskind, who had just taught a summer session with Callahan at Black Mountain College.

Very early in his tenure as a faculty member at the Institute of Design Aaron Siskind photographed the Walker Warehouse. As his Walker Warehouse ornament photographs demonstrate, Aaron Siskind quickly answered Wright's challenge, that "the truth concerning the elusive depth-dimension of organic architecture defies the camera." His Walker Warehouse carved stone pier capital ornament detail photograph (Exhibit Photograph 3) uses natural light to show interlocking tendrils and other leaf-form features emerging from a carved stone block, where translucent shadows capture every tool mark on the undulating plane and measure every change in surface elevation. The rectangular picture frame, close focus, and shallow depth of field seem to exaggerate or concentrate the energies and tensions of the nongeometric, or organic, elements: the tendrils and leaf forms intertwine and rise from the flat surface; the carved outlines of the plant forms contrast with the short parallel cuts within the outlines to produce a delicate network of textures; the shadows that at the moment reveal these spatial relationships will change, in an instant, to delineate another in a series of limitless variations. Siskind's photograph sets the model for Sullivan ornament photography, and it makes possible the documentation of that neglected part of Sullivan's architecture that Wright considered so important.

Wright's challenge notwithstanding, it is easy to imagine how Sullivan's shallow, abstract, three-dimensional exterior building ornament would have been so attractive to Siskind, who had distinguished himself as a documentary photographer in New York in the 1930s,

but turned to symbolic and abstract photography in the 1940s. Sullivan's three-dimensional ornament was an ideal subject for exploring concepts fundamental to the Institute curriculum, such as that of the light modulator.[8] In the first-year Foundation course every student constructed a small three-dimensional light modulator, typically from a sheet of paper, to study the behavior of light as it flows through and is reflected by curved, bent, and perforated planes. Siskind found his light modulator on the side of a building; even though it is darkened by soot the Walker Warehouse ornament pattern comes alive in the light that Siskind pours into his photograph.

While Siskind's Walker Warehouse ornament detail photographs resemble his abstract photographs of "found" planar surfaces, it is important to recognize that his Sullivan ornament detail photographs are interpretative rather than documentative. As interpretative photographs of an architectural subject, they represent a new application of techniques now almost exclusively associated with Siskind's abstract photography. As we shall see, a photographer's interpretative aims involve specific procedures and are in no way merely "impressionistic." For they are aimed at revealing the idea within the thing, a goal that requires informed fidelity to the object before that idea can come to life in a photograph.[9]

Siskind's photography—both the documentary and abstract kinds—prior to his Institute of Design appointment is important because it explains his distinctive photographic vocabulary and teaching strategies. In the 1930s and 1940s, while teaching advanced students at the New York Photo League, Siskind organized and managed groups of student photographers, or "feature groups," for seven documentary projects, including "Portrait of a Tenement" (1937), "The Harlem Document" (1938-40), and "Sixteenth Street: A Cross-Section of New York Today" (1940). In a 1940 essay on the "feature group" method, written after the Harlem Document project, Siskind addressed the problem of unity in group projects and the nature of "documentary" photography:

> I felt from the beginning the first problem and necessity for any group was unity (in an aesthetic sense), that some common ground, some general understanding (agreement too presumptuous?) must be found for these five persons grouped about a table, looking at each other out of their separate, varied, mysterious selves—brought together here by a vague though single purpose (to make documentary features) and by private (and who knows what?) motives. That that unity could not be had through the logical, blanket acceptance of any general principles or ideas, but rather by the detailed exploration and experiment of minute implications, the special case. For instance, instead of beginning with a study of critical statements on documentary photography by eminent moderns (Strand, for instance) and a review of the tradition (the procedure of [Sid] Grossman's course in Documentary Photography), we concern ourselves with the problem of how an idea comes to life in a photograph, and the special characteristics of that life....

We learned a number of things about the form and continuity of a picture story; but, mostly, we came to see that the <u>literal representation of a fact</u> (or idea) can signify less than the fact or idea itself (is altogether dull), that a picture or a series of pictures must be informed with such things as order, rhythm, emphasis, etc, etc.—qualities which result from the perception and the feeling of the photographer, and not necessarily (or apparently) the property of the subject.[10]

In Siskind's "feature group" documentary projects in New York, a team of student photographers started with "a predetermined idea, and tried them out on the rest of the group to find out how far they worked"; then "examined a set of pictures all using the same material and having the same general aim, working away from the literal toward a growing concentration of feeling, from a picture without a point of view (the literal picture) to one whose meaning is more specific, limited, definite"; "explored the relationship between print tone (depth, contrast, etc.) and subject"; and finally "made scripts for features," chose one, and "we were on our way—<u>makers of pictures</u>" (p. 28). By articulating novel aims for the documentary photograph and by implicating and affirming for its achievement an imaginative role for the "makers of pictures"—that is, "the perception and the feeling of the photographer, and not necessarily (or apparently) the property of the subject," Siskind provides an alternative to documentative photography, the latter a documentary method much more suited to the "International Style" of architecture. The new procedures that Siskind articulates result in *interpretative photography,* a manner of photographic documentation much more appropriate for what might be termed the "interpretative style" of Sullivan's architectural works.

For Siskind, a feature group documentary is an experimental and social process, in which a "predetermined idea" is tested and revised through the comparison of initial photographs and translated into a "script" that guides further photographing. This process insures "unity" in a series of group photographs, and also enables or sanctions a "growing concentration of feeling" that is communicated in formal qualities in the photographs. Siskind associates these formal qualities in photographs, such as "order, rhythm, emphasis," with the "perception and the feeling" of the photographer; photographs without these qualities risk signifying "less" than the subject. Nowhere in his essay does Siskind illustrate any of these claims with particular photographs, so these claims must be taken as clues or hints for reading them. The social process of comparing photographs and developing a "script" is nowhere illustrated; although it is a social, it is also a visual process in which images dominate words. Siskind's remarks suggest that he used the process of visual experimentation and interpretative insight quite deliberately to resist textual and documentative representation. They also suggest how a "feature group" of photographers, directed by Siskind, could see more of Sullivan's buildings by allowing the exploration and comparison of their photographs to govern their "script" than could midcentury architectural historians who worked in the textual tradition initiated by Morrison—or, for that matter, single photographers working in the documentative tradition.

Siskind and the Teaching of Architectural Photography

Nearly everything we know about Siskind's Institute of Design Sullivan project is based on student recollections. Siskind and his students kept no written records of the project. In 1971, Len Gittleman recalled that the Sullivan project started before the fall 1953 semester, with Siskind's photographs of the Walker Warehouse: "I think that it started in one respect even in the class before us," with photographs by Siskind and an Institute of Design student of the Walker Warehouse, as it was being prepared for demolition. "Crombie Taylor [then Acting Director of the Institute and a professor of architecture] pointed out to somebody that it was an important piece of architecture and should be documented, so it started with this Sullivan building. Our awareness grew of the fact that there were other Sullivan buildings around."[11]

As an advanced class project the Louis Sullivan project developed quickly and continued through several classes and semesters, with eight students recording over 60 buildings by March 1954. It followed the first-year fundamental course that introduced all Institute students to materials, form, color, and light, as well as a broad range of photography concepts and techniques, including tone, texture, print quality, light modulation, depth of field, focus, point of view, close ups, reflection, and multiple exposure, as well as photographs to capture the "essence" and "meaning" of objects.

Figure 5. (Top) James Blair, Asao Doi, Len Gittleman
(Bottom) Leon Lewandowski, Alvin Loginsky, Richard Nickel

According to Len Gittleman and Jim Blair,[12] students worked on the Sullivan project in their senior year, so the project consisted of two teams: Asao Doi, Casimir Estramskis, Paul Hassel, Leon Lewandowski, and Alvin Loginsky in the 1952-53 academic year, and Blair, Gittleman, and Richard Nickel in 1953-54.[13]

Students read about Sullivan in Morrison's *Louis Sullivan* (reissued in 1952), with the early building photographs, and possibly in Sullivan's own writings, especially *Kindergarten Chats* (originally published in book format in 1934 and reprinted in 1947, with substantial revisions) and the *Autobiography of an Idea* (originally published in 1924, but out of print by 1952). The Sullivan buildings that the Institute students photographed were very different from the pristine buildings in the Morrison book photographs. The Walker Warehouse was demolished during the project and much of the Auditorium Building was closed, without lighting for the large interior volumes. Jim Blair recalls that the students were so enthusiastic about the Sullivan project and about

the opportunity to work with Siskind that they overlooked the grime and decay and sought to capture the "essence" of each building and of Sullivan's genius.

At the end of the project, Richard Nickel wrote a short class report, the only written account made at the time, especially important because it records details easily lost over time:

> Amid the mass of buildings which speak of the growth of a city, the architecture of Louis Sullivan now stands unnoticed but for the student of architecture and those who believe that architecture is the very essence of civilization. The philosophy of Louis Sullivan is of particular note to the students of the Institute of Design in that it bears striking resemblance to their own aesthetic conception.
>
> Seven years ago, and twenty-two years after his death, the American Institute of Architects rendered these honors to Louis Sullivan: "His profession of architecture was a lifelong dedication of all his energies and spirit. By esteeming practical requirements and aesthetic responsibilities he unfolded a new discipline of design. He believed that the dimensions of American architecture are the dimensions of American life, and thus directed us to an art of, by, and for our own people. He approached each task afresh, believing that each problem contains and suggests its own solution. He attacked entrenched beliefs. He repudiated false standards."
>
> In Chicago, where Sullivan was once inspired by the progressive and ambitious attitude of that city, a new progress was in its making. Land clearance in preparation for new thru-city expressways and a general rebuilding program on the blighted South Side brought to light many of the fine documents of Louis Sullivan's architecture.
>
> It was at this time that Aaron Siskind generated the idea of a photo-documentary project of Sullivan's architecture. The advanced photo students were in unanimous agreement on the plan though few realized what benefits would evolve from a simple beginning. But the benefits were many! Students new to Chicago were soon to know the city more intimately, there was a renewed interest in architecture and the fine quality of finished photographs as a result of a documentary attempt was unbelievable. Most importantly, they had the sublime personal satisfaction of recording the beginning shapes of the first modern creative architect, the architect who proposed a system of thinking—one which is bearing its fruits in a genuine modern architecture.
>
> Acquiring fine prints of the hundred and five existing structures proved to be a lengthy task. A desire to have three prints of each building in the form of one volume detail, one structural detail, and one ornamental detail has been loosely adhered to. Experience has proven it more advisable to depend on the particular character or importance of the building. Many buildings are so simple or so altered through time as to require only one volume photograph. Others such as the Auditorium Building or the Carson building deserve an entire series of all three types.

The four by five inch negative size is used throughout for its general flexibility and adaptability to architecture, for economical factors and primarily because most students own this size of camera.

Proper rendition of these dark, aged buildings is readily achieved by the manipulative qualities or character of black and white film. Color film is used in cases where the quality of the architecture might be enhanced to a greater degree than with black and white materials. Generally speaking, these cases tend to be the colorful buildings. Of course there is a restricting factor in the high cost of color materials and the additional technical problems of color rendition.

Photographing these buildings requires a genuine dedication to duty in the sense that the buildings are not so easily recorded. Very often a student will figuratively shoot a building to death only to accomplish nothing. Buildings are frequently dropped only to be reworked by another student: sometimes with overwhelming success and at other times with another failure. Approximately six impossible buildings exist, that is, those which have gone through the ranks but remain undone.

Many other problems plague the photographers. To work with any efficiency, a student must have a series of lenses to cover the desired field in close quarters or to use for telephoto effect. Many times the use of offices in adjoining buildings is necessary and this is characterized by the fearful, questioning secretary who has never heard of Louis Sullivan and is not particularly concerned with assisting. And, in Chicago, the weather ever predominates and is usually very fitful. All these factors make the project into the task that it is.

In a school such as the Institute of Design, one might expect a conglomeration of experimental, abstract photographs or even a general tiring of the entire project. Although freedom of interpretation is encouraged, it is a tribute to the students that they have persisted with a high level of integrity.[14]

Nickel notes the general neglect of Sullivan, the special rapport between Sullivan's philosophy and the "aesthetic conception" the students acquired at the Institute, the astounding achievements of a project that had such a modest beginning, the difficulties of photographing aging, urban buildings, and the surprising discipline and fidelity exhibited by design school students. But Nickel's account is governed by Morrison's justification for Sullivan's value, that is, Morrison's identification of Sullivan's "system of thinking." For Nickel, the passage of time since Sullivan's death in 1924 and the publication of Morrison's book in 1935 simply has confirmed Sullivan's role as the instigator of a "genuine modern architecture," and the relationship between "the beginning shapes" of his own buildings and the "genuine modern architecture" does not seem problematic.

According to both Gittleman and Blair, the project proceeded rather informally: student assignments for Sullivan buildings were not set at the beginning of the term, but weekly, sometimes spontaneously, and depended on their other class and part-time job schedules. Siskind often worked "on location" at Sullivan buildings with students, in Chicago and in New York, St. Louis, and rural Wisconsin and Iowa. For some local buildings, students worked independently. Asao Doi, who photographed local Sullivan buildings, recalls working alone, in rare cases with another student.[15] Because Siskind often had the only automobile, the students had to rely on Siskind for transportation to out-of-town buildings. Gittleman and Blair recall that, driving to in-town buildings, Siskind frequently arranged to have an attractive female student in the front seat; the male students were relegated to the back seat, with the long wooden tripods across their laps. The out-of-town automobile trips allowed for wide-ranging, collegial discussions about photography, art, and the character and social identity of the artist. The very arrangement of the Institute photography program facilities made it easy for Siskind to involve other faculty members. The film processing and printing darkrooms were on the third floor, behind the turret to the Ontario Street side of the building. Siskind and Harry Callahan used the turret room for meetings with students. The darkrooms, which were managed by former Institute photography student Art Sinsabaugh, the turret room, and the adjacent print drying area made one connected space. Siskind worked side by side with the students in the darkrooms; Callahan looked at every print, from every project, that was hung to dry. Each Monday, Siskind and Callahan would review a stack of student photographs and comment on print quality. Gittleman and Blair also recall the intimate social relationships that Siskind and other Institute faculty members had with their students, with many social functions in his North Avenue apartment, visits to jazz and burlesque clubs on Clark Street, and even trips to New York and the Cedar Tavern on vacation breaks, occasionally with painting instructor Hugo Weber. The trips to photograph out-of-town Sullivan buildings and the parties and social outings may have afforded students the best opportunities for extended commentary from Siskind. Doi, who did not participate in these social events, recalls that he knew Siskind liked a student photograph only if he used it in the exhibit.

The student perspective needs to be distinguished from that of Aaron Siskind. It is easy to understand Siskind's pedagogical strategy of reducing the distance between student and teacher, particularly for an artist. It was a strategy used by Hugo Weber and other Institute colleagues. And, perhaps because the Sullivan project photographs were not published, Siskind was rarely asked about them or about the project. We thus have little verbal commentary from Siskind. But we can read in Siskind's Sullivan building photographs his scholarship and other information he apparently suppressed, or perhaps took for granted, in his teaching.

Siskind brought long personal experience in architectural photography to the project as well as a keen interest in that of his contemporaries and predecessors. In the 1930s Siskind made comprehensive photographic studies of Tabernacle City, a Methodist summer camp

or retreat community of Victorian buildings on Martha's Vineyard, and early Bucks County, Pennsylvania buildings. In his "Harlem Document" and "Most Crowded Block in the World" projects, he also photographed New York City buildings, as well as the demolition of the Civic Repertory Theater. For Siskind, architectural photography marked an important, perhaps the crucial, phase in his artistic development in the 1940s:

> But the whole documentary interest, as far as I was concerned, at that time began to get transferred to architectural material. For quite a few years, working weekends, I used to go out to Bucks County and I worked with an architectural historian [Charlotte Stryker Perry, the wife of Roy Stryker who as Director of the Division of Information for the Department of Agriculture Resettlement Program, recruited Berenice Abbott and Walker Evans for documentary work]. I made a fairly complete study of the development of architecture in Bucks County and the various styles.... It was never published because of text difficulty. Also, even before the Bucks County thing, I had gotten interested in a wonderful architectural community on Martha's Vineyard, a community that isn't indigenous architecturally....

> You see, the early things were purely documentary, factual in the sense that Walker Evans' are. They are like social documents, in which you are very conscious not of the thing being a picture, but of the thing as a scene, almost as you would see it. And then there was kind of an injection of a thing, which was probably natural to me, of an interesting formal element, and that's where the architecture came in. Everything was still very straight, but the formal elements were very accented. You can see that from this interior, how simple and formal the thing is....

> From then on, when you get into '43 and '44, there is a great change that takes place. This great change was a result not of any decision that I made—intellectual decision—and this is very important, what I am saying now. It was the result of a picture experience which almost, I would say, sort of surprised me as to its meaning to me...and that's what changed the whole course of the thing.

> During one of the years I was on the Vineyard—I think it was '43 probably—I did a whole batch of pictures. I didn't know why I was doing them. And then, when I examined them that year, it was revealed to me that I had made pictures that had a meaning very basic to my whole life. Now, the fact that you could take a picture in a pleasant way, without thinking too much, and then suddenly find that this reveals terrific meaning to you, and also that these pictures have a consistency of meaning to me, showed me that I had gotten at something very fundamental. So I decided to continue to work that way, because I was very stirred by it, by this whole business. I'm not dramatizing this one iota. This actually was so. It actually, as far as my feelings were concerned, was even more dramatic. In working in the documentary style, I was always trying to search and find out what kind of meaning you could get in a picture of that kind. I was beginning to feel that I wasn't getting it, as far as I was concerned. I felt probably, I wasn't getting anything

really personal, really powerful, really special. And I also, in examining it, found that I wasn't made for it, really, because my documentary pictures are very quiet and very formal. Look at how isolated those two people are, and how well placed they are. That's not right for that kind of picture....

It's simple enough, the formalism isn't pushing, but there is a strong tendency. That's probably why I got so much pleasure out of working in the architectural material, and went to a lot of trouble to do it. There's something even more important, as for photography, and photography as an art, that happened when I did these pictures in '43. I noticed that I was photographing *objects in a setting* [my emphasis]. I noticed that always, in all the pictures I did. And I did this without consciously deciding it, although I laid some of these objects in places—something I don't do anymore, actually have never done since. I found that the total effect was a picture on a flat plane. I wiped out deep space. I had objects which were all organic looking objects, shapes, and these were in a geometrical setting....[16]

In this 1963 interview Siskind describes a series of important small steps that led to a major shift in his artistic development. These passages bear lengthy citation because they disclose, in Siskind's own voice, his early interest in architectural subjects. Here he first notes the transfer of "documentary interest," that is, the representation of social subject matter, to "architectural materials," to make photographs that function as "social documents," with the emphasis on "the scene, almost as you would see it." In this early practice of architectural photography, Siskind found himself balancing "straight" photography with something else, initially a new stress on "formal elements." A series of photographs made in the summer of 1943, upon close inspection, then revealed to Siskind a transformation in his own procedures, a "picture experience," in which a "social document," "a scene, almost as you would see it," is converted to a formal composition that includes but transcends that scene. For Siskind, architectural photography was the catalyst, and thus links his documentary and "abstract," or formal, photographic procedures. This autobiographical episode provides an explanation (as much as words can for him, because he continues to use a language of pointing) of the technique for converting the "literal representation" of documentative photographs into an interpretative "picture" in his well-known 1940 "Feature Group" essay.

Architectural photography provided the ideal subject for Siskind's exploration of space because architecture is three-dimensional and the picture plane, two-dimensional. Siskind's architectural subjects provide an infinite variety of formal relationships in space: relationships of planes that make three-dimensional space, but are converted by photography to two-dimensional space. Siskind used "architectural material" to explore the modulation of apparent dimensionality, and also to explore the relationships of objects, or, as he later called his abstract photographs of objects, their "conversations." It is this early exploration of architectural parts that established Siskind's range as a photographer, and Siskind recounts

it with passion. Aside from his systematic documentation of Sullivan's buildings, however, "architectural material" disappears from Siskind's published work, just as a catalyst is consumed in a chemical reaction, to be replaced by strong compositions of abstracted planar subjects, such as walls, signs, and windows.

The important role of architectural photography in Siskind's development is unappreciated, very likely because his early architectural photographs were largely inaccessible or unseen when he made them and then made widely available after critics established the broad outlines of his artistic development. His architectural photographs of the 1930s typically were exhibited in short installations but not published until much later. As Siskind notes in his 1963 interview (itself unpublished until 1994), the Bucks County photographs went long unpublished: in 1948 they briefly were exhibited in New Hope, Pennsylvania, but published in 1974.[17] His Harlem photographs were exhibited in Harlem in 1939, but not published until 1981.[18] The Tabernacle City photographs were exhibited at the New York Photo League in 1941 and, though single photographs have been reprinted, the entire exhibit remains unpublished.

Siskind and His Contemporaries

Siskind's contemporaries, such as Walker Evans and Berenice Abbott, also used architecture to explore photographic technique, occasionally photographing the same subjects. Evans and Abbott exchanged their work in the early 1930s (Evans photographed Abbott in 1932), and their coincidental photograph of the same doorway at 204 West 13th Street (in 1931 and 1937, respectively) is well known. In 1931 Evans photographed Tabernacle City, the Methodist retreat on Martha's Vineyard that Siskind cites as one of his own important subjects.[19] Their work was much published, in large and small periodicals, such as *Fortune* and *Hound and Horn* (sometimes with New York Photo League photographs), and widely exhibited in New York.

In 1938 the Museum of Modern Art opened *Walker Evans: American Photographs,* the exhibit and catalogue designed by Evans, assisted by Lincoln Kirstein who also wrote the catalogue commentary that follows the images, reproduced one to each page opening.[20] While not a systematic exploration of American architecture, *American Photographs* includes many architectural photographs. For this first major one-person exhibit Kirstein takes great care to relate photography to the other visual arts, and he uses the architectural photographs to illustrate Evans's distinctive artistic talents, perhaps even to set a standard for the photographer as artist. For Kirstein, contemporary photography, by comparison to painting, is a uniquely social medium: "The use of the visual arts to show us our own moral and economic situation has almost completely fallen into the hands of the photographer." And, for Kirstein, Evans's achievement is to have assembled a series of single images, marked by "their

exhaustiveness of detail, their poetry of contrast, and, for those who wish to see it, their moral implication." It is through Evans's architectural photographs, taken during the Great Depression, that this "moral implication" is best conveyed. As Kirstein's discussion indicates, Evans's photographs involve considered assumptions about American cultural and economic history:

> The eye of Evans is open to the visible effects, direct and indirect, of the industrial revolution in America, the replacement by the machine in all its complexities of the work and art once done by individual hands and hearts, the exploitation of men by machinery and by men. He records alike the vulgarization which inevitably results from the widespread multiplication of goods and services, and the naïve creative spirit, imperishable and inherent in the ordinary man. It is in this spirit which produces sturdy decorative letterings and grave child-like picturings in an epoch so crass and so corrupt that the only purity of the ordinary individual is unconscious.

> A sophisticated, yet unaffected eye prizes the naive for the sake of its pure though accidental vision, not for the paucity of its technical means. In our architecture of the mid-nineteenth century our carpenters and builders made a human and widely acceptable familiarization of gothic and renaissance models. By way of uncolored engravings, similar in spirit to Evans's hard uncolored prints, we accommodated European stone to the delicacy of our pine and stucco. By 1850 we could afford ourselves the bold appropriation of every past style, spurning the finicking refinement of bourgeois "good taste" that castrated the Georgian into the weakened scale of our post-revolutionary New England and colonial architecture. Later we were given the neo-gothic Woolworth Tower and the degradation of the collegiate style at New Haven and Princeton, the neo-colonial at Harvard. Only Evans has completely caught the purest examples of this corrupt homage—innocent and touching in its earlier manifestations—which can be taken as the thematic statement in the symphony of our conglomerate taste. His eye is on symbolic fragments of nineteenth century American taste, crumpled pressed-tin Corinthian capitals, debased baroque ornament, wooden rustication and cracked cast-iron moulding, survivals of our early imperialistic expansion. He has noted our stubby country gothic courthouse columns, the thin wooden gothic crenellation on rural churches, images of an unquenchable appetite for the prestige of the past in a new land. Such ornament, logical for its place and its time, indigenous to Syracuse in Sicily, or London in England, was pure fantasy in Syracuse, New York, or New London, Connecticut. Evans has employed a knowing and hence respectful attitude to explore the consecutive tradition of our primitive monuments, and advanced philosophical and ideological technique to record their simplicity (pp. 194-95).

Evans's images of architectural decay, that is, of abandoned nineteenth-century buildings and of building fragments, are important to Kirstein because they mark both the unsustainability of American imitation but also the substitution of machine production for handwork:

"His work, print after print of it, seems to call to be shown before the decay which it portrays flattens all sagging roof-trees and rusts all the twisted automobile chassis. Here are the records of the age before an imminent collapse. His pictures exist to testify to the symptoms of waste and selfishness that caused the ruin and to salvage whatever was splendid for the future reference of the survivors" (p. 196).

Despite what now may appear to be a polemical argument, or an argument for polemical photography, Kirstein claims that the "most significant single feature of Evans' work is its purity, or even its Puritanism. It is 'straight' photography not only in technique but in the rigorous directness of its way of looking. All through the pictures in this book you will search in vain for an angle-shot" (p. 197). Here, Kirstein's rather facile correlation of "straight" photography with the camera angle points to the great difficulty of defining "straight photography" in one's own time. For an introduction to a major Museum of Modern Art exhibit, Kirstein struggles both to establish the artistic and intellectual complexity of Evans's apparently simple documentary photographs and to separate an impressive body of work from the government agency (Farm Security Administration) that commissioned and paid for it. Kirstein's aggressive and apparently inconsistent claims for Evans's *American Photographs* as social commentary and "straight" photography must be read against their original occasion and their second incarnation as museum exhibit objects.[21] What is unambiguous in Kirstein's commentary, however, is the central role of architectural photography in Walker Evans's early career and the visibility afforded architectural photography by his early successes.

At the same time that Evans photographed architecture in the rural American south, Berenice Abbott was photographing urban American architecture. From 1931 to 1939, Abbott surveyed New York City, with an emphasis on documenting the quickening pace of change in the built environment. And in July 1934, Abbott traveled with the architectural historian Henry-Russell Hitchcock by automobile through cities along the Atlantic seaboard to photograph nineteenth-century urban vernacular buildings for his 1934 *American Cities* exhibit and H. H. Richardson buildings for his 1936 Museum of Modern Art exhibit and book. In October 1934 the Museum of the City of New York exhibited 41 of her city photographs; in December 1937, a larger exhibit of 110 photographs. In 1939, the project was published as *Changing New York.*

For her New York City photographs Abbott developed a very deliberate approach to urban architectural photography that depended on both the deft use of natural light and the juxtaposition of buildings to moving human figures and of the movement implied by soaring bridges and highway structures to smaller urban buildings. In her applications for project funding, Abbott decried the building losses associated with accelerating development:

> Old New York is fast disappearing. At almost any point on Manhattan Island the sweep of one's vision can take in the dramatic contrasts of the old and the new and the bold foreshadowing of the future. This dynamic quality should be caught and recorded

immediately in a documentary interpretation of New York City. The city is in the making and unless this transition is crystallized now in permanent form, it will be forever lost. Such documents would be of increasing historical value for the archives of this city.[22]

In her notes to photographs in *Changing New York,* over and over again Abbott remarks on the difficulty of finding the best light at the best time of day. Of her Daily News Building photograph, taken from a point above, in which full sun lights the building and separates it from the grey toned buildings below, Abbott wrote that "I had to go up in the Chanin Build-ing, but was unable to reach the exact height I wanted. I had to settle for an office that would allow me to be present.... The light was very good; it was midafternoon—and just when everything was ready the sun went in, not for just a moment, but for the day. I knew it would be a bad photograph if the light was dull, and so I had to come back another day" (p. 134). Of her photograph of the Old-Law Tenements on East 1st Street, taken at street level, she writes: "The buildings in the foreground were down; a subway line was being constructed and this row of houses was exposed.... This was taken in the afternoon; in fact a high percentage of the changing New York project photographs were taken then. I'd often get up early, but found the morning light to be weaker. It became stronger as the day went by. The early morning light was beautiful but too weak; it took me a while to discover this" (p. 159).

For the Hitchcock project architectural photographs she could not be so patient. Although Hitchcock selected the sites and left the compositional decisions to Abbott, she was limited by the light she had, the travel schedule, the season—and by Hitchcock's polemical ends. By contrast to the *Changing New York* photographs, her *American Cities* and H. H. Richardson building photographs are muddy, with dark shadows and little gradation of tones. In the 1936 Museum of Modern Art Richardson exhibit Abbott's photographs were reproduced as 8 by 10 inch contact prints, with trimmed margins; the book format was much smaller, with two and three photographs on a 6 ½ by 9 ¾ inch page.[23] To capture an entire façade of a large building, as in her photographs of the State Hospital, Albany, she moved far from it, with considerable loss of detail. Indeed, for all of the building photographs she made for Hitchcock Abbott used the same distance: "To maintain similar proportions within each of the photographs, she placed her camera at a standard distance from her subject, allowing the sky to frame the buildings, whose contours she rarely cropped."[24]

For Hitchcock, these limitations may not have been significant to his argument that modern architecture had its origins in unornamented nineteenth-century urban vernacular buildings and that these provided a set of useful conventions to early modern architects, such as Rich-ardson. Indeed, Hitchcock opens his Richardson exhibit catalogue with the bold claims that Richardson is "the greatest American architect of the nineteenth century" and that "Modern American architecture may be said to have begun with Richardson shortly after the Civil War." He then introduces the exhibit building photographs and plans with a short section on "Richardson and the Skyscraper" and four analogies that link Richardson's buildings to

features he identified as characteristic of the International Style. Richardson's Quincy Library (1880-93) illustrates the analogy of "functional asymmetry" (with Walter Gropius's City Employment Building, Dessau, 1928); his Paine House (1884-86), "open planning" (with Mies van der Rohe's Tugendhat House, Brno, 1930); his Brattle Square Church (1870-72), "ribbon windows" (with Le Corbusier's Jeanneret House, Vevy, 1923), and his F. L. Ames gardener's cottage (1884), "small house in wood" (with Richard Brown's Brown House, Chestnut Hill, 1934).[25] With the International Style as his benchmark, Hitchcock had no need for ornament details or photographs that used natural light to register the textures and shapes of different materials.

Throughout the 1930s, while Siskind was photographing buildings on Martha's Vineyard and in Bucks County, Abbott's architectural photographs were exhibited at major cultural institutions in New York. Her Richardson building photographs became part of a sustained effort by Hitchcock and his colleagues Alfred Barr and Philip Johnson to define modern architecture and, by looking backwards, rewrite its history. Siskind knew Abbott's work so well that he appears to have taken it for granted; they sometimes photographed the same subjects and, in the 1930s, Siskind recalled, "we knew documentary work of some sort, we knew the work that Berenice Abbott was doing in New York."[26]

Siskind brought to the Institute Sullivan project a keen interest in Evans, Abbott, and other documentative (both social and architectural) photographers, including those represented in Morrison's book. The early Sullivan building photographs taken by J. W. Taylor, Ralph Cleveland, and Henry Fuermann are extraordinary documents of Sullivan buildings at the time they were built. Even though they are compressed to the same small format as the Berenice Abbott Richardson building photographs in Hitchcock's book (coincidentally, Robert Josephy[27] designed both the Morrison and Hitchcock books), Morrison's Sullivan building images are somewhat sharper and the range of tones more distinct, perhaps because the earlier films were sensitive to fewer waves of light.

But there is a contradiction in Morrison's book between his argument and his visual evidence. According to Morrison, Sullivan's position as the "great forerunner of modern architecture" depended more on his contributions to architectural theory, "his system of thinking," than on his practice: "the bare logic of Sullivan's architectural thinking would have been more clearly apparent to his contemporaries if his buildings had not been adorned by such lyrical enrichments in the way of ornament." In the early Sullivan building photographs, however, ornament details are clear, crisp, and pervasive, in silent resistance to Morrison's text.

It is in his early architectural photography and that of Walker Evans and Berenice Abbott, along with the scholarly uses to which photographs of Richardson and Sullivan buildings were put, that we can understand the distinctive perspective Siskind brought to the Institute Sullivan project. Evans and Siskind gave visibility and status to architectural photography

as a modern art form. By contrast to Evans in *American Photographs,* Siskind is interested only in the systematic recording of the complete work of a single modern American architect. Siskind's Sullivan is an answer not only to Abbott's Richardson, but to Hitchcock's Richardson and Morrison's Sullivan because Siskind depends on the eye, not the text. Siskind succeeds in revealing a Sullivan not seen by these architectural historians because his eye is capable of utmost fidelity to his subject—namely, "objects in a setting"—and of the sympathetic transformation of that subject into stunning pictures from which meaning, or the idea, shone forth, unsought. As the project photographs indicate, Siskind used all of his documentary and abstract photography techniques to document Sullivan's architecture anew. With his innovative documentation he converts architectural parts and fragments into whole pictures, stops the passage of time and confers dignity on buildings at their most vulnerable, and teaches us how to close the physical and psychological distance to the work of America's seminal modern architect.

Siskind on Sullivan's Doorstep: Three Paradigmatic Examples

Three series of Sullivan building photographs—the Walker Warehouse, Max M. Rothschild Flats, and the Auditorium Building—demonstrate how Siskind worked with his subject and his students and can serve as an introduction to the exhibit.

The Walker Warehouse series is perhaps the most significant of the entire exhibit. Because the building was demolished in October 1953, it is the only photograph series in the exhibit that does not point to a standing building. By contrast to all the other Institute project building photographs, the Walker Warehouse photographs stand for the building: when Siskind and student Al Loginsky took these photographs, they knew that theirs would be the last ever made of the building.

The Walker Warehouse figures as an important building in the two books about Sullivan that Siskind knew well. For Hugh Morrison, the Walker Warehouse was among Sullivan's best designs, important because it showed how Sullivan learned from Richardson—and surpassed him:

> The most interesting aspect of Richardson's influence on Sullivan is the rapidity with which Sullivan assimilated it and developed it into something entirely new. It is hard to overestimate the importance of the Walker Warehouse in this respect. Architecturally, the Walker Warehouse is far more significant than the Auditorium, and it takes its place with the Wainwright Building as one of Sullivan's great achievements. Being a commercial structure in the inner part of Chicago's Loop, it is not well known, and the present obliteration of the building by advertising signs prevents the casual observer from gaining an idea of its quality....

Each building [Richardson's Marshall Field Wholesale Store and Sullivan's Walker Warehouse] is a seven-story warehouse structure occupying a full block; the mass in both cases is cubic, with only a slightly projecting cornice and a clear-cut silhouette; ornamental detail is virtually omitted, so that the architectural effect depends almost solely on the plastic articulation of the larger forms. The difference between the two buildings lies in the arrangement and treatment of these forms. Richardson's building, although a great advance over previous structures, represents the persistence in a slight degree of conventional design, in that, although grown away from the historical styles, it is not yet entirely free from them....

The Walker Building goes beyond the Field in two essential respects: the greater freedom from historical or conventional forms, and the more precise statement of its elements of design in a firmly articulated whole. It is a sort of pure architecture, using the fundamental elements of the pier, the lintel, and the arch in an abstract composition, dissociated from the expression of specifically masonry effects. The omission of heavy rustication on the arches signifies that Sullivan is using a geometrical shape, not a traditional form. The use of smooth ashlar masonry instead of rustication signifies an emphasis on the wall plane rather than on the surface of the wall as solid mass. In every detail, Sullivan develops toward an abstract architecture....[28]

In *Genius and the Mobocracy,* Frank Lloyd Wright recounts Sullivan's comments on the building as it was being designed: Sullivan said it was "the last word in the Romanesque." Sullivan's phrase seems to validate Morrison's claim. But Wright goes on to say that "[t]his building, though a prominent one, seems lost to sight as I have seldom seen it illustrated. It has a façade in Romanesque terms (not rock-face however), an arched cut-stone structure much in keeping with the Auditorium façade and of the same Bedford stone—with a fatal defect: great twin arches landing on a pier dividing the building in the middle."[29] Wright's judgment again is Siskind's cue. As with his comment on ornament detail photographs, so too with this comment on the "fatal defect": Siskind's photographs of the "great twin arches landing on a pier" and the ornament detail are the largest prints and the most compelling images in the series.

As we shall see, Siskind's photographs and the Walker Warehouse exhibit series indicate an independent perspective, in which the power of the image contradicts the authority of both the disciple and the architectural historian.

When Siskind and Loginsky photographed the Walker Warehouse, adjacent buildings already had been demolished and interior demolition already was underway. They photographed in the late summer or early fall, in the late morning, after the sun cleared the buildings to the east and cast strong shadows along the sidewalk in front of the Market Street façade. Late morning was the only time that the east façade was in sunlight, and Loginsky used the dark

shadows to subdue the buildings to the east and frame the Walker Warehouse. Of the 31 photographs they made, Siskind selected eight for the exhibit: the four Siskind detail photographs are centered on the installation panel, with the two Loginsky photographs and two façade photographs at the two ends.

The series begins with a demolition photograph, an interior view that uses the demolition pit to reveal the building's structure, otherwise not visible in the intact building. Demolition exposes the open volume between floors, the structural framing system with the cast iron columns and floor framing, and the effortless base that contrasts with the heavy thick stone façade in subsequent photographs. Despite the debris and dusty chaos of demolition, the interior is calm; the photograph must have been taken on a weekend or early in the day, while the newly prepared debris pit, cut into the structure by the wrecking company, is clear. Loginsky stands in deep shadow, using bright daylight to highlight structure and shadow to subdue demolition. The result is a strong, complex composition of three-dimensional triangles, circles, and straight and curved lines, with shaded and illuminated variants superimposed on the structural grid, and the two sources of natural light creating axes that intersect and animate the interior volume.

As with this interior view, the second photograph in the series, Loginsky's three-quarter perspective, also connects demolition to revelation and exposure: in showing the Walker Warehouse in relation to all its surviving neighbors, it indicates that the demolition of buildings to the south reveals the Walker Warehouse, albeit partially. In late summer, Loginsky can capture only two elevations, the south façade in full view and the front façade only obliquely. He floods the dark building with late morning light, waiting until the dark shadow is closest to the building. Using shadow to frame (as opposed to cropping) is a typical Siskind technique, and Loginsky applies it with great skill. Strong vertical lines form in the shadow frame, and the Walker Warehouse stands in the middle of a tonal range that runs from dark to light in the Willoughby Building, the warehouse addition, and the Civic Opera House.

These first two photographs insist on demolition and loss, at the same time that they indicate the possibility of using the death of a building to understand it. Following these two Loginsky photographs, Siskind's tendril ornament detail is an extraordinarily powerful composition: it fills a much larger photograph with a self-contained part, a whole that represents the organic process of plant growth and motion. The jump in scale of the prints, from the first two (and the first is the smallest in the series) to the third, gives emphasis to Siskind's use of the series in the Sullivan exhibit: the series makes the exhibit a documentary exposition composed of interpretative photographs to be read against the architectural historians Morrison, Wright, and Hitchcock, against Sullivan's early photographers J. W. Taylor, Ralph Cleveland, and Henry Fuermann, and against Siskind's contemporaries Berenice Abbott and Walker Evans. Siskind's Sullivan is not Morrison's or Wright's Sullivan, although he is capable

of using Wright's clues to look more closely at Sullivan's buildings. Siskind's Sullivan buildings are no longer pristine; they are aged, worn from use, apparently approaching the end of their lives as buildings, and the beginning of their lives as only photographs and fragments.

Rather than exhibit what Morrison thought to be important—that is, how Sullivan simplifies Richardson on the way to a full-blown modern architecture—Siskind emphasizes Sullivan's difference, showing that even in his simplest buildings Sullivan used ornament that Richardson never dreamed of. To document this ornament with his abstract photography techniques, Siskind of course must approach the Walker Warehouse, coming so close that the surface planes, textures of the materials, and shadows can be discriminated. Closing the distance of photographer to subject is an important part of Siskind's technique in the Sullivan project: it implies a rapt attentiveness to formal detail, and an intimate physical relationship as well.

Where Morrison sees only simplicity and abstraction, Siskind, as the tendril capital and corner photographs indicate, also sees a variety at the smallest scale. In the tendril capital and corner photographs, Siskind shows Sullivan varying the intersection of planes, using the horizontal, utilitarian lines of the stone cutting at the base as ornament, juxtaposing organic and geometrical patterns and negative and positive volumes. These photographs are stunning technical achievements: Siskind saturates the image with shadows and stained surfaces, nearly continuous gradations of tone that register detail and depth. These two detail photographs also illustrate Sullivan's "organic" architecture in which parts, or details, are subdivisions that partake of the "function of the whole."[30] The base details are subdivisions that show the surface and texture of the structural stone as an ornamental feature that complements the tendril ornament detail. In Siskind's ornament photographs Sullivan emerges as both artist and architect, and his building, as an art form. The photographer's subject is a work of sculpture whose artistic value is conveyed by the photographer's artful composition.

With these three photographs in this series, Siskind thus can question or contradict Morrison's claims about Sullivan ornament in an especially poignant way. The two Loginsky photographs at the beginning and the two photographs at the end of the series establish general relationships between the interior and exterior and along façades (the window in the interior photograph is the left window in the last exterior photograph). With his three ornament detail photographs, however, Siskind poses an enduring open question about how well Sullivan buildings were seen and understood. Where is the tendril capital? How was it photographed? Where is the recessed corner? With these ornament detail photographs, Siskind also memorializes the building's hidden, or "secret," parts that offset the exposure and vulnerability associated with demolition. These secrets, the parts of the building visible only at close distance, provide the building with a measure of dignity, and the viewer, a capacity for sympathy that comes with physical intimacy.

Siskind's double arch photograph, Wright's "fatal defect," is perhaps his most beautiful Walker Warehouse photograph, a tall rectangular image that uses the geometry of the print format to exaggerate the arches and record and balance a variety of planes and tones. It is a tour de force of composition. Siskind records the irregular staining of the stone and the precise three-dimensional geometrical ornament patterns within the broad lines of the arches and lintel. To gain detail within the edge of the interior of the shallow arch curve and on the building façade he overexposes the edge of the arch and the lintel. The range of shaded tones, the low contrast between the brightest and darkest extremes in that range, slightly flattens the three-dimensionality of the arch and balances the strong curves of the arches against the highly decorated horizontal band of the lintel. For Siskind the irregular staining on the blocks that form the interior of the arch becomes a two-dimensional ornamental feature, the product of weather and time, that complements Sullivan's precise modeling of stone. Most impressive, however, is Siskind's framing of the double arch and lintel sections. It is the juncture of the strong vertical curved lines with the full measure of the arch width and the horizontal lintel whose strapwork-like decoration suggests the strain of holding the two arches that sets the boundaries for his composition. Those picture boundaries, in turn, strengthen the composition by cutting the arches before they reach their highest point, so that the eye is fixed on the transmitting of forces from above and beyond the frame of the photograph—or, perhaps more accurately, on the lines that complete the two arches beyond the frame. That Siskind lifts the decorated lintel off the lower edge of the photograph suggests that this image is not about structure, but about the beauty of lines and planes, that is, the artistic values of Sullivan's ornament, even the ornamental or aesthetic character of Sullivan's structural features. As with his tendril and corner detail photographs Siskind here insists on Sullivan as artist, and the building as art form. By selecting a portion of the façade and composing a fragment for visual attention, Siskind focuses on the art of Sullivan's structure and the visual delight it affords an attentive observer.

The last two photographs complete the study of light and shadow initiated by the first photograph. In Loginsky's interior photograph, light fills three-dimensional space to illuminate structural components and multiply patterns. The fire escape photograph (not attributed, likely Siskind) traces a two-dimensional pattern superimposed along the flat plane of the exterior wall, overexposing the façade in the bright sun to exaggerate the tonal contrast between the shadow and architectural patterns. With the double arch photograph, Siskind uses high clouded sunlight to exhibit the context for the interior demolition photograph and his detail photograph, a complete arch and window module section, with the entire range of tonal values in the stained arches. The four nearly symmetrical relocation signs in the building windows (one within each arch; one above each arch) present a final image of a building made to advertise its own abandonment.

It would be difficult, I believe, to overstate the importance of the Walker Warehouse series to the entire exhibit. In these photographs, with his student, Siskind establishes a technical standard and a set of issues and relationships for the other building photographs. In large

part, Siskind's exhibit achieves special power and significance for the absence of text and for the illuminating presence of the exhibit's formal content—of its felt, humanized objects. In terms of photographing technique, his lesson is that, for Sullivan's buildings, the skills of documentative photography are essential to architectural photography, but they are not sufficient for producing photographs that prove the most revealing of architectural forms. For that an "interpretative" method is required of the artist/photographer, a procedure that demands the "injection of a thing…an interesting formal element" rather than the pure, "factual" photograph that yielded a mere "scene." Only in this way could the artist, as well as the viewer, get out of it "anything really personal, really powerful, really special," as Siskind put it. For Siskind the "injection" of Sullivan's ornament was the "thing" that enabled the kinds of photographs which both permitted the photographer to become an artist in his own right and resulted in a fidelity to formal particularity necessary for Sullivan's buildings to be re-viewed by architectural historians, thereby permitting the acknowledgment of Sullivan's "interpretative style" and finally securing the importance of architectural photography to architectural history. As I have suggested, the Walker Warehouse photographs establish a sophisticated conceptual framework for reading Sullivan's buildings visually in the mid-twentieth century by connecting visual, psychological, and social space.

Another series of photographs—Richard Nickel's photographs of Siskind photographing Sullivan's Rothschild Flats—dramatizes Siskind's investigation and representation of this conceptual framework. Neither Siskind's photographs of the Rothschild Flats or Richard Nickel's photographs of Siskind photographing that building appear in the exhibit. But they provide important information, again of the visual kind, about Siskind's relationship to his architectural subjects, to the families that inhabited so many of Sullivan's residential buildings in the 1950s, and to his students.

The Rothschild Flats are just across from the Barbe Residence (Exhibit Photographs 79, 80). Siskind, Casimir Estramskis, and Nickel photographed the two buildings on an early spring day, with high overcast sun, using at least three large-format cameras on wooden tripods. Nickel's eight photographs show Siskind on the sidewalk at the Rothschild Flats taking a façade detail photograph, probably of the carved front door. Siskind is surrounded by neighborhood children in constant motion. Both Siskind and the children are comfortable: they are uninhibited, he is unembarrassed. They play, dance, and pose affectionately with each other; they stop in front of the camera; they attend to what Siskind is looking at. Adults pass through the photographs, on foot and in automobiles; they appear to be unconcerned about Siskind and their children. Estramskis watches the cameras, the children, and Siskind, who is nearly a still point, close to the Flats building.

These unexhibited photographs are important because they show that, to photograph Sullivan's residential buildings in the 1950s, Siskind and his students had to spend time in African-American neighborhoods and interact with families there. These neighborhoods

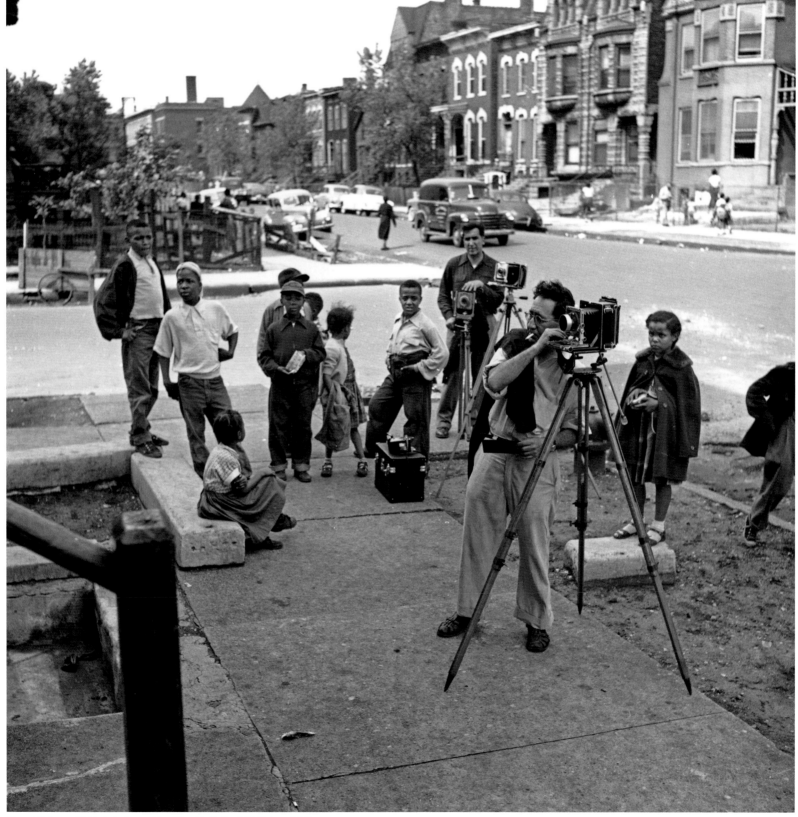

Figure 6. Aaron Siskind photographing Max M. Rothschild Flats, c.1953

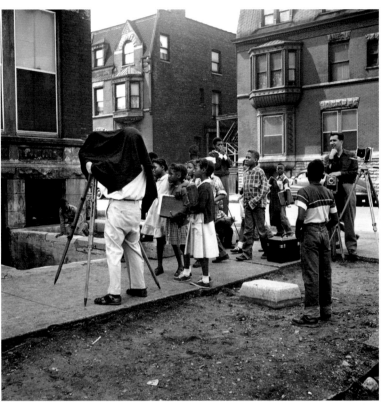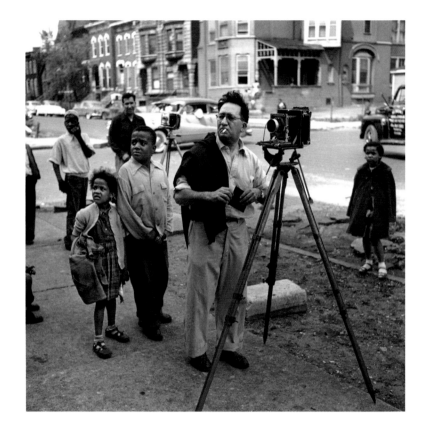

Figures 7-12. Aaron Siskind photographing
Rothschild Flats, c.1953

constitute a kind of public, or social, space, very different from the desolate, uninhabited space of the Walker Warehouse. The Rothschild Flats are not abandoned; the grass and trees are worn away by children and poverty; a constant stream of automobiles and pedestrians moves through the photographs. In this social space, the photographers, come to scrutinize the buildings, are outsiders; as whites, the photographers cannot blend in; their differences, as spectators, cannot be overlooked. In the act of photographing, however, Siskind becomes vulnerable. In covering his head with the black cloth to compose the building photograph on the ground glass, Siskind participates in the vulnerability, if only for a few moments, of the socio-economically disenfranchised tenants and their children, perhaps making it easier for them to approach and trust him. For Siskind, photographing Sullivan buildings thus involves some engagement of social difference. The photograph of Siskind on the front porch of the Flats is especially significant because it shows, again, Siskind's strategy of approach and respect for the tenants who find themselves the caretakers of Sullivan's otherwise neglected buildings. Siskind closes the physical distance with the building's tenant and engages her in conversation, as she stands just at that physical line—the threshold—that separates the public façade and private interior of the building. But photographing buildings also involves some social indifference. For whereas Siskind is comfortable in the social setting, Nickel's photographs also demonstrate that the quotidian activities taking place around him in no way distract Siskind from the formal elements of the building he is preoccupied in photographing.

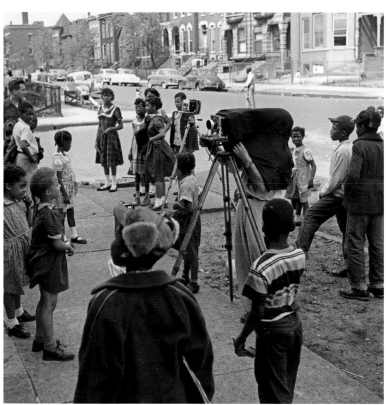

Nickel's photographs document Siskind's mastery of the photographer's space, here one of ethnic difference and indifference at once. Siskind succeeds in photographing Sullivan's residential buildings because he can move comfortably in their social spaces. The relationship between Siskind, Estramskis, and Nickel in these photographs indicates, I believe, that Siskind saw this skill as essential to the Sullivan project, even though he may not have made it explicit in his teaching. These photographs dramatize a practice based on Siskind's long experience as a public school teacher and documentary photographer in African-American districts in Manhattan. To photograph Sullivan's early residential buildings, Siskind demonstrates to Estramskis, the architectural photographer must communicate such respect and deference to their inhabitants that children feel invited to approach, that adults suspend their concern, and mothers converse at the open front door, despite social differences. This respect and deference is expressed in Siskind's building photographs: his Rothschild Flats photographs do not use the condition of the building to accuse or blame the tenants, or even the absentee landlords.

Siskind's practice, as represented in these photographs and his Walker Warehouse photographs, also suggests that the application of social documentative techniques to architectural photography involves treating inanimate buildings as if they were animate, or living, objects. For Sullivan buildings, the application of social documentative techniques is especially important, given Sullivan's organic architecture, his juxtaposition of severe geometric structure, precisely incised planes, and abstract naturalistic ornament that rises from planar surfaces. More importantly, by treating buildings, his subjects, as living objects Siskind allows aging to be a natural, inevitable part of a building's life cycle. These documentative techniques, when applied by Siskind to architecture, enable him to study aging (rather than suppress or ignore it) and to confer dignity on aged buildings: just as the lines of age, labor, and exposure to weather add character to the human body, so with Sullivan's buildings, discoloration, staining, decay, and fragmentation add, not subtract, value.[31] Siskind's interpretative photography both confers dignity on buildings and converts a photographer into a creative artist.

In the three Rothschild Flats building photographs (Figures 13, 14, and 15), taken on another, warmer spring or summer day, Siskind captures the entire building, with its cornice missing; the side elevation perspective, with the vertical and horizontal components balanced in a shadowless overcast sun (and the dog leaning over the third-story window sill); and the side elevation detail. Low contrast reduces the unevenness in the building condition, subdues the staining, and emphasizes the sculptural character of building mass. The African-American woman at the open door with Siskind reappears here, again on her front porch, with the ubiquitous children in the foreground.

Figure 13. Max M. Rothschild Flats. *Photograph by Aaron Siskind*

Figure 14. Rothschild Flats. *Photograph by Aaron Siskind*

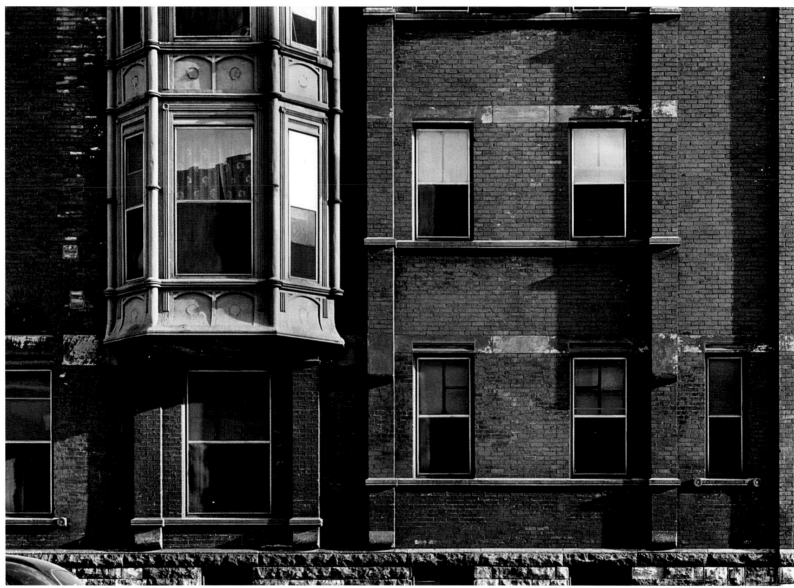

Figure 15. Rothschild Flats. *Photograph by Aaron Siskind*

The Auditorium Building series photographs provide information about Siskind's relationship to his students as a group and their response to his models. With 17 photographs (five exterior and 12 interior), it is the largest series in the exhibit, with only one by Siskind. As Siskind withdraws, the Auditorium Building series becomes much more a student production. Their photographs move from the exterior to interior volumes, and finally to ornament details. The first exterior photograph, by Leon Lewandowski, is a masterful panorama, showing the entire east façade in relation to its Michigan Avenue neighbors. Nickel's tower photograph, showing Adler and Sullivan's offices, was taken from the roof of the Congress Hotel, just to the south. Lewandowski's façade detail photograph is a superb composition of receding arches and brackets. As the largest Sullivan building, a collection of performance, hotel, and office spaces, it challenges the project guidelines for exterior, interior, and detail photographs. The first interior photographs are details (by Paul Hassel and Lewandowski, along with one by Siskind) that glance at the different interior spaces: the auditorium, the auditorium lobby, the tenth-floor dining room, and so forth. By contrast, four banquet hall photographs (by Hassel and Lewandowski) show its entire volume, including its distinctive inner wall planes with their continuum of representational nature painting, abstract naturalistic stained glass, and the highly figured birch grained piers and carved capitals. The last four ornament details (at least two by Hassel and Lewandowski) record ornament in different media: fretsawn screen; cast plaster; mosaic; and stained glass.

Sullivan's early photographers far more systematically recorded the performance and hotel spaces. J. W. Taylor strained against the limits of his camera and lighting equipment to photograph the volume of the theater—and when he photographed the building, the banquet hall was not completed. By contrast, Siskind's selection emphasizes ornament; ornament details unify the photographs of the various students. But none of the students compose photographs that convert a piece of ornament to a "whole" image, or self-contained composition, as Siskind does with the Walker Warehouse tendril. Nor do the students, in physically approaching their subjects for detail photographs, exploit the psychological and social aspects of social documentative techniques. While proficient, their ornament detail photographs lack the animism and sympathy in Siskind's subtle compositions. By comparison to the Walker Warehouse series, however, the Auditorium Building series emphasizes student independence, and the diversity of the student work serves as a foil and restraint for Siskind's individuality.

Exhibit Installation: Documentary Photographs, Provocative Sequences

The Sullivan project was exhibited in the 45 by 55 foot Institute building auditorium. In 1946 the Institute moved from temporary quarters at 1009 North State Street to the Chicago Historical Society building, a three-story red-granite Romanesque revival structure designed in 1892 by Henry Ives Cobb at 632 North Dearborn Street. Student project exhibits typically were installed on the auditorium stage because the auditorium was used for large classes

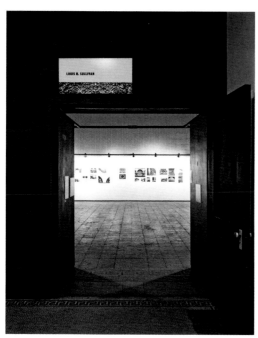
Figure 16. Entrance to exhibition

and lectures. The size of Siskind's exhibit and its public appeal merited special treatment, but its didactic function for the entire Institute (and Illinois Institute of Technology) community can been seen in the installation photographs of student chairs sharing the exhibit space. After entering the auditorium (with the portrait photographs of Sullivan and Adler and their two tombs in the entranceway), visitors to the exhibit would have been drawn to the Walker Warehouse panel to the right of the stage at the front of the room and then clockwise to the remaining seven panels. These simple monolithic white panels set just off the plane of the floor, with lights mounted on metal bars that seem to float above, define an alternate "modern" space within Cobb's late nineteenth-century columns, capitals, and wall finishes and his masonry construction. The overlapping of panels at the exhibit corners is particularly sophisticated; these corner intersections imply a larger extended, rather than a bounded, space consistent with the scale of the exhibit's subject.

Of the 126 exhibit black-and-white photographs on eight panels, at least 23 are Siskind's. Some series include no Siskind photographs; each panel, however, includes at least one. Print size ranges from 44 by 36 inches to 9 by 7 inches. The Wainwright Building series is the only other series dominated by Siskind's photographs. His three photographs confidently document the building exterior: a superb oblique building façade, with the high sun drawing shadow lines along the cornice and side façade, that emphasizes Sullivan's conventional treatment of the "tall building" front façade; a front façade grid detail that records Sullivan's expression of hidden metal frame construction; and an ornament detail, like the Walker Warehouse details, that converts an otherwise overlooked, stained, and apparently insignificant element into a luminous whole image, larger than the façade detail.

With its 126 photographs, the Institute of Design exhibit was the largest Sullivan building photograph exhibit to date. Although Siskind described the project as a "complete visual documentary," the exhibit includes only 35 buildings. By comparison, Hugh Morrison included 78 photographs of 50 Sullivan buildings in his 1935 book. The Institute exhibit includes 10 Sullivan buildings not illustrated with photographs by Morrison: the Rothschild Flats, the Barbe Residence, the Adler Residence, the Marengo Schoolhouse, the Brunswick-Balke-Collender Company Factory, the Jewelers' Building, the Henry Stern Residence, Holy Trinity Church, and the Krause Music Store (all in or near Chicago). The Morrison book and Institute exhibit share 25 buildings. Some Institute photographs thus complement Morrison's, by providing views of additional Sullivan buildings; others correct inadequate photographs, such as Morrison's single indistinct Walker Warehouse and Stock Exchange photographs; still others, such as the Bradley Residence and Babson Residence photographs, emphasize Sullivan's links to Frank Lloyd Wright, with a building type apparently of little interest to Morrison.

One fundamental difference between the Morrison book photographs and the Institute exhibit photographs lies in the numbers of photographs of each building: the Institute exhibit includes far more multiple photographs, or photograph series, of Sullivan buildings. Indeed, nine photograph series (of at least five photographs of a single building) constitute over three-quarters of the exhibit photographs: Babson Residence (6), Bradley Residence (8), the rural banks (14 photographs of four banks), Kehilath Anshe Ma'ariv Synagogue (6), Carson Pirie Scott and Company Store (8), Garrick Building (6), the Chicago Stock Exchange Building (5), the Auditorium Building (17), and the Walker Warehouse (8). With these series, Siskind includes views and ornament details completely omitted by Morrison, and Siskind exploits the exhibit format to present a new visual—and, I propose, physical and psychological—relationship to Sullivan's buildings. Siskind's sophisticated decisions about print size and scale, about the lengths of series and the rhythm and pace of images, and about the composition of the eight panels, demonstrate an interpretative exploration of Sullivan's architecture, all the more powerful for the absence of text.

The exhibit panels are not predictable; buildings are not presented in chronological order or by building type; there are asymmetrical relationships among perspectives, elevations, and ornament details; there is no repetition of scale or placement of photographs on panels or in series. Three exhibit panels (1, 2, and 8) are devoted to a single building (Walker Warehouse, Auditorium Building, Carson Pirie Scott Store). One panel (5) is devoted to a single building

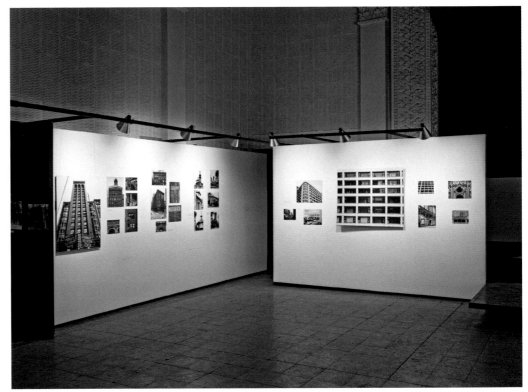

Figure 17. Exhibition installation panels at corner

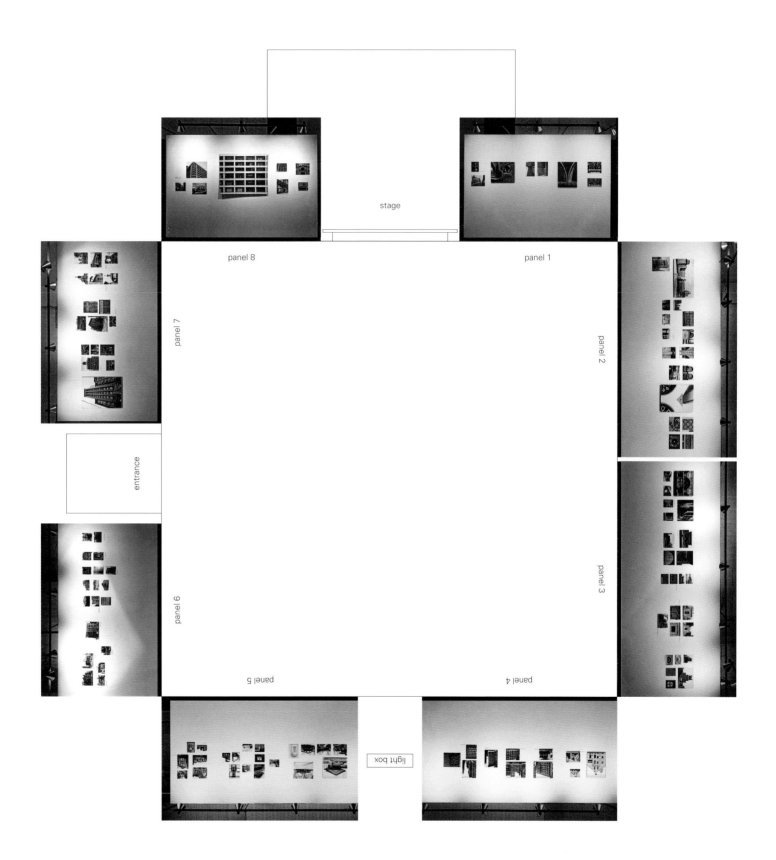

stage

panel 8

panel 1

panel 7

panel 2

entrance

panel 6

panel 3

panel 5

panel 4

light box

Figure 18. Exhibition plan diagram

type, residential buildings (Babson Residence, Bradley Residence, Rothschild Rowhouse, Barbe Residence, Adler Residence). Other panels with more than one series are not: panel 3 includes banks, tombs, and a religious building; panel 4, a school building and urban office buildings; panel 7, urban office, commercial, and residential buildings; panel 6, tall office buildings and religious buildings.

The absence of repetition invites the viewer to consider the chronological and formal relationships among the buildings and among the photographs—a nonlinear process of moving forward and backwards within a single panel and among panels. A single building series on a single panel invites the consideration of part-whole relationships, a visual puzzle that is varied on each panel by the variation of exterior and interior views from building to building. Panels with a greater number of smaller photograph series invite comparisons of parts, such as structural features (arches or framing and fenestration) or ornament. Ornament details are juxtaposed with photographs of unornamented façades (or façades stripped of their ornament) that emphasize silhouette and mass. But the exhibit format, with its large-scale prints, creates more than a nonlinear process of exploring the relationship of buildings and photographs. It creates a dynamic physical relationship with the images as well. Over and over again, in the Walker Warehouse, rural banks, Wainwright Building, Auditorium Building, and Carson Pirie Scott Store series, Siskind juxtaposes a smaller full building photograph with larger ornament or building part details. To see the full building it is necessary to approach the small photograph, but that close physical relationship is too close for the ornament detail in the adjacent large photograph. The print size modulates the physical distance of the viewer to the photographic subject. By inverting the experience of physical distance with an actual building (where the closer the viewer, the less he or she sees of the whole building and more of the ornament detail), Siskind calls attention to the power of interpretative photography to surprise the eye and direct visual consciousness. Siskind's purpose here is to stimulate visual curiosity about an unknown Sullivan. The Walker Warehouse series documents lost opportunities; the other series, however, point to standing Sullivan buildings and to the possibilities for more sustained visual inspection.

Of the student-dominated series, the Carson Pirie Scott Store series, with eight photographs on one panel, is among the best. The building had just been cleaned as part of the firm's hundredth anniversary, and the students exploited the differences between its white, light-reflective glazed terra cotta surface and its darkened neighbors. A large exterior photograph of the upper story window grid centers the panel, with three and four photographs to each side. As the largest photograph in the panel, it acknowledges the building's modern sheathing and elegantly varied fenestration. But it also establishes a syncopated sequence, in which the eye is drawn first to the center, then to the two subsets of photographs, and then, perhaps, to the relationships among them all. The set to the left, the first three photographs in the series, epitomizes the building's function as a large, urban retail space: a large upper story corner exterior photograph isolates the unadorned structure of the building, with the

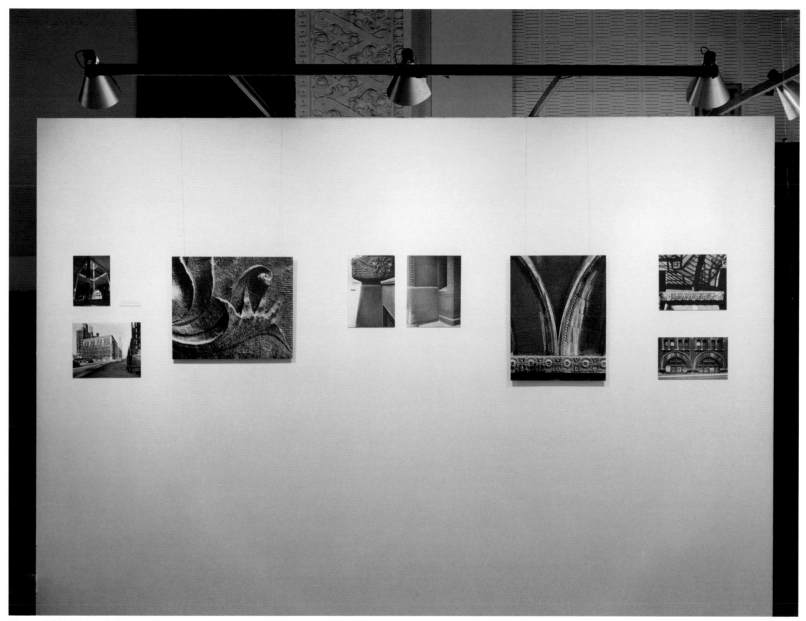

Figure 19. Exhibit installation panel 1

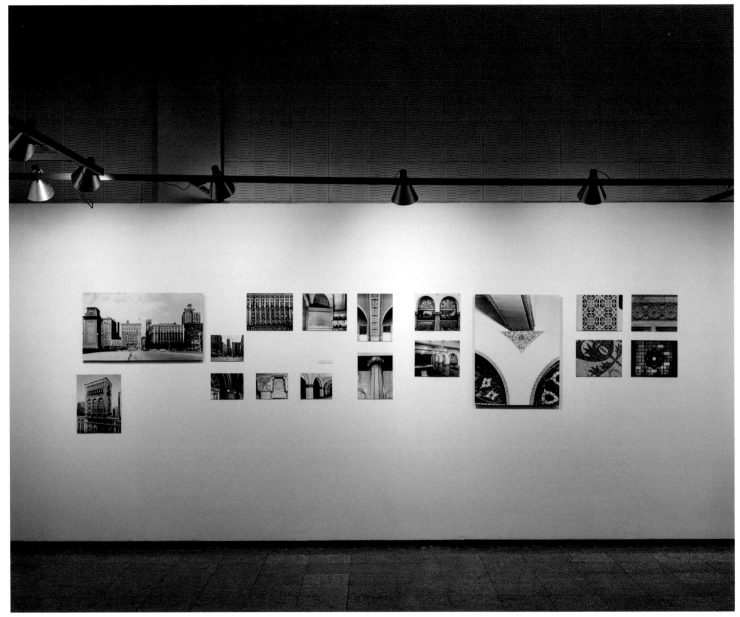

Figure 20. Exhibit installation panel 2

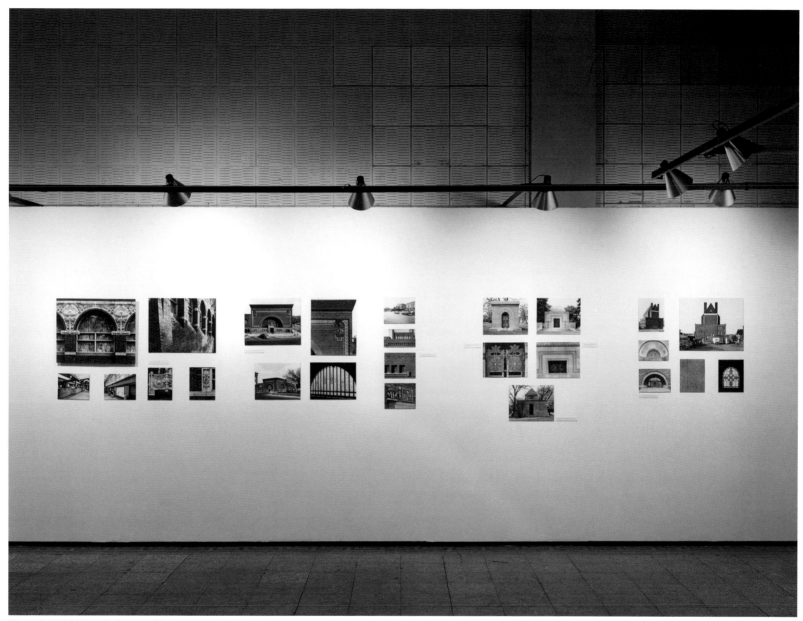

Figure 21. Exhibit installation panel 3

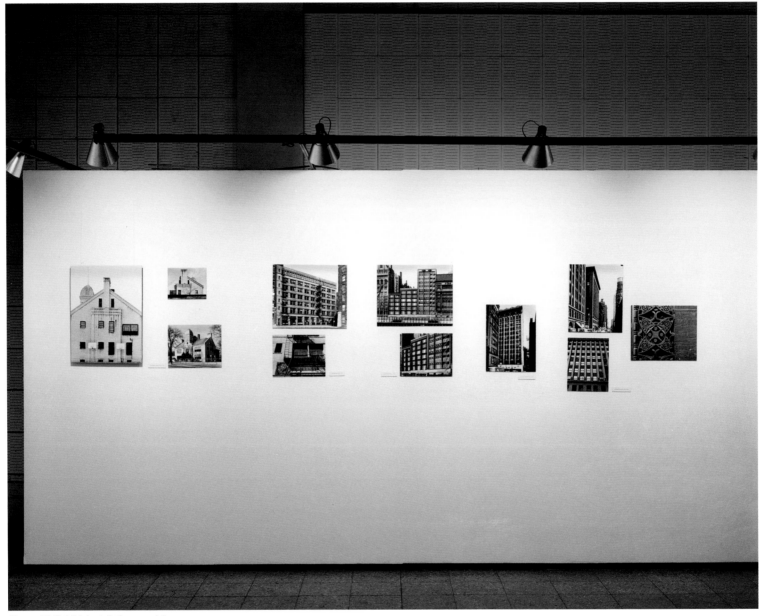

Figure 22. Exhibit installation panel 4

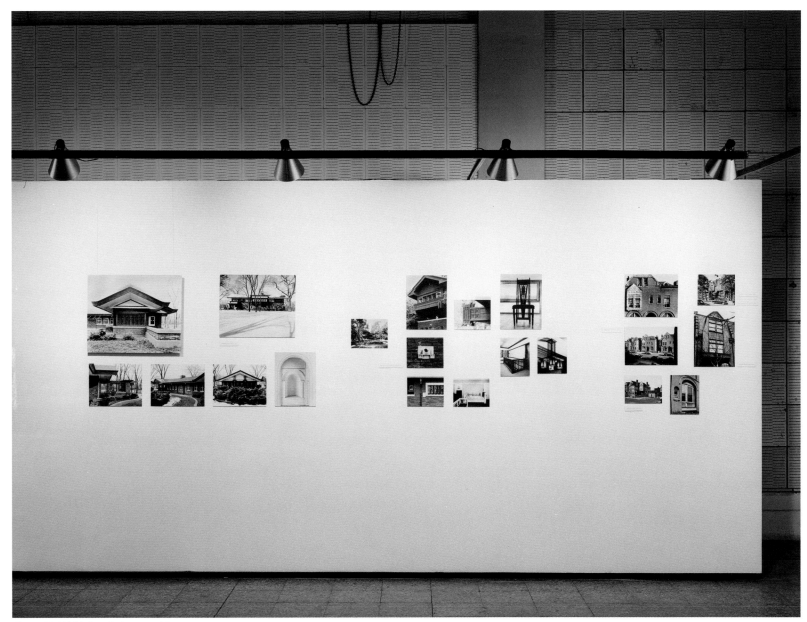

Figure 23. Exhibit installation panel 5

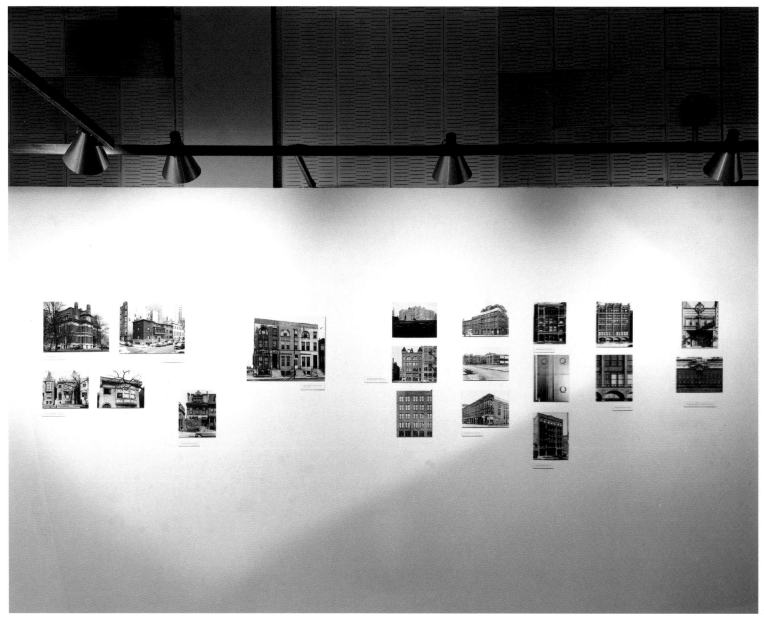

Figure 24. Exhibit installation panel 6

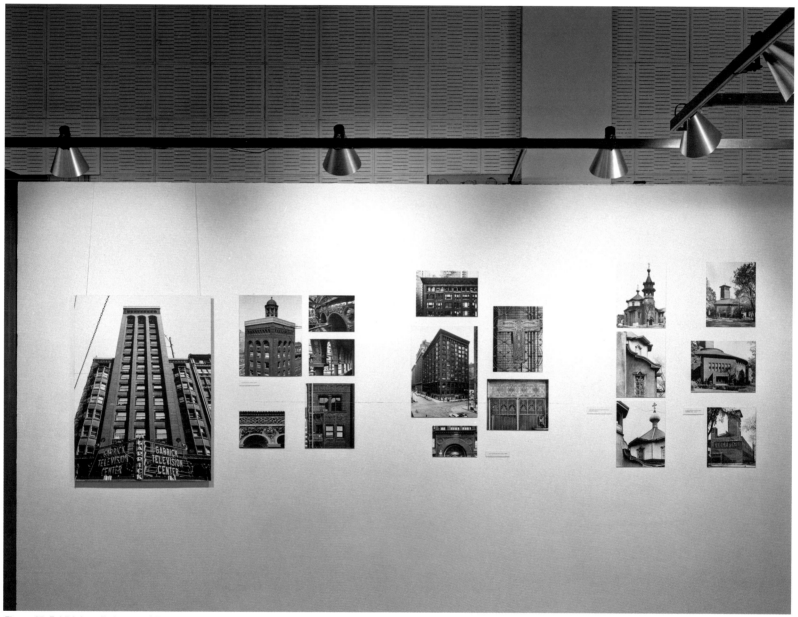

Figure 25. Exhibit installation panel 7

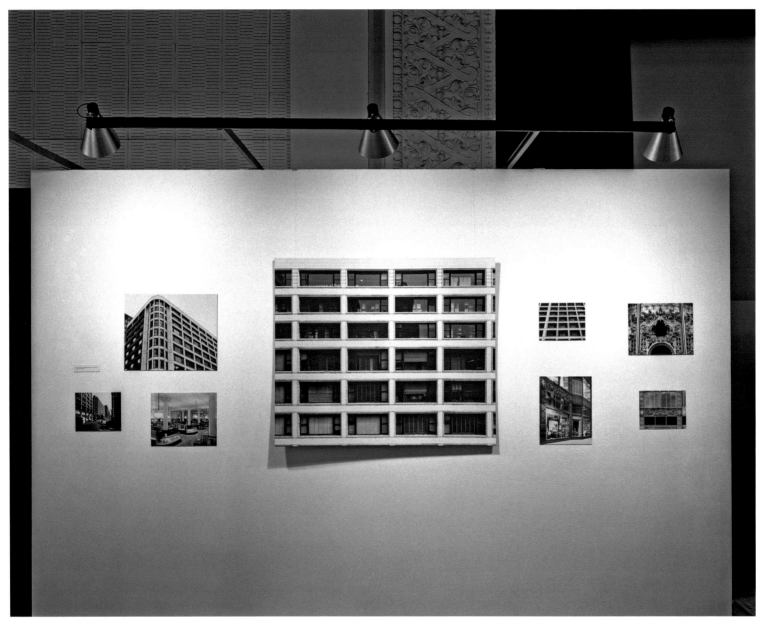

Figure 26. Exhibit installation panel 8

late morning sun creating positive and negative values that emphasize and balance the horizontal and vertical dimensions; a smaller oblique exterior photograph uses late morning sunlight to contrast, in dramatic fashion, the delicate scale of the façade and entrance rotunda against the darker adjacent buildings and street traffic; and, an interior photograph, the only one in the series, that reveals the large, undivided first-floor display space. The set to the right explores the relationship between the smooth terra cotta surface and geometric light and shadow of the upper stories and the intricate naturalistic cast-iron ornament that frames the display windows, ornament whose irregular dimensionality is revealed by thin shadows. The Siskind and Gittleman ornament photographs are especially important because they exhibit the short stretch of especially vibrant ornament used in the 1899 remodeling but not repeated along the east façade, an example of Sullivan's artistic variation not mentioned by commentators.

By contrast to this series, the Chicago Stock Exchange Building series is far less successful; like so many other tall urban buildings, it is difficult to photograph because it is in shadow most of the day, indeed, most of the year. While the students were able to photograph the Washington Street façade cornice and upper floors (from the bank building across the street) and the entire building from the west (the LaSalle Street façade), the darkened building façade, with its eastern orientation, resists any creative use of natural light: it is always in shadow, and without the contrast of light and shade its façade remains undifferentiated. The harsh interior lighting, including the back lighting from inside the elevator shafts, creates too much contrast between the bronze plates and the painted grilles. At the distance needed to record the ensemble of ornamental pieces, much detail is lost; closer, the photographer has little control over his composition.

In this series, indeed, in most of the series, Siskind varies the distance of photographer to building or moves the photographer to the rear of the building quite deliberately. By comparison to Morrison, Siskind presents a Sullivan whose buildings must be approached, whose buildings are best appreciated from a variety of distances and directions. For Siskind, a comprehensive visual survey of Sullivan's buildings involves a dynamic, energetic relationship of eye to architectural subject, not the static, unmoving, documentative relationship implied by Morrison's photographs (or, coincidentally, by Abbott's photographs of Richardson buildings). This dynamic physical relationship of viewer to image suggests an equally animated, physical relationship with the buildings themselves, in which sight leads almost to touch, a relationship of buildings as animate objects to active viewers. These clusters of characteristics and values—active photographers who change their physical positions in the images and active viewers who change their physical relation to the images; buildings that reveal the same features as human subjects in social documentative photographs—also point to another distinguishing feature of the Institute exhibit: its consistent representation of Sullivan's as aging, even expiring, buildings.

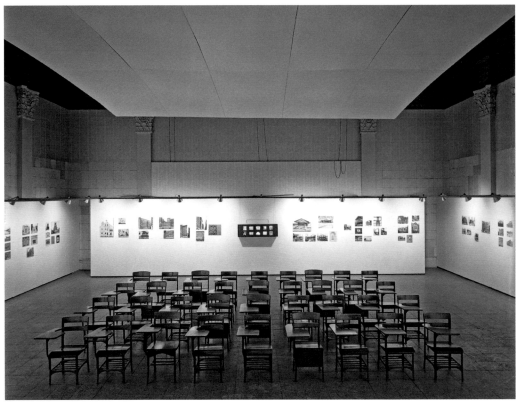

Figure 27. Exhibit installation panels with light box

The Institute exhibit finds beauty, or aesthetic value, in architectural aging, wear, and decay; Siskind's embrace of building condition gives the exhibit a distinctive temporal unity. As a comprehensive survey of the work of an early modern architect made at the mid-twentieth century, the Institute exhibit challenges architectural historians to account for the fate of actual buildings in addition to their impact on architectural history. For Siskind, aging, wear, and decay become part of a natural process. In the early 1950s, the pace of demolition of Sullivan buildings increased, and while the first Sullivan building restoration, of Auditorium Building interiors, begun in 1954 by Crombie Taylor, few if any other Sullivan buildings in Chicago have been rehabilitated or preserved.

Exhibit Opening, Responses, and Reviews

The Institute of Design *Louis H. Sullivan* exhibit, "an exhibition of new photographs of the buildings of Sullivan made by students and faculty of the Institute of Design Photo Section," opened on 19 March 1954 (it closed on 9 April) in the Institute building auditorium, with an evening reception for Institute students and faculty members, Illinois Institute of Technology students and faculty members, financial supporters, and invited guests. The Institute press release noted Siskind's leadership, Sullivan's role in the "Chicago school of architecture," the

photographing of the Walker Warehouse before its demolition in the fall of 1953, but not the number of buildings or photographs included in the exhibit. It reported the project goal of making "a complete visual documentary of Sullivan's work and to preserve it in published form for the history of architecture" and Siskind's interest in various media: in addition to black and white 8 by 10 inch and 4 by 5 inch format photographs, "some colored photographs, 16 millimeter motion pictures, and 35 millimeter slides as well."[32]

Siskind sent out 1,189 invitation cards, including many to his artist, writer, and publisher friends from New York.[33] The 4 x 7 5/8 inch announcement card, a handsome design in red, black, and white, with an ornament detail photograph by Len Gittleman, was designed by Institute student James Wood (see Figure 28, enlarged for the exhibit title panel, see Figure 16). James Johnson Sweeney, director of the Guggenheim Museum, visited the exhibit (and perhaps attended the opening reception) and requested a copy of the Walker Warehouse tendril ornament detail photograph. Local newspaper reports solicited comments from Dankmar Adler's daughter, Sara Weil; the two sisters of George Elmslie, Sullivan's long-time chief draftsman, attended the opening night reception.[34] Hugh Duncan, an instructor of social and cultural history at the Institute, delivered a lecture on "Sullivan: Prophet of a New World Architecture."[35] The exhibit attracted considerable attention from the local and national press. In his 28 March review *New York Times* photography critic Jacob Deschin celebrated the Institute Sullivan exhibit as "the product of a unique approach to teaching photography."[36] While Deschin had less to say about the photographs than about that "unique approach," his article disarmed critics not familiar with Siskind or the Institute who might discount the project as student work.

These were trying times for the Institute. Following the 1949 merger between the Institute and the Illinois Institute of Technology, Institute board chair Walter Paepcke (chair and CEO of the Container Corporation of America) had turned his attention to the Aspen Institute, a new

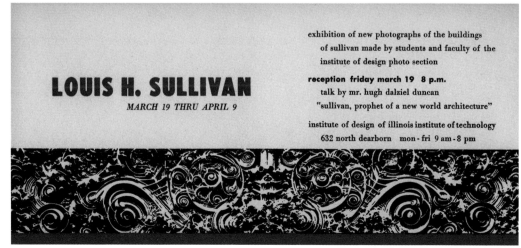

Figure 28. Exhibit announcement card

project in Colorado; Institute director Serge Chermayeff had resigned; and acting director Crombie Taylor had completed several interim appointments while the Institute sought a new permanent director.[37] The relationship between the two institutions was an awkward one at best. Still separated geographically despite the merger, they practiced very different educational aims and methods, differences that had been exacerbated by personal differences between Institute founder Lazlo Moholy-Nagy and director of the IIT architecture program Mies van der Rohe. And the disinterest of Mies van der Rohe in Sullivan's ornament was well known.

Duncan's presentation acknowledged all these tensions: between the exhibit and its focus on Sullivan and the memory of Dankmar Adler and presence of the Elmslie sisters; between Sullivan and Mies ("To the students from various schools who may be here tonight I would ask you not to close your mind to one master because you have opened it to another."); within the Institute, as factions struggled for power; and between an arts and design school and the business community. But his strategy in addressing these tensions and audiences, I believe, was to establish his credibility for two strong claims for the Institute exhibit: that the Institute of Design faculty and students documented, or preserved, Sullivan's great architecture at a time when architectural critics and historians failed to see its value, and that this contribution to Chicago history was an exemplary, but typical, Institute project, indicative of the great social value of the institution. This strategy, of course, deflected attention from any detailed consideration of the photographs or installation.

As Duncan's subtle references to the various parties suggest, the institutional context for the Sullivan exhibit was one marked by dramatic, even theatrical, divisions. Tensions within the Institute faculty and between the two institutions continued to increase, peaking in 1955 with IIT's appointment of Jay Doblin as Institute director and the resignation of Crombie Taylor, Konrad Wachsmann, Hugo Weber, Charles Forberg, and other key faculty members. Despite Taylor's strong personal support, Siskind now was on his own in completing the Sullivan building survey. After the graduation in 1954 of the last group of students to participate in it as a class project, Richard Nickel and Siskind began to work together on *The Complete Architecture of Adler & Sullivan* as an independent project.

National press coverage and enthusiastic comments from leading curators, journal editors, and historians suggested a ready market for the Adler and Sullivan materials. The exhibit traveled to North Carolina State University, Oberlin College, and Yale University. The Museum of Modern Art, the Art Institute of Chicago, Yale, Oberlin, and the University of Minnesota purchased copies of the exhibit photographs.[38]

Publication of Institute exhibit photographs in professional journals, even in the shortest of essays, began to indicate the challenges Siskind and Nickel faced in converting a large format exhibit without text into a book format, where the size and impact of visual images are

reduced and even compromised by the addition of text. In October 1954, for example, the *Architectural Forum* published an unsigned review, "Chicago's Sullivan in New Photographs," that refers to "a recent collection inspired by Aaron Siskind, assistant professor of photography at the Institute of Design, who assigned his classes the valuable task of recording this cultural legacy before it is all chipped away or painted over."[39] This *Architectural Forum* essay includes a short four-paragraph introduction and 10 project photographs (five by Siskind; five by students), with "captions [that] are quotations from [Sullivan's] writings" (129). For the *Architectural Forum,* there appears to be no better commentator on Sullivan's buildings, or photographs of Sullivan's buildings taken in the 1950s, than the architect himself, "30 years after Sullivan's life ran out in a Loop hotel room" (129). Of course, Sullivan's writings then represented a 30-year-old position, an incomplete perspective on his buildings and their role in modern architectural history, and Sullivan never set eyes on the Institute photographs. Substituting Sullivan's writing for contemporary commentary begged the question of what should be said in 1954 about both the buildings and the new photographs.

After 1954 the absence of critical commentary on the Institute photographs very likely was due to the continued inaccessibility of the exhibit and the exhibit photographs. The only critical essay to treat the Institute Sullivan building photographs, "Architectural Photography in Chicago," a 1981 essay by David Travis, curator of photography at the Art Institute of Chicago, compares Siskind, Nickel, and John Szarkowski as architectural photographers, but includes only one Institute exhibit photograph (Siskind's Walker Warehouse corner detail) and no photographs by Szarkowski.[40] Instead, Travis uses lengthy quotations about Chicago from Nelsen Algen, Gertrude Stein, Charles Sheeler, and Carl Sandburg to establish a position about Chicago as a setting for architecture that supports the assumption that architectural photography, like poetry, is an "imaginative" enterprise: "It is the result of a photographer's imaginative response to the appearance that a building leaves on the character of a city. It is the response of an imagination informed by architecture." Here Travis relies on fellow curator, John Szarkowski, whose Photographer's Foreword to *The Idea of Louis Sullivan* (1956) included prescriptive generalizations about architectural photography based on his own experiences photographing Sullivan buildings. Travis accepts Szarkowski's generalizations; indeed, he uses Szarkowski's generalizations as the standard by which to measure Siskind and Nickel. Travis thus misses the opportunity to investigate Siskind's calculated juxtaposition of photographs in a series or his acceptance of building condition or the happy convergence of capacity for detail photographs with Sullivan's conception of "organic architecture" in which details are the test of design integrity. From Travis's essay, it is clear that the inaccessibility of the Institute Sullivan photographs enabled a tradition of commentary on architectural photography to develop in which the actual photographs were overshadowed and neglected, and the history of architectural photography, as represented by the distinctive case of Louis Sullivan, unexplored.[41]

Post-Exhibit Research and Publication Intentions: *The Complete Architecture of Adler & Sullivan*

From the very start, Aaron Siskind wanted the Institute project to contribute new evidence for architectural history in the form of a book publication. The Institute exhibit press release and exhibit brochure point to book publication as the means for preserving the photographs, after their ephemeral life in a short-lived exhibit:

> The purpose of the study is to make a complete visual documentary of Sullivan's work and to preserve it in published form for the history of architecture....

> The aim of the project—now in progress for more than a year—is to make a photographic record of all the buildings that, in part or in whole, resulted from the labors of Louis H. Sullivan. We feel that, when it is completed and published in its entirety, this document will be a rich and inspiring storehouse for the scholar, the architect, and persons interested in our cultural heritage....[42]

Four days after the exhibit closed Siskind wrote to the Museum of Modern Art that he had plans to publish the photographs, along with Sullivan's unpublished writings: "We're hoping for publication in about a year with as definitive a set of photographs as we can manage along with Sullivan's unpublished writings, letters, poems, etc. Architectural Record has written that they are interested in such a book. Horizon Press is interested. But nothing as yet."[43]

According to Nickel, it took another two summers (1954 and 1955) to identify and photograph the remaining Sullivan buildings. As Nickel noted in his 1957 Illinois Institute of Technology masters' degree thesis, *A Photographic Documentation of the Architecture of Adler & Sullivan,* the completion of the "complete visual documentary" led to a more systematic investigation of both buildings and building designs by Adler and Sullivan. Nickel located 38 "lost" Sullivan buildings and designs, that is, buildings and designs not known to Morrison, and accurate addresses for nine others. Nickel reported that he started with Morrison's Adler and Sullivan building list: buildings with incomplete addresses and "buildings for which the information provided was insufficient to find any particular building."[44] In describing his research methods, typically consulting "new sources of information," including "early architectural journals," such as the *Inland Architect and Building News,* which he scanned "page by page" (pp. 3-5), followed by physical searches, Nickel points to three early Sullivan buildings not known to (or seen by) Morrison: the Knisely Store and Flats (1883), the Ann Halsted Residence (1883), and the Aurora Watch Company Factory (1883-84), each of which contradicts a Morrison generalization about Sullivan's development.

Nickel's comments on these buildings are especially important, because they show him using elementary research methods to locate standing Sullivan buildings, apparently overlooked by Morrison and other architectural historians:

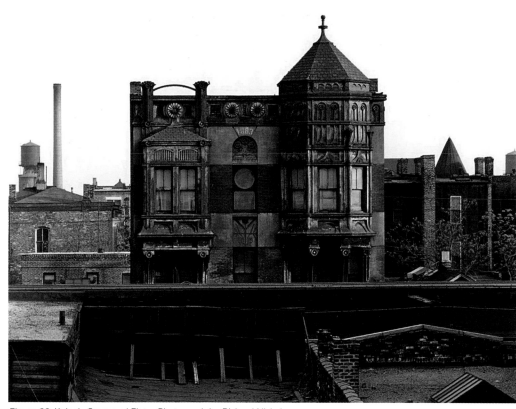

Figure 29. Knisely Store and Flats. *Photograph by Richard Nickel*

The Knisely Building was one of the earliest findings of this investigation. It is amazing that, in spite of all the alterations which must have been made on this block, that this is the one building still standing and in unusually good condition.

Designed early in 1883, it was one of the first of a series of store and flat buildings that Adler & Sullivan built. It has the added distinction of being the most unusual. The projecting bays…are the reason for this. Mr. Knisely was a sheet metal contractor, which undoubtedly accounts for Sullivan's handling of this feature. Once the structural requirements were met, he treated the bays as sculptural material….

In a functional sense, not much can have been gained by these bays because the excessive metal framing stopped more light than it can have passed, and the gain in floor space seems negligible. But it is the only one of this type building in which the function of store and flat are clearly separated (pp. 54-55).

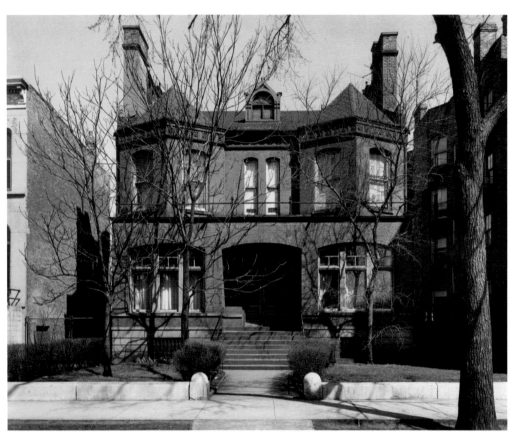

Figure 30. Ann Halsted Residence. *Photograph by Richard Nickel*

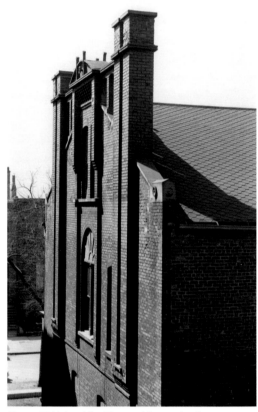

Figure 31. Halsted Residence, chimney detail.
Photograph by Richard Nickel

A rather simple building, [the Ann Halsted Residence] is characterized chiefly by a strength of line and form. There are three gentle arches on the main floor, composing a central entranceway and the large windows on of the main rooms. The second floor has pointed triangular bays, blending into a sloped roof. Constructed of smooth red brick, it is one of the warmest and most inviting of Sullivan's residences.

However, the most outstanding feature escapes all but the critical observer. This is an elaborate chimney construction…on the sides of the building. Simple at its base, it rises in complexity and strength: a combination of windows and sills, relief brick-work and ornamental iron forms, producing an effect of power. Indeed, if abstract form and function representative of Sullivan's deepest feelings is to be experienced in any of his earliest buildings, it is to be found here.

Other than the appeal of the entranceway, the general skeleton-like quality of this residence separates it from all the others designed by Sullivan…. One of Sullivan's finest, this hitherto unknown residence is an excellent example of the dignity and monumentality which he could endow on even a simple residence (pp. 56-57).

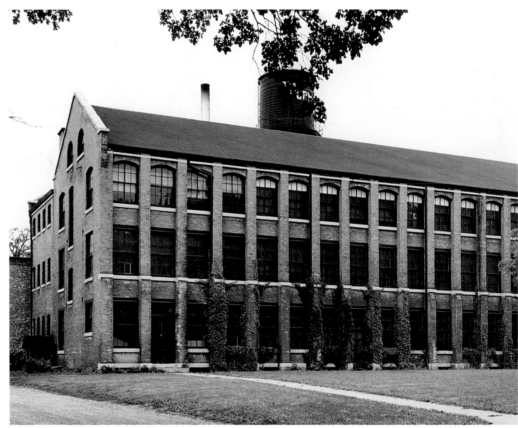

Figure 32. Aurora Watch Company Factory. *Photograph by Richard Nickel*

Designed in mid-1884, the Aurora Watch Company Factory is one of the earliest in a series of small industrial buildings designed by Adler & Sullivan. In its essential design conception, it can be considered a prototype for all of the later factory-type buildings....

The Aurora building is the most distinctive of these in several respects. It has a certain open simplicity and romantic quality not found in the others. The essence of a watch is delicacy, precision and beauty, and appropriately, these are the qualities of this build-ing. Even the small buildings are endowed with the same characteristics. Precision manufacture requires light, and this is the outstanding result of the construction. In fact, the constructional purity of this building was rarely equaled in any of the other early buildings (p. 59).

Figure 33. F. A. Kennedy and Company Bakery.
Photograph by Richard Nickel

In his description of the F. A. Kennedy and Company Bakery (1883), Nickel clearly states the challenge of his "new" evidence to Morrison's account of Sullivan's early development:

> The Kennedy Bakery is certainly one of the finest of the early buildings...at least in the control of elements into a unified whole. It gives serious dispute to Morrison's analysis of the Wirt Dexter Building (No. 72, 1887) as a "new simplicity and monumentality." Most of all, it exemplifies Sullivan's fertility in design from the beginning and proves that there never was any conscious "wiping clean of the slate," as Morrison has suggested (p.64).

With these four examples of four different building types Nickel demonstrates that the "visual documentary" methods of the Institute project led not only to a new perspective on the "known" Sullivan but to an "unknown" Sullivan as well (see Figures 29, 30, 31, 32, and 33). In these early Sullivan buildings that Morrison could not have seen Nickel claims to have found evidence that contradicted Morrison's argument that Sullivan comes to a "new simplicity and monumentality" in 1887 after false starts in his earliest buildings.

But Nickel stops short of pursuing Morrison. Indeed, in pointing to Morrison's use of Sullivan's 1887 Wirt Dexter Building, Nickel suppresses the remainder of Morrison's sentence and, thus, the extent of his apparent differences with Morrison, differences not expressed in the his 1954 project report. Morrison had written that, with the 1887 Wirt Dexter Building, Sullivan "attained a new simplicity and monumentality growing directly out of the problems of the commercial office building."[45] Morrison frames Sullivan's early development in terms of the office building: "It was in the office buildings that the most signal advances in construction and design were achieved. The engineering problems were more difficult than those of residential building, and the opportunities for improvement in design more apparent, to a man like Sullivan, than those of residential or theater architecture"(p. 55). By contrast to the Wirt Dexter Building, Morrison finds little innovation in the early residential work: "In the latter part of 1883 and in 1884 the style of Adler and Sullivan's residences reaches the apogee of its impressionistic disintegration of volume and emphasis on brilliant, not to say florid, ornament.... They seem to represent a conscious, if unsuccessful, striving for originality" (p. 73). Nickel's evidence suggests that, with approving clients, Sullivan attained "simplicity and monumentality," as well as the expression of multiple functions, in a variety of building types well before 1887.

Nickel's deference to Morrison is illuminating, for it depends, I believe, on a distinction between documentary photography (whether documentative or interpretive) and architectural history. In his thesis preface, Nickel writes of his hope that "the material brought to light by this study will prompt a reappraisal of the work and thought of Adler and/or Sullivan by some qualified architectural historian. If this wish is never fulfilled then perhaps it will serve its original purpose as a reference document for students and scholars of art."[46] And, in his first chapter, Nickel writes that his primary aim is to "create a comprehensive photographic record of the architecture of Adler and Sullivan" (p. 2); this "primary aim" governs his

presentation of his building research: "This research, therefore, is part of a synthesis whose major element is the photographic document" (p. 2). For Nickel, documentary photography is a visual medium, and the verbal interpretations of the photographs should serve the visual documents. These discursive interpretations can support or question architectural history, but they are not documents of architectural history.

Nickel's position in his thesis thus reaffirms Siskind's remarks about the Institute of Design project. But Siskind's exhibit installation suggests a more sophisticated position about the relation of architectural photographs to architectural history. By presenting interpretative photographs without interpretative texts, by juxtaposing different kinds of photographs, and by juxtaposing photographs to dominant, but absent, texts, Siskind summons the eye to insist on the visual reality of present buildings and the inadequacy of narratives about Sullivan that stem from a much earlier historical moment.

Despite Nickel's primary aim of creating "a comprehensive photographic record," the presentation of his photographs in book, or thesis, form results in a very different presentation than Siskind's exhibit. Nickel's identifications of the "lost" Sullivan buildings he re-discovered however suggest the power of a visual approach to architectural material. Even in 1957, Nickel writes with easy confidence when he is interpreting what he has seen; his verbal treatment nicely complements his photographs.

When Nickel completed his thesis, Siskind's "photographic record" of Sullivan's buildings was complete. Siskind and Nickel had materials sufficient for a catalogue raisonné. With every publication of an Institute project photograph, they continued to announce their intention to publish *The Complete Architecture of Adler & Sullivan.*[47] Why were they unable to publish their book? There are several reasons, each instructive to our understanding of the progress of modern architectural history. The change in presentation formats, from exhibit panels to pages in a book, diluted the visual purity of the exhibit and divided Siskind and Nickel. According to John Vinci, as they added plans, drawings, vintage photographs, and information about owners, construction, and costs for each building, Siskind began to lose interest in the mixed content and stepped aside to let Nickel take more responsibility for the publication.[48] This anecdote is quite suggestive. In 1959, when Siskind published his first book, *Aaron Siskind: Photographs,* with Horizon Press, the page size was large (11 by 14 inches), one photograph on each right hand page (some bleeding to the edge of the page) and a one-line caption on the left hand, a severe, minimalist design that allowed Siskind the self-contained creativity of each image and the referential creativity of the sequence of images.[49] The visual impact of this format is perhaps as close to that of an exhibit installation as commercially feasible. By contrast, the page mock-ups that Siskind and Nickel prepared with Horizon Press president and editor Ben Raeburn for their *Complete Architecture* sacrifice the integrity of the Institute photographs and the power of the exhibit installation for the variety of visual and verbal information; the mock-up pages are unified by their subject alone.[50]

In the 1950s Siskind and Nickel had no model for an architect's catalogue raisonné based on visual information. In Morrison's *Louis Sullivan* and Hitchcock's *The Architecture of H.H. Richardson and His Times* (itself a translation of an exhibit), the text dominates the illustrations, and the small page size reduces the image quality considerably. Because Siskind and Nickel were photographers, not writers or scholars, they very likely postponed hard decisions about the relation of images and text or about the conventions of selection and completion in order to gather more visual evidence, or information, about what they photographed.[51]

At the same time that Siskind and Nickel were completing their "photographic record," Sullivan's buildings began to disappear with increasing frequency. From 1953 to 1961, 18 Sullivan buildings were demolished (from the Walker Warehouse in 1953 to the Garrick Theater in 1961). With building demolition, they found opportunities for expanded documentation, but also for salvaging and preserving building fragments. In the physical deconstruction and salvage of fragments, Nickel learned about construction techniques, original surface finishes and paint colors, and ornament fabrication, and these discoveries led him to Sullivan's craftsmen, their stories, and their role in the design and construction process. This information, I suggest, had no place in the conventions of modern architectural history that posited the architect's drawings as the best record of his creativity or posited buildings of relatively recent construction as static in time. While it was easy for Nickel to collect more and more information about Sullivan's buildings, especially unconventional information derived from the handling of fragments, it is not clear how this information about each building (in the form of expanded descriptions) would become architectural history (that is, textual narratives about continuity and change). What is clear is the growing tension and conflict between the fate of Sullivan's buildings and Nickel's sense of their value to a more adequate history of modern architecture. The more Nickel learned about Sullivan as architect and artist (in the different ornament media) the quicker the pace of demolition. And with each demolition, he experienced the repeated contrast between the buildings lost and the inadequacy of documentation and salvage.[52]

In applying the conventions of documentative photography to architecture, Siskind developed interpretative techniques for representing age and decay, for conferring dignity to worn out buildings, and for close investigations. But photographing requires some physical distance, and the explanation of architectural change, some intellectual perspective. In deconstruction and salvage, that physical distance is closed, as arms and hands, shoulders and legs, embrace building parts in a most intimate physical relationship. That physical intimacy brought Nickel a special knowledge of Sullivan buildings and with that knowledge, a sense of responsibility for and implication in their fate. Did Nickel feel such sympathy for (and kinship with) Sullivan's buildings that he identified with them, to the point that each loss was for him a kind of death? Nickel's well-known 1960 self-portrait, showing him standing on the roof of the Republic Building just before its demolition, suggests a strong identification

with his subject. How could he complete the project when he finally had no distance to it, no perspective, after all, for selecting for publication from an ever-expanding body of information or composing a narrative based on a wealth of unconventional knowledge?

Conclusion

This publication of the exhibit installation and exhibit photographs both recognizes Aaron Siskind's achievement of documenting Sullivan's buildings at the last best moment and explains his distinctive use of photography to reveal important but neglected features of Sullivan's architecture. The exhibit is a landmark in Sullivan studies and in the history of modern architecture. It represents a profoundly innovative strategy for systematic visual inquiry, one that applies the techniques of social documentative and abstract photography to the work of a single architect. As interpretative procedures, these new techniques allow the architectural object to rivet the viewer's attention, dominating any discursive commentary, and they allow the photographer to record with a sympathetic fidelity, permitting the object to become an authentic subject.

There is no comparable "visual documentary" of any other early modern American architect. Siskind's "feature group" project led to continued photographing and the eventual discovery and identification of more than 45 "lost" Sullivan buildings. As Hugh Duncan noted in his exhibit opening lecture, it is indeed remarkable that the fragile, short-lived design school produced such systematic and comprehensive scholarship.

Among his contemporaries Sullivan has been singularly fortunate with his photographers. When his buildings were new, Sullivan was able to direct J. W. Taylor, Ralph Cleveland, and Henry Fuermann, so that their photographs function as the architect's own documents, visual counterpoints to his lyrical treatment of philosophical or theoretical topics. With Siskind and his Institute students, Sullivan found photographers unafraid to re-present his buildings after years of use and neglect.

Taken together, the early Sullivan building photographs and Institute project survey constitute an extraordinary resource for the history of architectural photography. The differences between the early and later photographs become apparent only by comparison, and these differences insist on the historical character of the visual evidence for architectural history: building photographs illustrate not only buildings, but a perspective rooted in some particular moment. Siskind's Institute exhibit is thus a resource not only *for* architectural history but a powerful, innovative, and breathtaking example *of* architectural history as well.

Notes

1. Hitchcock and Johnson did not include Sullivan in their Museum of Modern Art (MOMA) *Modern Architecture: International Exhibition,* but did include him in their 1933 *Early Modern Architecture: Chicago 1870-1910,* MOMA Exhibit 23. This exhibit featured 33 annotated photographs of buildings by William Le Baron Jenney (3), Holabird and Roche (2), H. H. Richardson (3), Burnham and Root (4), Adler and Sullivan (9), Frank Lloyd Wright (1), and others. With their photographs and notes Hitchcock and Johnson emphasize the technological and aesthetic development of the skyscraper. In this chronology the unornamented masonry construction buildings of H. H. Richardson, particularly his Marshall Field Wholesale Store, provide "an aesthetic discipline of regularity and simplicity from which Sullivan rapidly created a new personal style"(*Early Modern Architecture Exhibit 23 Catalogue* [revised], p.13). But Hitchcock and Johnson also acknowledge Sullivan's highly ornamented interiors as indicative of his originality. Unfortunately the catalogue for this 1933 installation does not survive. MOMA Archives include a revised catalogue for a later installation; in this later catalogue Hitchcock and Johnson cite Morrison's 1935 *Louis Sullivan: Prophet of Modern Architecture* (jointly published by the Museum of Modern Art and W. W. Norton and Company, Inc.) and Hitchcock's 1936 *The Architecture of H. H. Richardson and His Times* (Museum of Modern Art).

2. For additional information about Sullivan and his photographers, see Crombie Taylor and Jeffrey Plank, *The Early Louis Sullivan Building Photographs* (William Stout, 2001).

3. Paul Sprague to Jeffrey Plank, 12 February 2002. Sprague retains Morrison's research archives and confirms that Morrison had access to no ornament detail photographs. In his edition of Morrison's *Louis Sullivan: Prophet of Modern Architecture* (New York and London, 1998), Timothy Samuelson added 10 Barron photographs that Morrison wanted to use in 1935. None are ornament details. Although Photograph 17, "Abraham Strauss House, Chicago. Detail of exterior ornament. 1884," is labeled a "detail" photograph (p. 307), it is taken from the street and includes the entire first story front façade, entry stair, and front door.

4. *Louis Sullivan: Prophet of Modern Architecture* (New York, 1935), p. xvii (page numbers for subsequent citations included in text).

5. *Genius and the Mobocracy* (New York, 1949), pp. 103-04. For Wright's review of Morrison's *Louis Sullivan,* see Frank Lloyd Wright, *Saturday Review* (14 December 1935), xxxi-xxxii.

6. Read to David H. Stevens, Rockefeller Foundation (18 October 1946), Special Collections, University Library, University of Illinois, Chicago.

7. Lloyd C. Engelbrecht, "Educating the Eye: Photography and the Founding Generation at the Institute of Design, 1937-46," in David Travis and Elizabeth Siegel, *Taken by Design: Photographs from the Institute of Design, 1937-1971* (Chicago, 2002), p. 13.

8. For the light modulator, see Lazlo Moholy-Nagy, *Vision in Motion* (Chicago, 1947): "A light modulator is the second step [after the photogram] in learning the elements of photography. The function of the light modulator is to catch, reflect and modulate light. A flat surface does not modulate; it only reflects light. But any object with combined concave-convex or wrinkled surfaces may be considered a light modulator since it reflects light with varied intensity depending on its substance and the way its surfaces are turned toward the light source" (p. 198). For the Institute of Design Foundation course, see Lazlo Moholy-Nagy, *The New Vision* (1928; rev. ed. New York, 1947) and his *Vision in Motion,* pp. 64-84.

9. Terminology used to indicate the relationship between photography and architecture has a confusing past. Early documentary photographs of buildings conventionally are said to have had a "descriptive" purpose, aiming to "describe formal architecture" (John Szarkowski, Photographer's Foreword, *The Idea of Louis Sullivan* [Minneapolis, 1956], not paginated). *Description, pure description, visual description, objective description* belong to a family of terms suggesting that the early photographer's goal was to capture, as objectively as possible, the apparently unmediated appearance of a building. Yet etymologically *description* refers to writing; more specifically, it denominates a kind of writing practiced in eighteenth-century Britain. To avoid these misleading terms not applicable strictly speaking to the visual or the plastic arts, I have termed the kind of documentary photography by which objectivity was built into the photographer's technical procedure *documentative photography,* a photographic method whose aim was to formulaically "reveal the impersonal and balanced truth of a building" (Szarkowski, "Photographing Architecture," *Art in America* [1959], 86). *Documentative photography,* in order to execute this set procedure, subordinates the photographer to his subject, suppressing architectural photography as a creative art form. Szarkowski was intent on inverting this relationship so that the photographer becomes "responsible for the content as well as for the execution of his work" (ibid.), thereby permitting photography to "become a powerful critical medium, rather than a superficially descriptive one" (Photographer's Foreword, *The Idea of Louis Sullivan*). What Szarkowski calls "content" becomes the open space for interpretation.

Interpretation is a mobile term—not tied to writing—that moves easily among the sister arts. *Interpretative photographs* aim to reveal the content, idea, or concept behind the building, not simply the "formal architecture" or the appearance. Szarkowski aligns objectivity with the surface, the superficial, and the architectural historian: "Historians…speak of objective as opposed to subjective photographs…. The historian's idea of objectivity in an architectural photograph seems to be defined in terms of a set technical procedure," the elements of which he then describes shrewdly, if ironically, at length ("Photographing Architecture," 86).

I identify as "interpretative" those strategies by which Siskind, Szarkowski, and others elevate the photographer's role in their treatment of architecture. However, the aims and procedures by which they pursue their art differ. Szarkowski's interpretative procedure proposes to transform architectural photography into "a powerful critical medium," rather than to document buildings. He would become architectural photography's Lionel Trilling. Siskind's interpretative procedure, on the other hand, aims to document the buildings through revealing the concept informing them in order to maintain fidelity to Sullivan's work and become useful to architectural historians yet to come.

10. "The Feature Group," in *Aaron Siskind: Toward a Personal Vision, 1935-55,* edited by Deborah Martin Kao and Charles A. Meyer (Chestnut Hill, MA, 1994), pp. 27-28.

11. Gittleman interview with Carl Chiarenza, 26 February 1971, Carl Chiarenza Collection, Siskind Tape 26 (CD format, Disc 1), Center for Creative Photography, University of Arizona, Tucson, AZ. Taylor recalled that he discussed Sullivan's strong geometric ornament with Robert Bruce Tague and John van der Meulen, colleagues on the Institute of Design shelter program faculty, in 1951, and then with Siskind when he arrived (Taylor to Jeffrey Plank, 10 March 1988). Taylor, Tague, and van der Meulen served as an informal project jury, and Taylor secured financial support from Institute Board member Samuel Marx for the exhibit installation. My *Crombie Taylor: Modern Architecture, Building Restoration, and the Rediscovery of Louis Sullivan* (forthcoming) will include a more comprehensive treatment of Taylor's pioneering investigation and restoration of Sullivan buildings as well as his own spare, even severe, architectural work in the late modern style.

For additional information on the Institute of Design Sullivan project, see: Carl Chiarenza, *Aaron Siskind: Pleasures and Terrors* (Boston, 1982), p. 97; Richard Cahan, *They All Fall Down: Richard Nickel's Struggle to Save America's Architecture* (Washington, DC, 1994), pp. 51-56; and Keith F. Davis, "'To Open an Individual Way': Photography at the Institute of Design, 1946-61," in *Taken by Design,* pp. 85-86.

12. Blair interview with Jeffrey Plank (5 January 2006); Gittleman interview with Jeffrey Plank (29 October 2005).

13. James Blair, Len Gittleman, Paul Hassel, and Richard Nickel became nationally prominent professional photographers; for biographical information, see *Taken by Design,* pp. 238, 240, and 243. Leon Lewandowski (1932-2005), from Cicero, IL, completed a master's degree in photography at the Institute in 1955; he became a commercial photographer with Rose and Mayer Photographers, Chicago (see also Liz Siegel telephone interview, 10 February 1999, *Taken by Design* Telephone Interviews I, Side 1, Ryerson and Burnham Archives, Art Institute of Chicago). Asao Doi (b. 1918), from Honolulu, Hawaii, briefly worked as a commercial photographer before a long career with the military subsistence testing authority in Chicago. Casimir Estramskis (b. 1920), from Chicago, worked as a wedding photographer while a student; after graduation he was a commercial photographer and then an employment agency administrator. Alvin Loginsky (b. 1930), from Chicago, worked as a commercial photographer and photography teacher in Chicago, including stints in catalogue and wedding photography.

14. Handwritten manuscript (undated, six pages), Richard Nickel Committee Archive, Chicago (hereafter, RNCA).

15. Doi interview with Jeffrey Plank (17 July 2007).

16. *Aaron Siskind: Toward a Personal Vision,* pp. 42-44.

17. *Bucks County: Photographs of Early Architecture, by Aaron Siskind, text by William Morgan* (Bucks County, PA, 1974 [Horizon Press]).

18. *Harlem Photographs 1932-1940: Aaron Siskind* (Washington and London, 1990), originally published as *Harlem Document: Photographs 1932-1940* (Providence, 1981).

19. For Walker Evans on Tabernacle City, see Douglas Eklund, "Exile's Return: The Early Work, 1928-34," in *Walker Evans,* edited by Maria Morris Hambourg, Jeff L. Rosenheim, Douglas Eklund, and Mia Fineman (New York and Princeton, 2000), p. 39, n. 54: "Provincetown excellent. I was there a month, with side trip to Martha's Vineyard, which I think I told you about. If I didn't, know ye that there is on the island a tabernacle in center of little village of cottages of wood built in 70's about, jigsaw-gothic and complete-god damn nuts and very funny to see. Naturally there will be photographs and will send some. Am working now on many films from whole trip" (Evans to Skolle, 2 October 1931).

20. *Walker Evans: American Photographs,* MOMA Exhibit 78, and *Walker Evans: American Photographs, with an essay by Lincoln Kirstein* (New York, 1938). Walker Evans's first museum exhibit was of architectural photographs (the very first one-man photographer MOMA exhibit), organized by Lincoln Kirstein at the Museum of Modern Art in 1933, *Photographs of 19th-Century Houses by Walker Evans,* MOMA Exhibit 30b. According to Evans, with this project Kirstein introduced him to architecture, a subject of keen interest to Kirstein and one that Evans immediately embraced: "You know, that's something I wouldn't have done myself. It was interesting chiefly because of Kirstein and it was a perfectly respectable thing to do, that is, documenting architecture. And it taught me a lot. In fact, it introduced me to a knowledge of how to appreciate and love and respond to various kinds of architecture and architectural styles. I had a natural attraction to architecture but no experience. And this gave me a certain sophistication. I was always interested in architecture and in the way buildings looked" (Archives of American Art, Smithsonian Institution, Oral History Interview, 1971, p. 14). Evans considered Kirstein his best critic, and his *American Photographs* catalogue commentary prophetic: "His 1938 essay put me down prophetically…. [H]e's a brilliant mind, a brilliant man. He foresaw what I was doing. In fact, he taught me a lot about what I was doing" (ibid., p. 29). On the publication of Walker Evans's architecture photographs,

see also Douglas Eklund, "Exile's Return," *Walker Evans,* pp. 36-39, esp. "Tin Relic (1930)," pl. 24; also, Jeff L. Rosenheim, "'The Cruel Radiance of What Is': Walker Evans and the American South," *Walker Evans,* pp. 59-67, 83-85, 95-96.

21. In *American Photographs,* Evans issued a disclaimer to sever the relationship of his photographs to their original sponsors: "The responsibility for the selection of the pictures used in this book has rested with the author, and the choice has been determined by his opinion: therefore they are presented without sponsorship or connection with the policies, aesthetic or political, of any of the institutions, publications or government agencies for which some of the work has been done" (not paginated).

22. In Hank O'Neil, *Berenice Abbott: Sixty Years of Photography* (London, 1982), p. 16.

23. *The Architecture of H. H. Richardson and His Times* (New York, 1936). In the exhibit catalogue (*Exhibition of the Work of H. H. Richardson: A Description of the Exhibition* [Jan. 14-Feb. 16, 1936], 26 unnumbered pages [mimeograph], MOMA Archives) photographs and photographers are not identified; comparison of illustration descriptions with the book suggests that Hitchcock used 23 Abbott Richardson building photographs (of 58) in the exhibit and 23 Abbott Richardson building photographs (of 76) in the book.

24. See Janine A. Mileaf, "Reading *American Cities:* 1930s Photographs by Berenice Abbott," in *Constructing Modernism: Berenice Abbott and Henry-Russell Hitchcock,* edited by Janine A. Mileaf (Wesleyan University, 1993), p. 18. Abbott's *Changing New York* (New York, 1939) photographs are much sharper, with much better lighting, than her Richardson building photographs.

25. Although Hitchcock notes that the Richardson exhibit and book were prepared simultaneously and with the same illustrations, he made these bold claims about Richardson and modern architects in the ephemeral exhibit description *(Exhibition of the Work of H. H. Richardson)* and not in the more enduring and more widely distributed book *(The Architecture of H. H. Richardson,* p. vii). In the book Hitchcock concludes that Richardson "was not the first modern architect: he was the last great traditional architect: a reformer not an imitator" (p. 299). Despite his use of traditional construction conventions, Richardson's architecture remains relevant to modern architects because he eliminated applied ornament: "although Richardson's construction was traditional, the time in which he lived was already modern" (p. 301) and traditional ornament was no longer available or appropriate. For Hitchcock architectural ornament remains appropriate only in vernacular building, under very limited conditions: "ornament is impossible on vernacular building unless, as was still sometimes the case in Richardson's day, it is a sort of folk-art hobby of those who occupy the buildings…. Academic architecture whether traditional or in the International Style offers no hope for ornament" (pp. 303-04). Interestingly, Hitchcock's estimation of Richardson and architectural ornament is informed by the assumption that "what we know as modern architecture has reached completion and is applicable as an academic discipline" (p. 303).

26. "Interview with Aaron Siskind" (1963), *Aaron Siskind: Toward a Personal Vision,* p. 42. In other interviews and commentary on his own development Siskind stressed the social aspects of artistic creativity and the "community of artists": "You use whatever you can, or you use whatever people around you are using so that they can understand what you are doing. Nobody makes photographs by themselves. Photographs are made in groups, people are influenced by each other. What methods they use, what devices they use, what materials they use, these are very complicated social situations" (Aaron Siskind, "Lecture at Columbia College," 29 November 1980 [CD format, Disc 1], Aaron Siskind Archive, Center for Creative Photography, University of Arizona, Tucson). Abbott photographed the Civic Repertory Theater in July 1936; for Walker Evans's building demolition photographs, see "The Wreckers," *Fortune* (May 1951), 105-08.

27. For Josephy, see his *Taking Part: A Twentieth-Century Life* (Iowa City, 1993), esp. pp. 64-81, for his relationships with Steichen, then curator of photography at the Museum of Modern Art, and Stieglitz.

28. Morrison, *Louis Sullivan,* pp. 114-15. Even Hitchcock, who ranked Richardson before Sullivan, admired the Walker Warehouse: "Sullivan also substituted smooth-faced masonry on the Walker Warehouse at this time and began to use detail considerably suaver [sic] than Richardson's" *(The Architecture of H. H. Richardson,* p. 298).

29. Wright, *Genius,* p. 48.

30. "[I]f the work is to be organic the function of the part must have the same quality as the function of the whole, and the parts, of themselves and by themselves must have the quality of the mass— must partake of its identity" *(Kindergarten Chats,* edited and introduced by Claude Bragdon [Chicago, 1934], p. 44).

31. For Sullivan's "organic architecture," the birth and death of architectural forms and functions, and, by implication, of particular buildings, is an on-going process: "And decay proceeds as inevitably as growth: Functions decline, structures disintegrate, differentiations blur, the fabric dissolves, life disappears, death appears, time engulfs—the eternal night falls. Out of oblivion into oblivion, so goes the drama of created things—and of such is the history of an organism" *(Kindergarten Chats,* p. 48; this passage was omitted in the 1947 reprint [see *Kindergarten Chats and Other Writings,* ed. Isabella Athey (New York, 1947), pp. 48-49]). In 1901, when he first published the *Kindergarten Chats* essays, however, Sullivan was interested in the "hey-day [sic]," the "NEW ARCHITECTURE" that would replace the decayed forms and functions of "contemporaneous American architecture" (pp. 48-49).

32. Institute of Design press release, 4 March 1954. Original installation photographs indicate that 10 color transparencies were exhibited in a small light box. These color transparencies were the first exhibition of color photographs of Sullivan buildings. Len Gittleman recalls that Siskind and the Institute students made Ektachrome color photographs in the second year of the project, particularly of Sullivan's rural bank buildings. The high cost of color film and processing, however, precluded wider use (Gittleman to Jeffrey Plank, 5 January 2008). The RNCA includes 4 by 5 inch color transparencies for each image shown in the installation light box. These transparencies do not retain their original color tones.

33. See Siskind to John Riley, 29 March 1954, RNCA, and Hugh Duncan and Aaron Siskind invitation lists (six pages), RNCA.

34. See, e.g., "Louis Sullivan's Architecture to Be Shown in Photo Exhibit" and "Famed Landmarks of Chicago's Vigorous Past," *Chicago Daily Tribune* (11 March 1954), C7; Edward Barry, "Photos Reveal Adler Touch in Architecture," *Chicago Daily Tribune* (6 April 1954), A2.

35. Typescript (16 pages), RNCA.

36. "Teaching New Ways: Four-Year School Course in Visual Design," *New York Times* (28 March 1954), X15 (with Asao Doi photograph of Chicago Stock Exchange Building elevator grille).

37. See John Chancellor, "The Institute of Design: The Rocky Road from the Bauhaus," *Chicago Magazine* (July 1955), 28-36.

38. Files, RNCA.

39. *Architectural Forum,* 129. In early March 1954, before the Institute exhibit opened, Chicago modernist architect George Fred Keck, a founding faculty member at the New Bauhaus who taught part-time at the Institute, suggested to the *Architectural Forum* editors that they feature the Institute's Sullivan building photographs; in turn, they wrote to Institute director Crombie Taylor (Emerson Goble, Managing Editor, to Crombie Taylor, 29 March 1954, RNCA). In a 17 March 1954 letter to Siskind, Ben Raeburn also noted the *Architectural Forum* interest. Raeburn reports that the editors thought Hugh Duncan would be the best writer for their Sullivan building photograph article (RNCA).

Institute project photographs (23, including Siskind's Walker Warehouse ornament detail photographs) also were published in *Casabella,* with extracts from Hugh Duncan's opening night lecture (Hugh Dalziel Duncan, "Attualita di Louis Sullivan," [*Casabella* 204 (1955), 7-30]). Institute of Design and Illinois Institute of Technology faculty members, such as Alfred Caldwell, also used Institute project photographs to illustrate journal publications on Sullivan; see, e.g., Alfred Caldwell, "Louis Sullivan," *Dimension* 2 (1956), 8-15, with seven Institute project photographs.

40. *Archetype* 2 (Spring 1981) [Special Issue: Architectural Photography], 14-19.

41. On Szarkowski's use of his Louis Sullivan building photographs to generalize about architectural photography, see his "Photographing Architecture," *Art in America* (1959), 84-89, reprinted in *Archetype* 2 (1981), with David Travis's essay. By accepting Szarkowski's autobiographical narrative in *The Idea of Louis Sullivan* Travis perhaps was led to overlook the Institute project chronology. The Institute project and exhibit preceded publication of Szarkowski's book—and Szarkowski's photographing of Sullivan buildings in Chicago. Szarkowski was familiar with the Institute project, and Siskind and Nickel shared Institute photographs with him. Szarkowski's elaboration in "Photographing Architecture" of the thesis "that photography can become a technique of significant architectural criticism" (85) could well be viewed as a shrewd interpretation of the Institute project exhibit. Yet rather than pointing to that series of photographs as exemplifying (at the very least) his argument, he uses his own photographs to make the case, implying that he is sole author and illustrator of a view he in fact shared. As photography director for the 1956 Art Institute of Chicago *Louis Sullivan and the Architecture of Free Enterprise* exhibit (25 October-2 December 1956), Szarkowski used Institute project photographs. The Art Institute of Chicago announcement of the Sullivan exhibit includes one Institute project and one Szarkowski Sullivan building photograph *(Art Institute of Chicago Quarterly* 50 [15 September 1956], 42-43). The 45-page exhibit catalogue, edited by Edgar Kaufmann, Jr. (*Louis Sullivan and the Architecture of Free Enterprise* [Chicago, 1956]) includes five Institute project photographs and three Szarkowski photographs. When *The Idea of Louis Sullivan* was published in 1956, Siskind and Nickel were surprised—and surprised that he did not acknowledge their work. But Szarkowski brushed off their concerns: "I personally see no reason to get excited about the intricacies of the overlapping publicity in regard to your book, my book, the exhibition, etc. Probably no one except our immediate families will ever get it quite straight as to who is doing what anyhow" (Szarkowski to Richard Nickel, 18 July 1956, RNCA). Szarkowski's failure to acknowledge the Institute project, in his "Photographer's Foreword" to the 1956 *Idea of Louis Sullivan* and again in the 2000 edition, indicates a commitment to the concept of the artist as individual so strong that it suppresses important information about his own collaborative development. Near the close of "Photographing Architecture" Szarkowski writes: "I believe that architectural photography will achieve its highest degree of clarity and intensity of meaning when the functions of cameraman, critic and editor are combined in a single person. Or at least, directed by a single person" (87). He clearly sees himself alone in this role.

The kind of collaboration Szarkowski does recognize can be found in *The Idea of Louis Sullivan*. There Sullivan's inspired writings and lyrical texts from various hands, selected to achieve a "just balance between word and picture," accompany Szarkowski's photographs of Sullivan buildings. Their collaborative purpose is to "re-enliven, by means of photography, the fundamental concepts which were born in [Sullivan's] works" and to "capture [by means of lyrical texts] the mind and the spirit of the man and the

time and the place" (Photographer's Foreword, *The Idea of Louis Sullivan*). Whereas Szarkowski saw himself as cameraman, editor, and architectural critic, Siskind, I would argue, saw himself as cameraman, editor, and architectural historian. Consequently, Siskind saw little need for interpretative text of any kind. The task of architectural history, the Institute's project and exhibit suggest, belonged to the interpretative photographer(s) well versed in architectural forms. Szarkowski's achievement came in introducing Sullivan to an uninformed general public more familiar with interpretative discourse than with architecture. Consequently, his procedure is to reproduce for the public his own introduction to Sullivan, "not through his buildings, but through his intoxicating, inspiring writings" (ibid.) and the lyrical writings of others. As Travis notes, Szarkowski's "inspiration in preparing…*The Idea of Louis Sullivan* was not visual or architectural, but literary" ("Architectural Photography in Chicago," 16). Travis recognizes the difference between the work of Szarkowski and Siskind, but his explanation of that difference is less than adequate, and he does not comment on the implications of that difference for architectural history.

In *Architecture Transformed: A History of the Photography of Buildings from 1839 to the Present* (Cambridge and London, 1987), Cerwin Robinson refers to the Institute Sullivan project after briefly discussing Szarkowski's 1956 book: "In 1953 students of Aaron Siskind (b. 1903) at the Illinois Institute of Technology photographed every building in the Chicago area that could conceivably be by Sullivan" (p. 152). Robinson includes a 1967 Richard Nickel photograph of Burnham and Root's 1888 Kansas City Board of Trade Building (and one Szarkowski Sullivan building photograph, but no Siskind photograph) that illustrates a broad generalization: "Its oblique perspective emphasizes the substance of the building's brick and terra cotta but says nothing about its organization. A lack of emotional distance from subject matter was a common characteristic of all categories of architectural photography in the fifties and sixties" (p. 152). By comparing selected individual photographs by Szarkowski and Nickel, Robinson can dismiss the Institute project and exhibit, including Siskind's photographs. By 2001 the Institute Sullivan exhibit had all but disappeared, especially to architectural historians working outside Chicago: "Not until 1956, the centenary of Sullivan's birth, was his ornament treated sympathetically. John Szarkowski, then beginning a career that would lead to the directorship of the Department of Photography at the Museum of Modern Art, published *The Idea of Louis Sullivan,* an exquisite portfolio of photographs of Sullivan's work…. Szarkowski's book…set in motion the rehabilitation of Sullivan as a major figure in American cultural history" (Michael J. Lewis, "Louis Sullivan after functionalism," *The New Criterion* [September 2001], 50-51).

42. Institute of Design press release, 4 March 1954, RNCA.

43. Siskind to Greta Daniel, Associate Curator, Architecture and Design, MOMA, 13 April 1954, RNCA.

44. Richard Nickel, *A Photographic Documentation of the Architecture of Adler & Sullivan,* M.A. Thesis, Illinois Institute of Technology, June 1957, p. 2.

45. Morrison, *Louis Sullivan,* p. 66.

46. *Photographic Documentation,* p. vi.

47. See, e.g., Hugh Morrison, "Louis Sullivan Today," *Journal of the American Institute of Architects* (July 1956): "I have heard recently that there is to be a new book 'The Architecture of Adler & Sullivan,' published by Horizon Press, with many pages of black-and-white illustrations, and about 15 color-plates. These will be from Illinois Tech's photo-project on Sullivan…. I am very excited and pleased at this development. Some of the photos, by Aaron Siskind and others, are wonderful" (99); and Edgar Kaufmann, Jr., "Introduction," *Louis Sullivan and the Architecture of Free Enterprise:* "[Richard Nickel's] investigations will be embodied, along with a complete photographic record made by Mr. Nickel,

Mr. Gittleman and other students under the direction of Aaron Siskind of the staff of the Institute of Design, in a publication of the complete works of Adler and Sullivan, announced for next year by Horizon Press" (p. 9).

48. Vinci interview with Jeffrey Plank, 28 April 2006. Siskind and Nickel worked directly with Raeburn on the book layout. In 1957 Nickel reported to Raeburn his differences with Siskind on the translation of the exhibit into book format and the kinds of information to be included for each building: "I think it is a little artificial to subordinate the full view to details especially in cases like the Knisely Bldg. It works with the Walker Whse…. I think Aaron always had in mind a kind of formal layout with each picture having a two inch white border but I have come to be dead against that. Its [sic] no longer a book about our photographs but about A & S's buildings. In that end, the more bleeds, drawings and plans…the better it is" (Nickel to Raeburn, 10 February 1957, RNCA). Siskind and Nickel continued to differ on the book layout: "Aaron has a sociological interest ("then and now") and I have an educational interest to show the important things…. And I'm frightened to death of how we use details large and general views small" (Nickel to Raeburn, 20 July 1958, RNCA).

49. *Aaron Siskind: Photographs* (New York, 1959), designed by Ivan Chermayeff, son of former Institute director Serge Chermayeff. Throughout his Introduction, Harold Rosenberg insists on the close relationship of Siskind's photographs to painting: "One will be struck directly by the resemblance of these photos to reproductions of advanced contemporary paintings. Aaron Siskind's collection is like the catalogue of a show of 'best Americans' that may take place next month in a leading New York gallery…. Siskind's photos are inseparable from painting…. Instead of scenes that seem like paintings, Siskind's pictures ARE paintings as they appear on the printed page…. Siskind has used the camera to make a book on modern art" (not paginated).

50. See, e.g., book mock-up pages reproduced in *Aaron Siskind: Toward a Personal Vision,* p. 69; Siskind, Nickel, and Raeburn produced several mock-ups (RNCA).

51. The first modern catalogues for early modern American architects were published in 1973 and 1982: James O'Gorman, *The Architecture of Frank Furness* (Philadelphia, 1973) and Jeffrey Karl Ochsner, *Henry Hobson Richardson: Complete Architectural Works* (Boston and London, 1982). Each publication elicited information about additional buildings for subsequent editions. In the absence, perhaps, of models for an architect's catalogue raisonné, Nickel rejected the conventions of completeness for publication proposed by Siskind and Raeburn, continuing to add information about Sullivan buildings as the book design proceeded. New information postponed publication, but new information also raised questions for Nickel about the adequacy of the conceptual framework for his building descriptions. In late 1959, after missing several deadlines for providing Sullivan book photographs and text to Raeburn, Nickel sought to clarify his responsibilities. According to Nickel these responsibilities expanded significantly since Siskind signed the publication contract. Initially Nickel was to provide "picture materials," not the text. As the research became more complicated, Nickel observed, he took responsibility for the photographs, plans, and text. While acknowledging his initial misgivings about preparing a text ("How was I to write about Sullivan with only a meagerly art history and architecture training and no writing experience?"), he proposes the terms on which he can proceed: "I am more confident I can do the job but in my own way, which is that I have to feel a *complete intimacy* [my emphasis] with the individual buildings and their history" (19 November 1959, RNCA). With financial support, Nickel felt he could complete the text in 1960, noting that he would re-photograph some buildings, continue his library research, draw plans of Sullivan buildings that were being demolished, and salvage ornament.

While project delays continued and Raeburn was unable to publish *The Complete Architecture of Adler & Sullivan,* he included 55 Institute of Design Sullivan project building photographs (but only 17 from the 1954 exhibit) in his 1971 reprint of Wright's *Genius and the Mobocracy* (New York, 1971).

52. In 1954 Crombie Taylor undertook the first restoration of a Louis Sullivan building with his restoration of the banquet hall and ladies parlor in the Auditorium Building (see, e.g., "Louis Sullivan and the Banqueting Hall," *AIA Chicago Chapter Bulletin* 4 [1956], 21-23). Taylor also recuperated Sullivan's polychromatic stencils, painted over in the early 1900s, in these and other Auditorium Building and Garrick Building interior spaces; see his "Systems of Stencil Ornament of Louis Sullivan," Smithsonian Institution SITES exhibit (1965). Although Taylor's Auditorium Building restorations and stencil exhibit constitute an innovative form of scholarship for modern architectural history, they have been neglected by architectural historians. For information discovered during Sullivan building demolition and restoration, see also John Vinci, *The Art Institute of Chicago: The Stock Exchange Trading Room* (Chicago, 1977), and *Conflict & Creativity: Architects & Sculptors in Chicago, 1871-1937,* curated by Timothy Samuelson and John Vinci; catalogue essay by Timothy Samuelson and installation by John Vinci, FAIA (Chicago, 1994 [The Arts Club of Chicago]).

The Institute of Design Photo Section Project
Exhibit Photographs

Exhibit Photographs and Photographer Attributions

1. James H. Walker and Company Store and Warehouse, Chicago, interior, under demolition. *Alvin Loginsky*

2. Walker Warehouse, exterior, south elevation. *Alvin Loginsky*

3. Walker Warehouse, exterior, column capital detail. *Aaron Siskind*

4. Walker Warehouse, exterior, column capital detail. *Aaron Siskind*

5. Walker Warehouse, exterior, east elevation, recessed entry detail. *Aaron Siskind*

6. Walker Warehouse, exterior, north elevation, double arch detail. *Aaron Siskind*

7. Walker Warehouse, exterior, east elevation, ornament detail. *Not attributed; no original print or negative*

8. Walker Warehouse, exterior, north elevation, lower floors. *Aaron Siskind*

9. Auditorium Building, Chicago, exterior. *Leon Lewandowski*

10. Auditorium Building, exterior, south elevation. *Not attributed; no original print or negative*

11. Auditorium Building, exterior, south elevation, tower and upper floors. *Richard Nickel*

12. Auditorium Building, exterior, hotel entry detail. *Leon Lewandowski*

13. Auditorium Building, exterior, east elevation detail. *Alvin Loginsky*

14. Auditorium Building, interior, theater, south wall near stage. *Not attributed*

15. Auditorium Building, interior, hotel, wood capital detail. *Paul Hassel*

16. Auditorium Building, interior, theater, first floor foyer. *Paul Hassel*

17. Auditorium Building, interior, hotel, 10th floor dining room, wall and ceiling detail. *Aaron Siskind*

18. Auditorium Building, interior, hotel, 10th floor dining room, wood column. *Leon Lewandowski*

19. Auditorium Building, interior, banquet hall, wall detail. *Paul Hassel*

20. Auditorium Building, interior, banquet hall. *Leon Lewandowski*

21. Auditorium Building, interior, banquet hall, ceiling detail. *Leon Lewandowski*

22. Auditorium Building, interior, ladies' lounge, fretsawn grille detail. *Paul Hassel*

23. Auditorium Building, interior, hotel, mosaic detail. *Paul Hassel*

24. Auditorium Building, interior, hotel, spandrel above door detail. *Leon Lewandowski*

25. Auditorium Building, interior, hotel, art glass window. *Paul Hassel*

26. Farmers' and Merchants' Union Bank, Columbus, Wisconsin, exterior, side elevation, window detail. *Len Gittleman*

27. Farmers' and Merchants' Bank, interior, tellers' cages. *Leon Lewandowski*

28. Farmers' and Merchants' Bank, interior, banking floor. *Leon Lewandowski*

29. Farmers' and Merchants' Bank, exterior, side elevation. *Len Gittleman*

30. Farmers' and Merchants' Bank, exterior, main entry, terra cotta cartouche detail. *Aaron Siskind*

31. Farmers' and Merchants' Bank, exterior, terra cotta ornament detail. *Leon Lewandowski*

32. National Farmers' Bank, Owatonna, Minnesota, exterior, front elevation. *James Blair*

33. National Farmers' Bank, exterior, front and side elevations. *James Blair*

34. National Farmers' Bank, exterior, front elevation, corner detail. *James Blair*

35. National Farmers' Bank, interior, art glass lunette. *James Blair*

Note on Photographer Attributions

Very few mounted prints from the 1954 exhibit survive in the Institute project records at the Richard Nickel Committee Archive. Each time the exhibit traveled for an installation that Siskind or Nickel could not supervise it sustained some damage. Nickel trimmed damaged prints and replaced some prints with others. He also continued to photograph the same Sullivan buildings photographed by the students again and again. By the late 1960s the project archive had grown to several thousand 4 by 5 inch black and white negatives. Nickel then filed the negatives, chronologically by building, combining Institute project exhibit negatives with those he made much later, including demolition and building fragment records.

Over time, photographer attributions noted on captions attached to the original mounted prints were lost, and inaccurate attributions for some iconic photographs proliferated, such as the attribution of Nickel as the photographer for Leon Lewandowski's splendid Auditorium Building panorama or James Blair's portrait of the Farmers' and Merchants' Bank in Owatonna. Fortunately, when other institutions, including the Museum of Modern Art, purchased copies of the Institute exhibit photographs in the mid-1950s Siskind provided photographer attributions on the prints (although his correspondence and the Yale University set indicate that he occasionally substituted similar images). Of those institutions, only Yale University retained any prints, but the Yale set now includes only two-thirds of the original set purchased in March 1955 (and of these, 35 are not exhibit photographs). The Yale set attributions provided the starting point for photographer attributions and served as a reference point for decoding the inconsistent marks on the negatives. Some negatives are marked with names or initials of project team members (such as Len, Leon, L, Doi, or Siskind or S, even S-N). Many negatives for prints in the exhibit also are marked "ID." But these marks are inconsistent and some negatives have no marks at all. The negative archive includes buildings photographed by the Institute project team, but not featured in the exhibit. For some buildings featured in the exhibit the project team took many unused photographs. While a project team member name or initial or the ID mark may indicate a photograph taken before 1955, the absence of marks on so many negatives makes definitive project attribution difficult.

Photographs of the 1954 exhibit panels are our best record of the exhibit photographs. By comparing Yale set attributions and panel photographs (and, occasionally, attributions supplied by Siskind for early publication) with negatives, Richard Nickel Committee Executive Director Ward Miller and I were able to attribute all but a very few exhibit photographs by early 2007. Miller since has completed an annotated list for the entire negative archive.

Exhibit Photograph Credits

The Institute of Design Photo Section Project
Exhibit Photographs

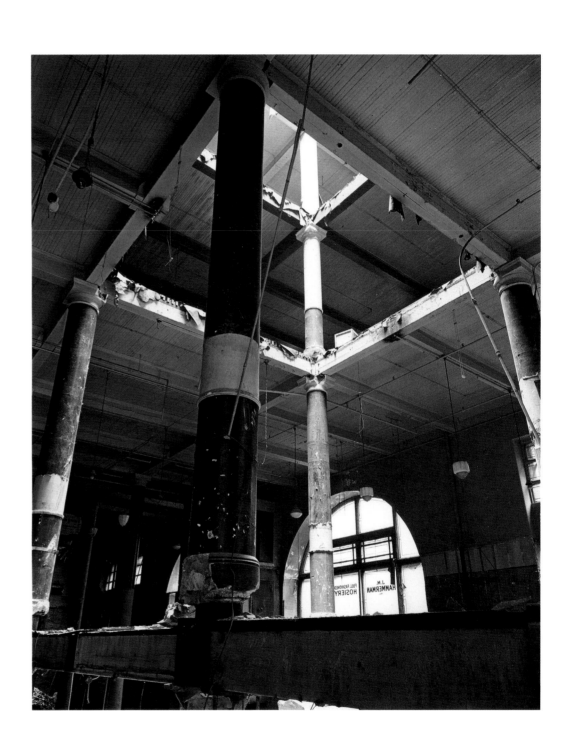

1. James H. Walker and Company Store and Warehouse, Chicago, interior, under demolition. *Alvin Loginsky*

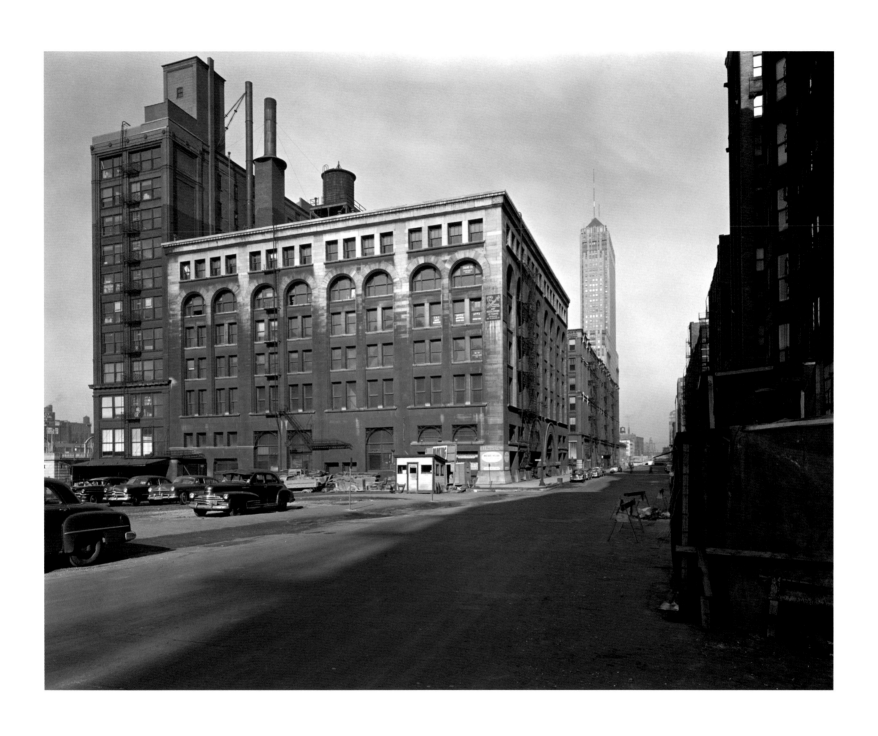

2. Walker Warehouse, exterior, south elevation. *Alvin Loginsky*

3. Walker Warehouse, exterior, column capital detail. *Aaron Siskind*

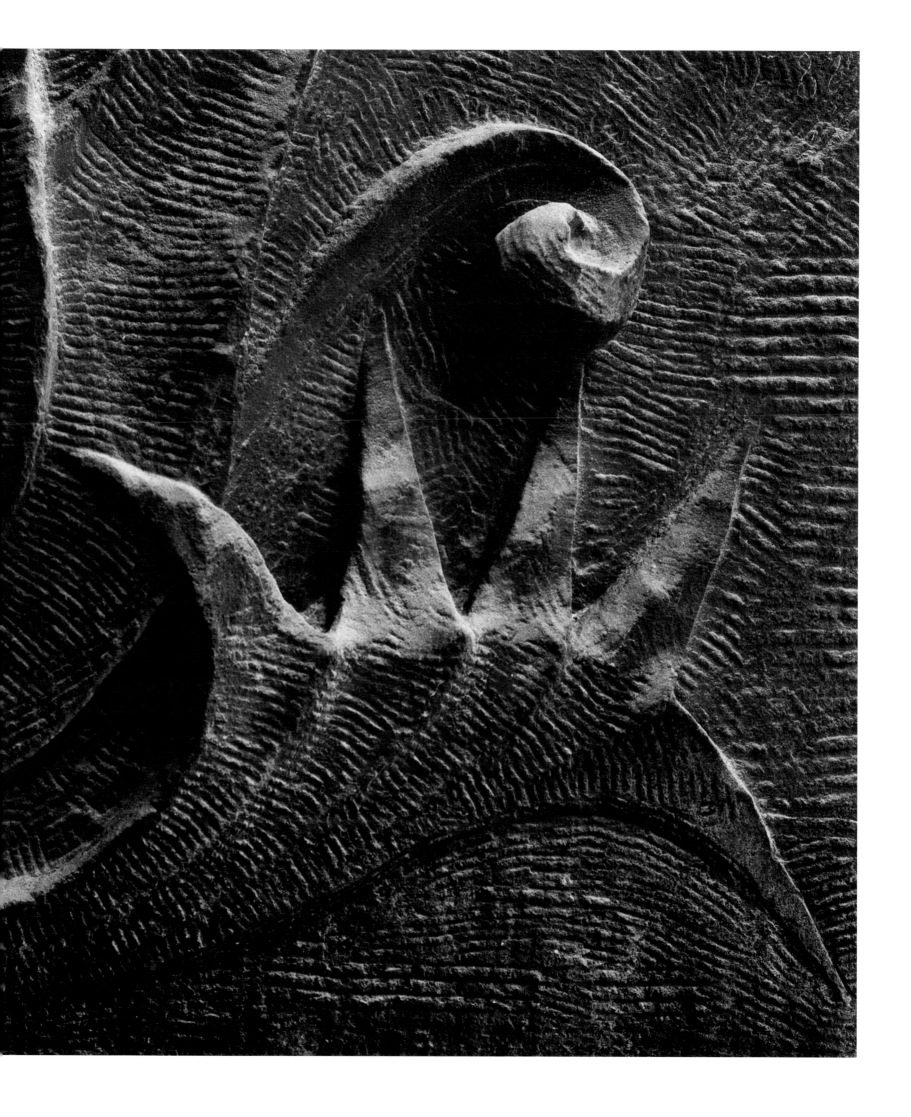

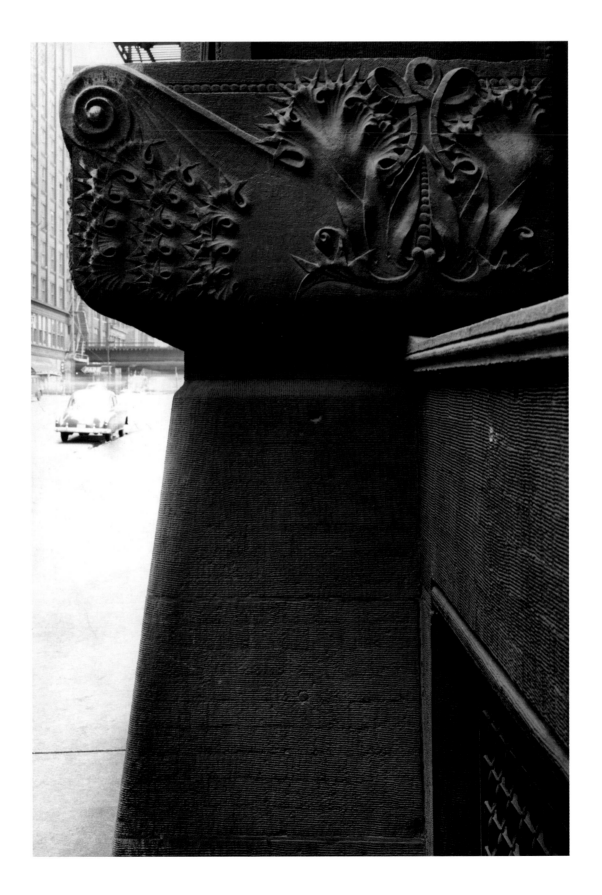

4. Walker Warehouse, exterior, column capital detail. *Aaron Siskind*

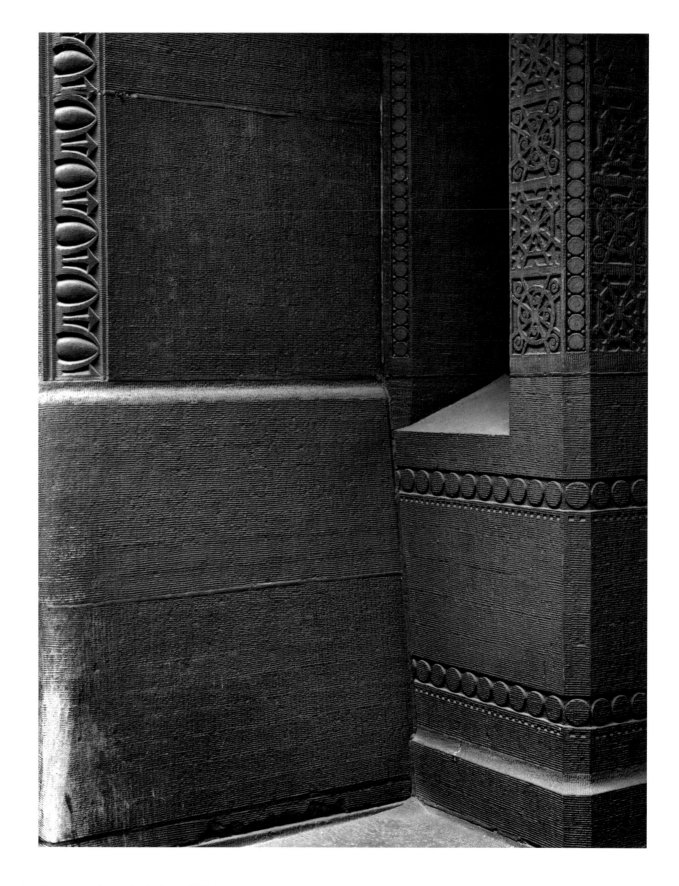

5. Walker Warehouse, exterior, east elevation, recessed entry detail. *Aaron Siskind*

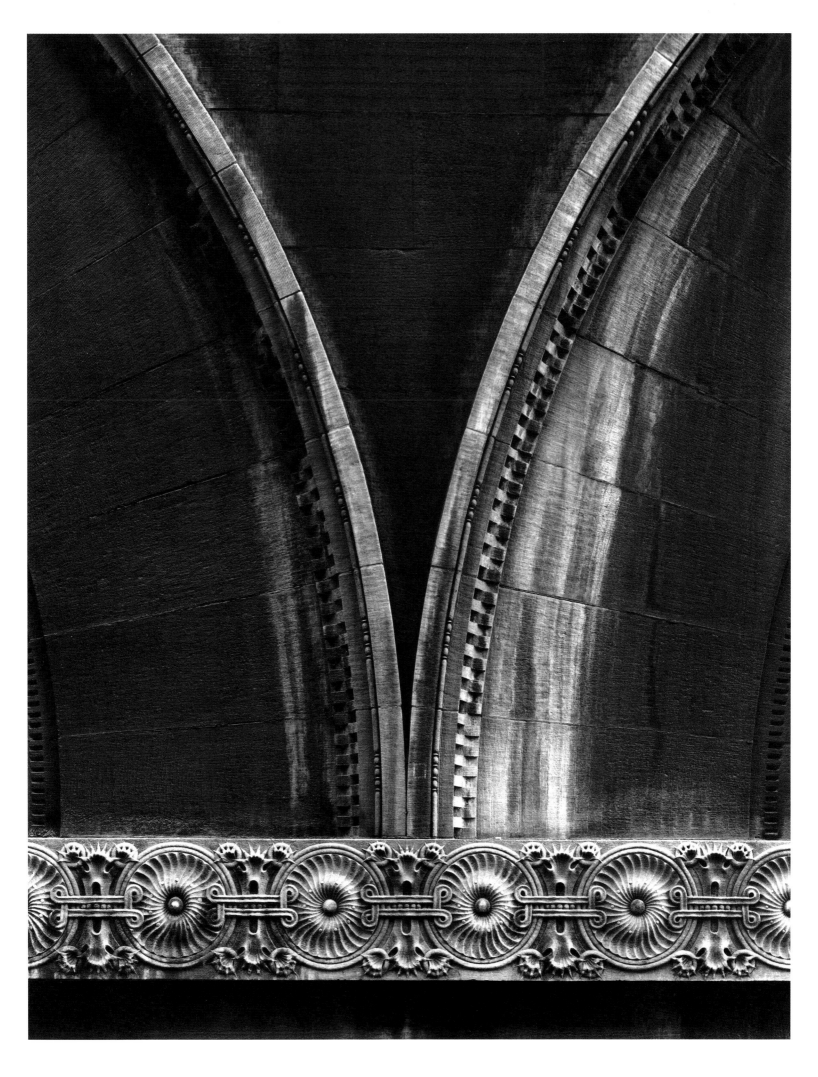

6. Walker Warehouse, exterior, north elevation, double arch detail. *Aaron Siskind*

7. Walker Warehouse, exterior, east elevation, ornament detail. *Not attributed; no original print or negative*

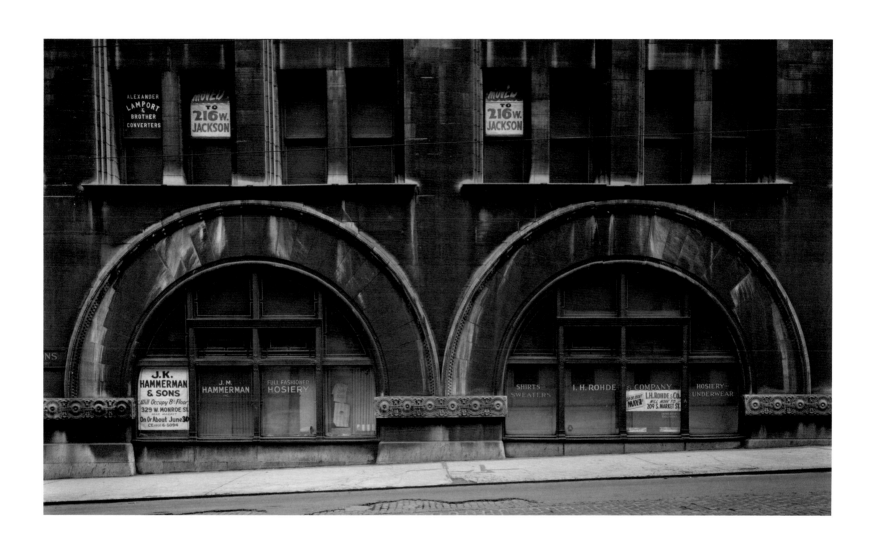

8. Walker Warehouse, exterior, north elevation, lower floors. *Aaron Siskind*

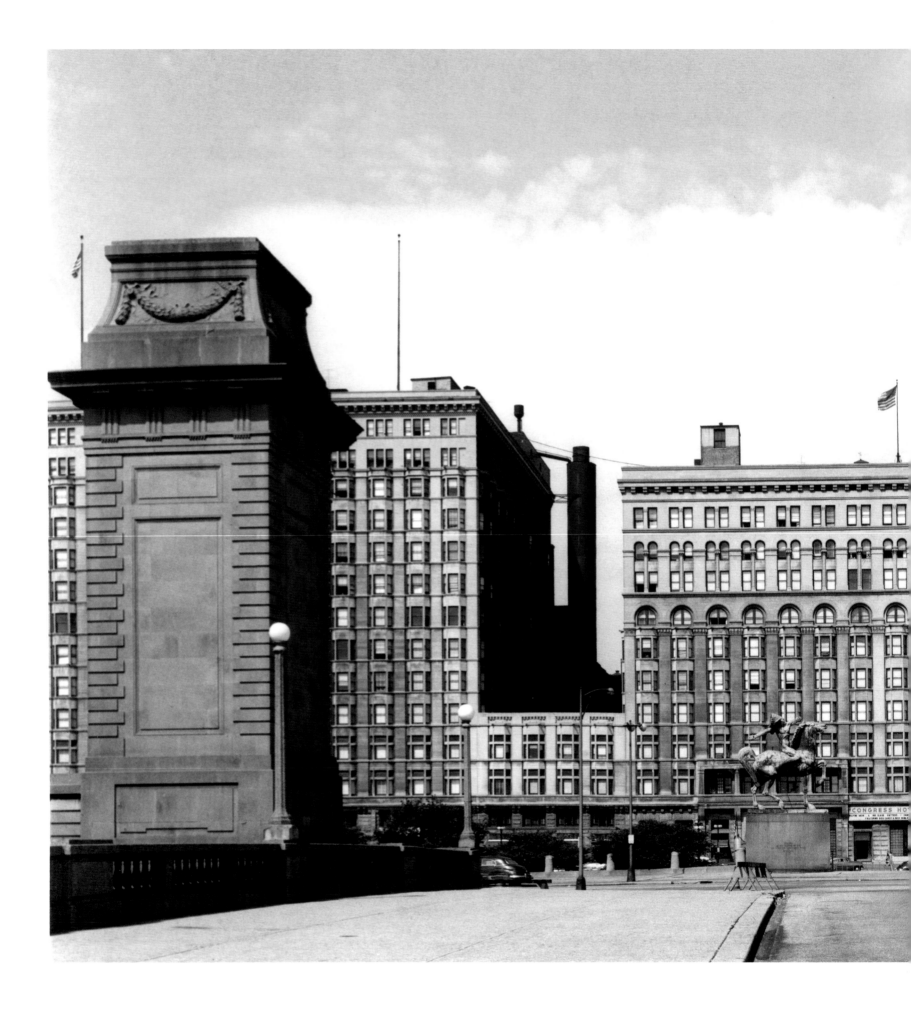

9. Auditorium Building, Chicago, exterior. *Leon Lewandowski*

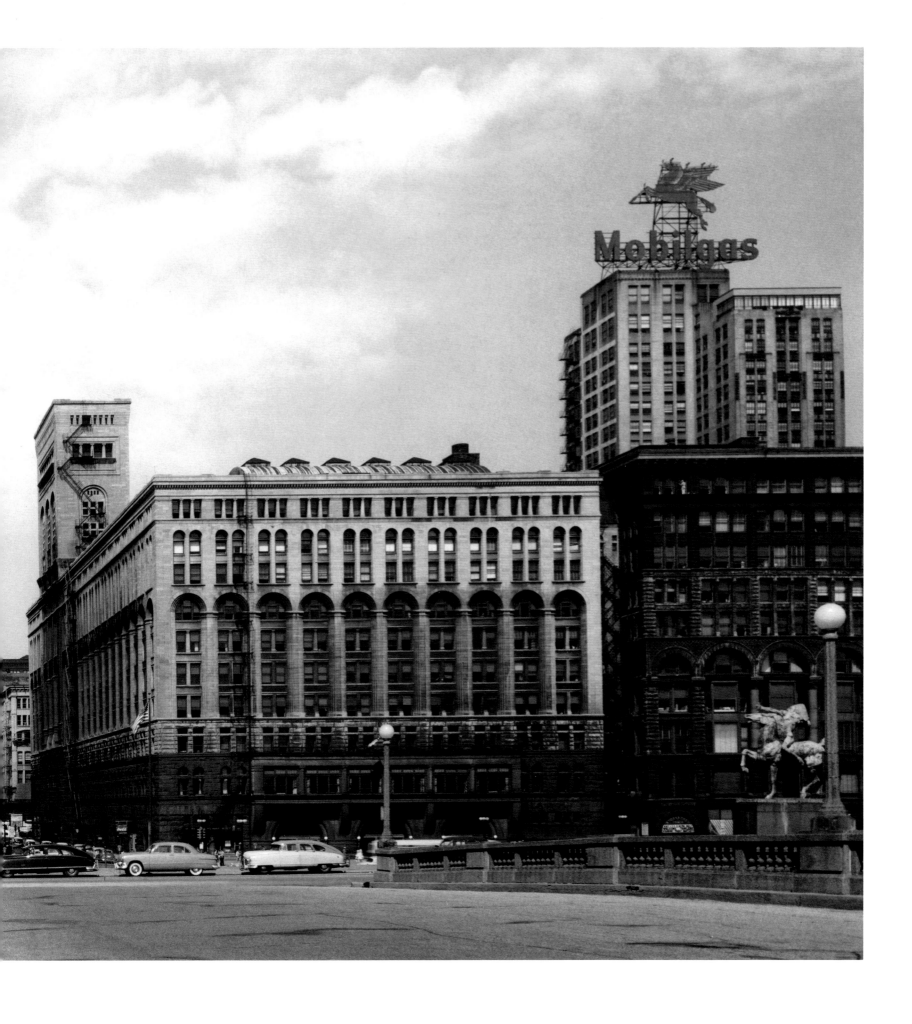

10. Auditorium Building, exterior, south elevation. *Not attributed; no original print or negative*

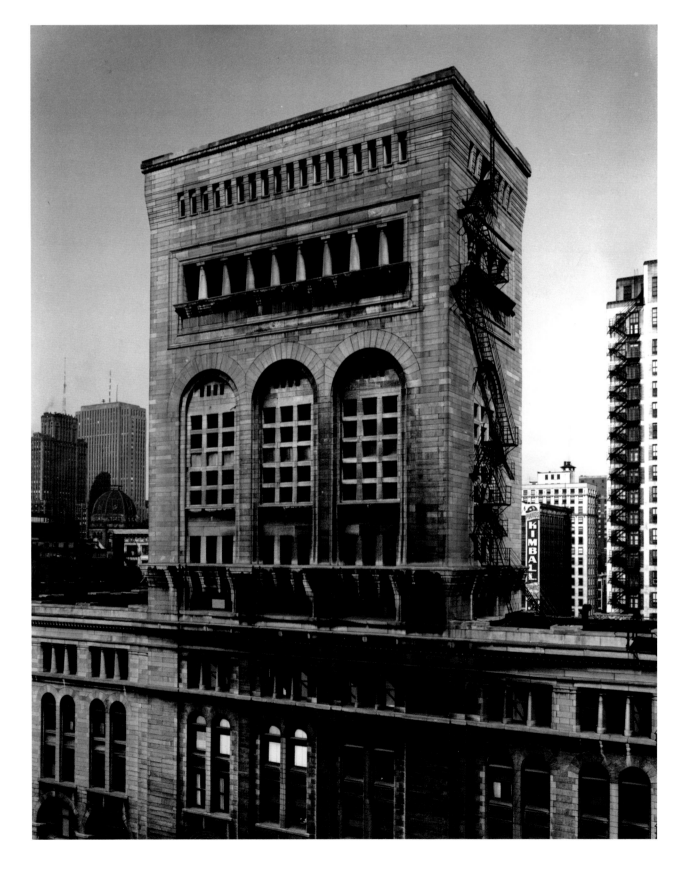

11. Auditorium Building, exterior, south elevation, tower and upper floors. *Richard Nickel*

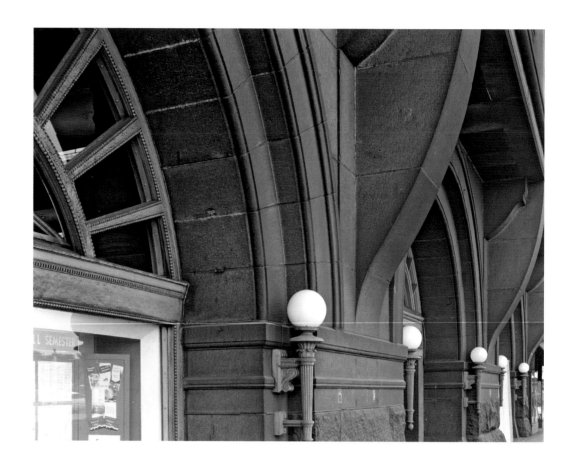

12. Auditorium Building, exterior, hotel entry detail. *Leon Lewandowski*

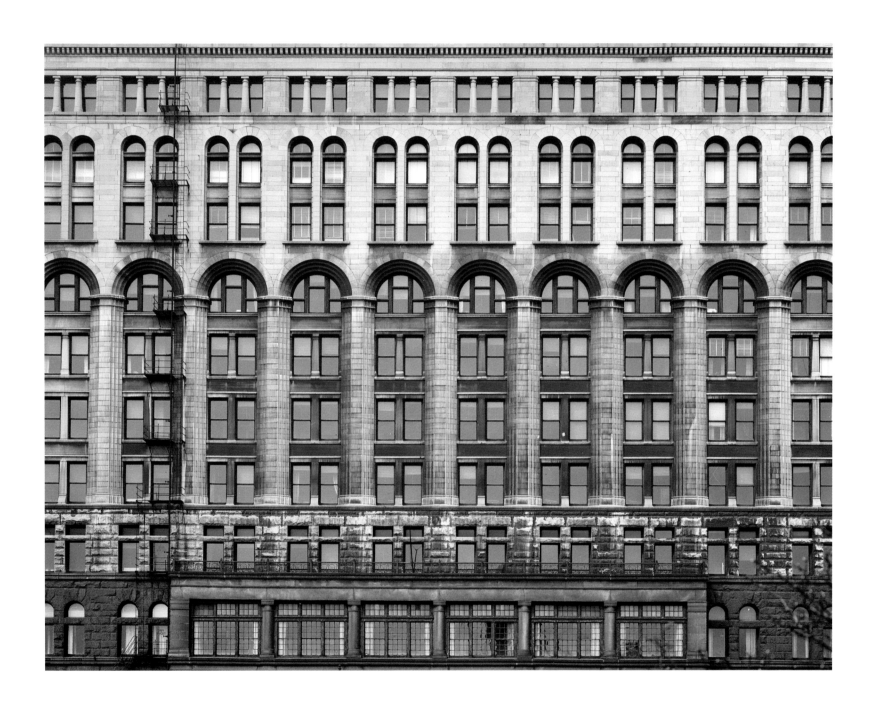

13. Auditorium Building, exterior, east elevation detail. *Alvin Loginsky*

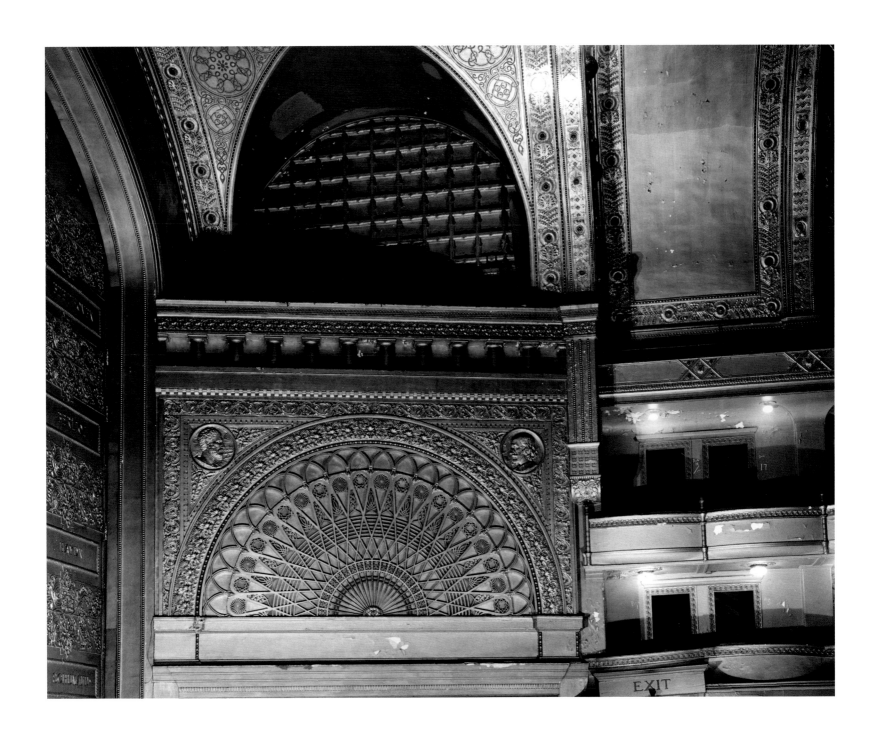

14. Auditorium Building, interior, theater, south wall near stage. *Not attributed*

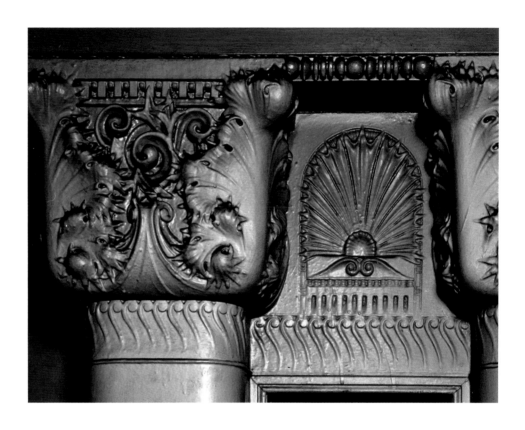

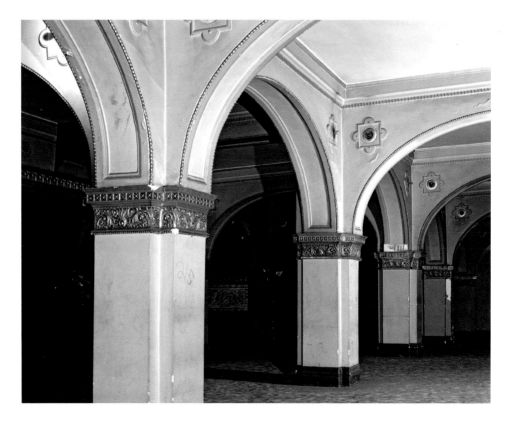

15. Auditorium Building, interior, hotel, wood capital detail. *Paul Hassel*
16. Auditorium Building, interior, theater, first floor foyer. *Paul Hassel*

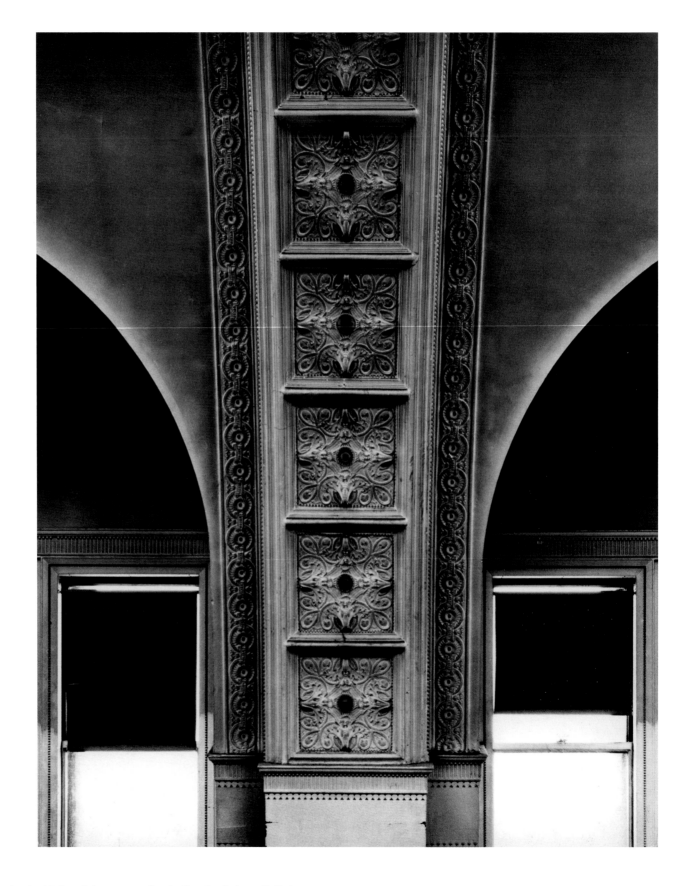

17. Auditorium Building, interior, hotel, 10th floor dining room, wall and ceiling detail. *Aaron Siskind*

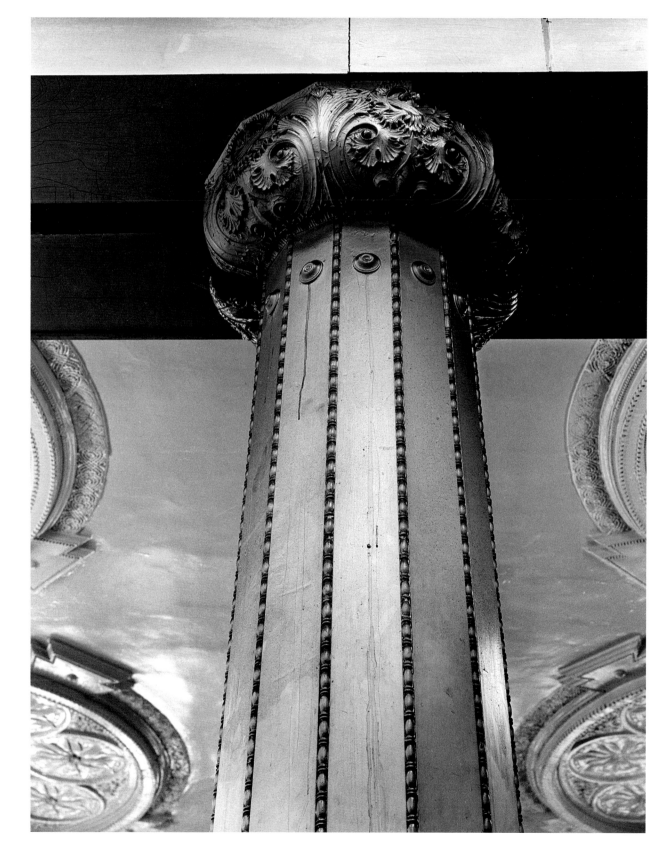

18. Auditorium Building, interior, hotel, 10th floor dining room, wood column. *Leon Lewandowski*

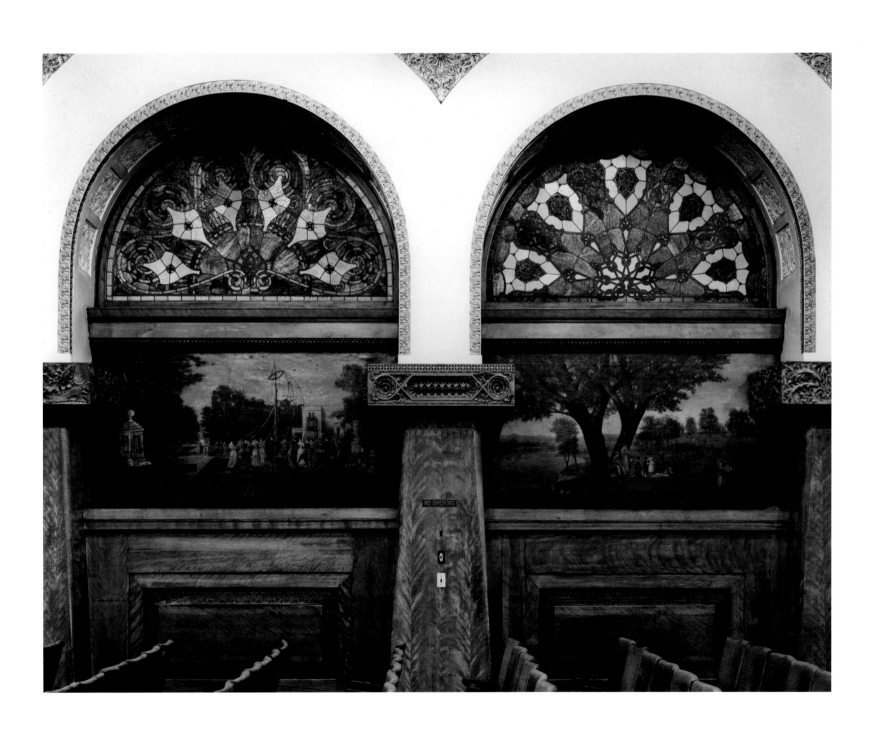

19. Auditorium Building, interior, banquet hall, wall detail. *Paul Hassel*

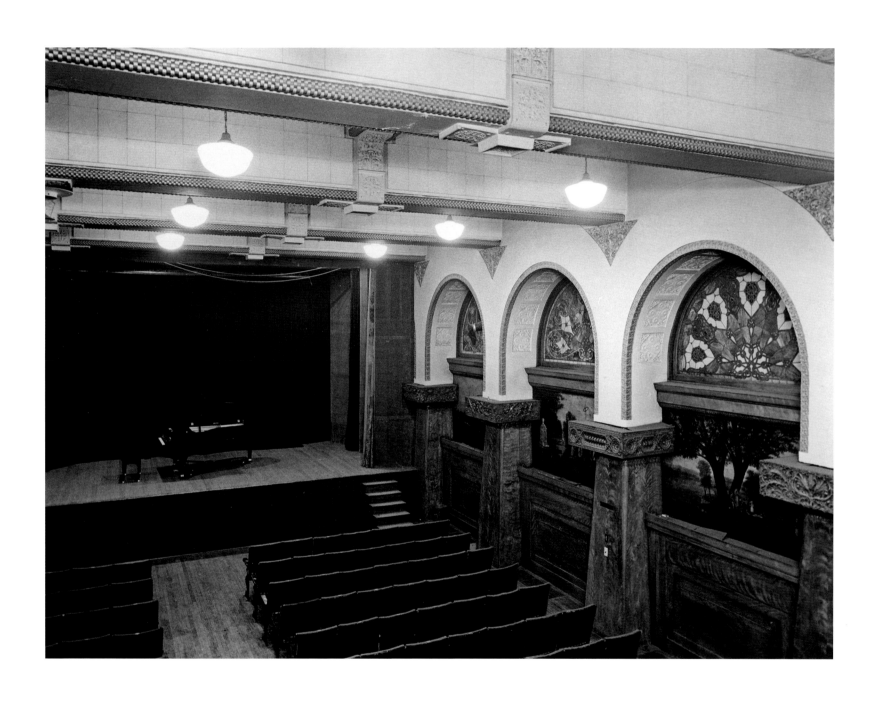

20. Auditorium Building, interior, banquet hall. *Leon Lewandowski*

21. Auditorium Building, interior, banquet hall, ceiling detail. *Leon Lewandowski*

22. Auditorium Building, interior, ladies' lounge, fretsawn grille detail. *Paul Hassel*
23. Auditorium Building, interior, hotel, mosaic detail. *Paul Hassel*

24. Auditorium Building, interior, hotel, spandrel above door detail. *Leon Lewandowski*
25. Auditorium Building, interior, hotel, art glass window. *Paul Hassel*

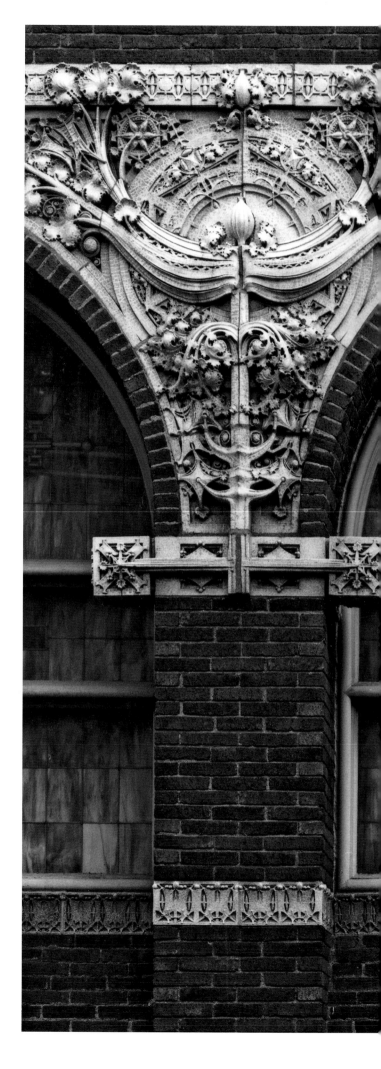

26. Farmers' and Merchants' Union Bank, Columbus, Wisconsin, exterior, side elevation, window detail. *Len Gittleman*

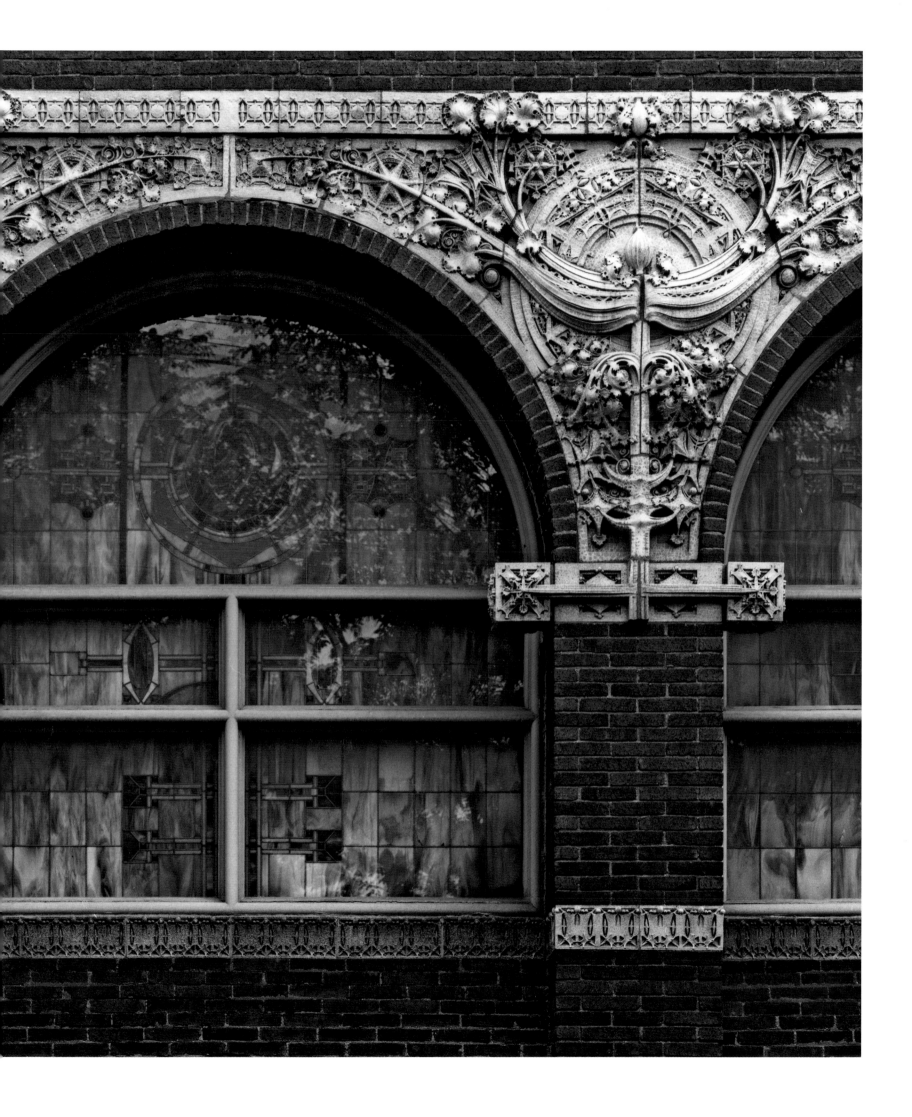

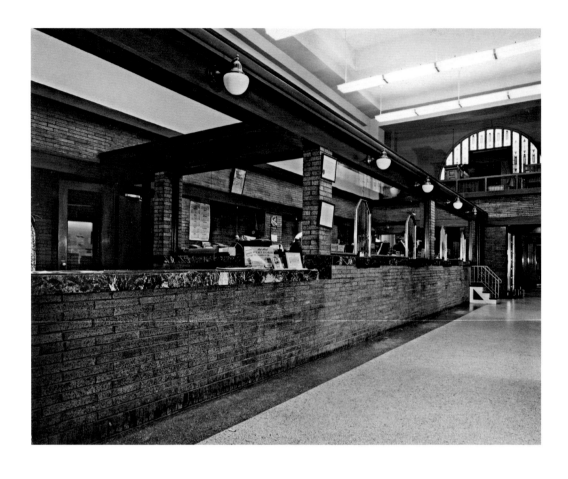

27. Farmers' and Merchants' Bank, interior, tellers' cages. *Leon Lewandowski*

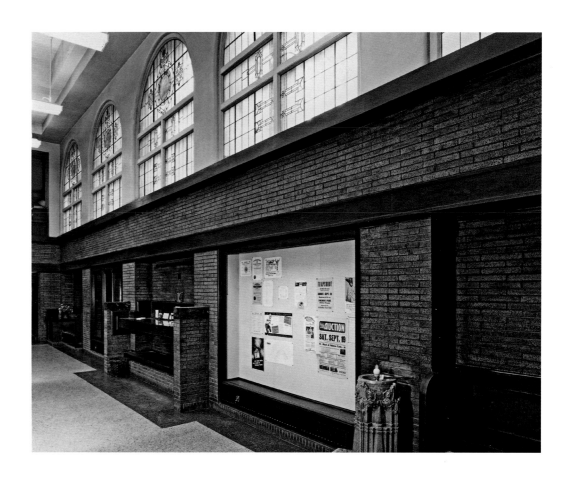

28. Farmers' and Merchants' Bank, interior, banking floor. *Leon Lewandowski*

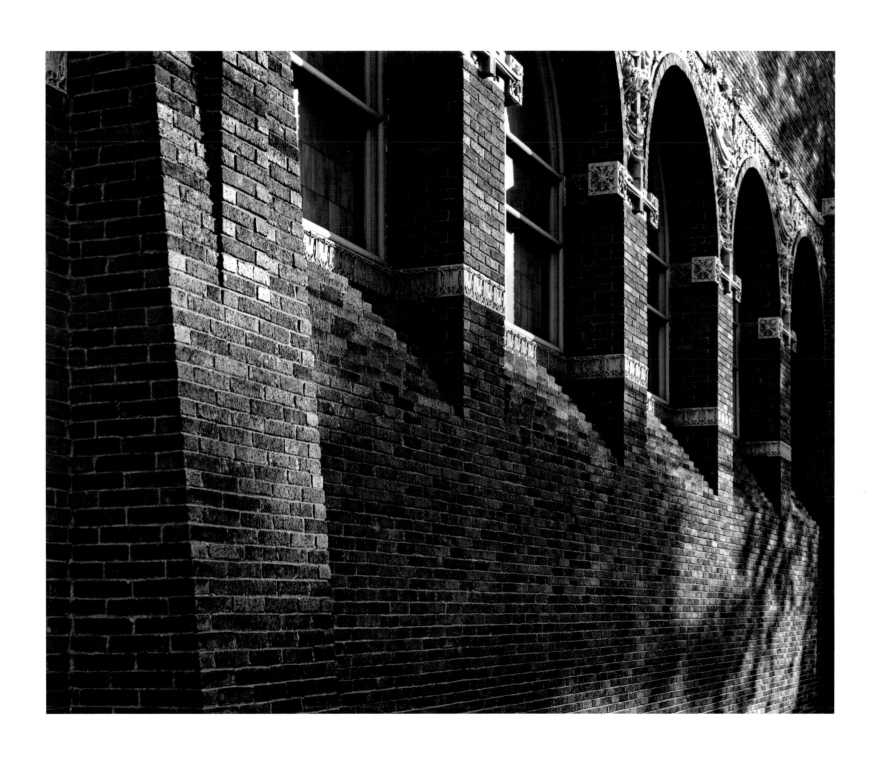

29. Farmers' and Merchants' Bank, exterior, side elevation. *Len Gittleman*

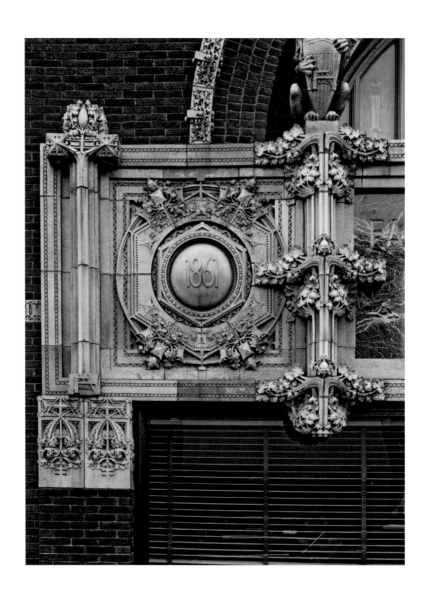

30. Farmers' and Merchants' Bank, exterior, main entry, terra cotta cartouche detail. *Aaron Siskind*

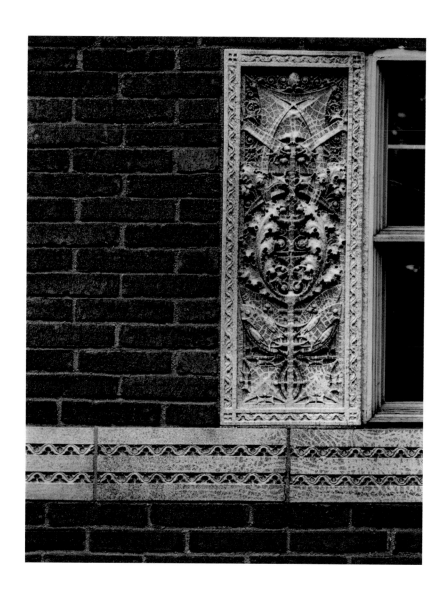

31. Farmers' and Merchants' Bank, exterior, terra cotta ornament detail. *Leon Lewandowski*

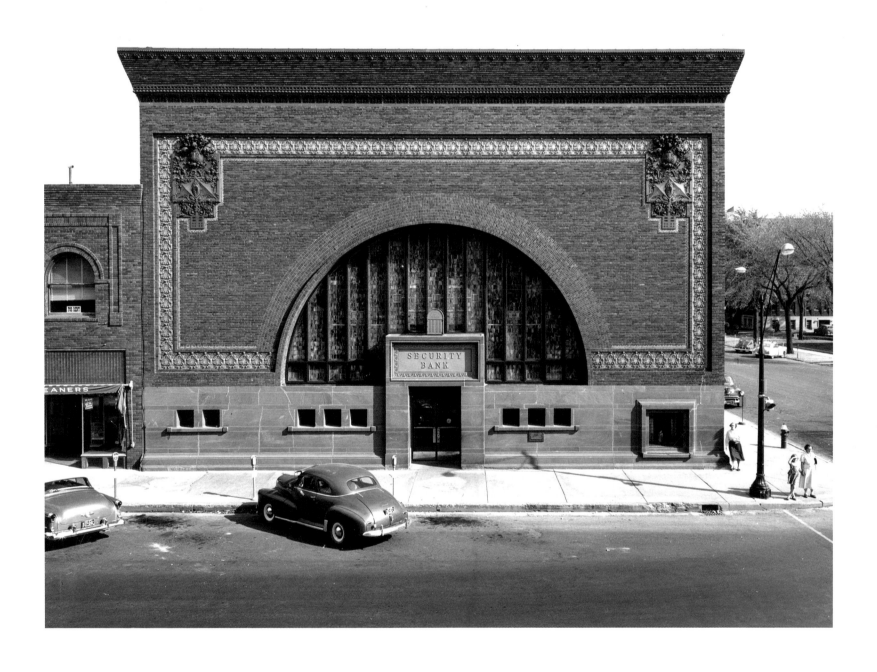

32. National Farmers' Bank, Owatonna, Minnesota, exterior, front elevation. *James Blair*

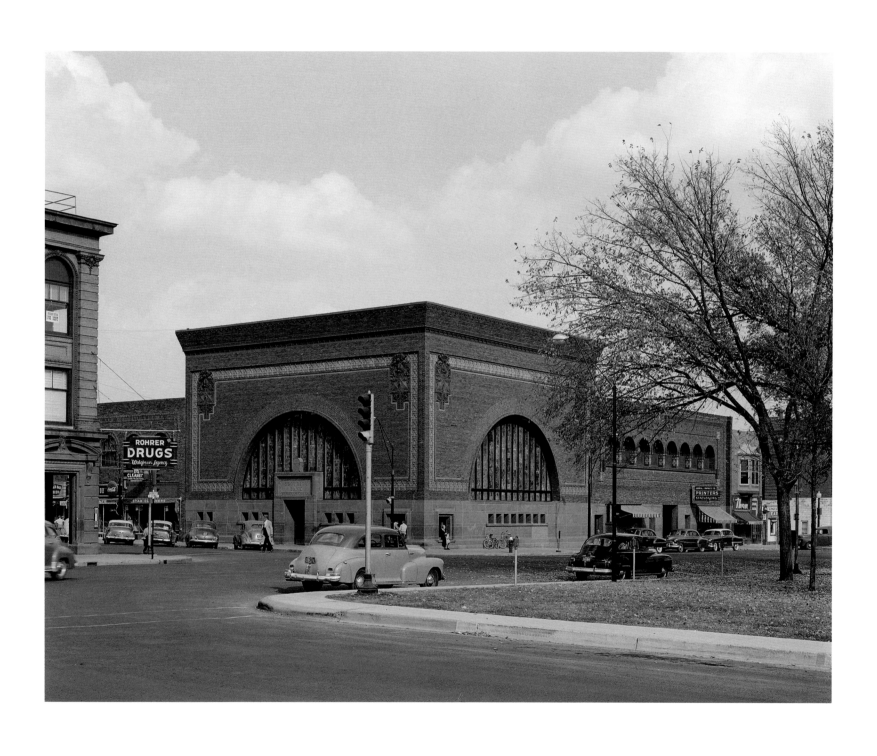

33. National Farmers' Bank, exterior, front and side elevations. *James Blair*

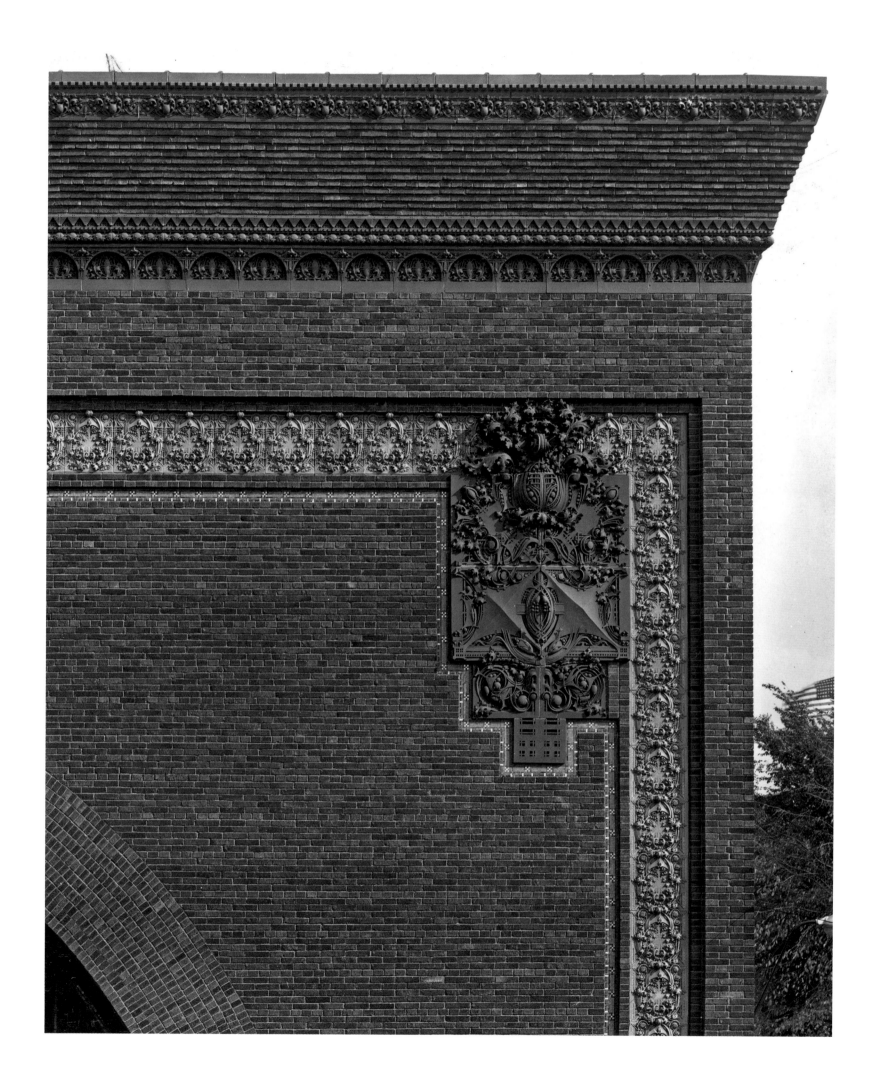

34. National Farmers' Bank, exterior, front elevation, corner detail. *James Blair*

35. National Farmers' Bank, interior, art glass lunette. *James Blair*

36. Peoples Savings Bank, Cedar Rapids, Iowa, exterior, front and side elevations. *Len Gittleman*
37. Peoples Savings Bank, exterior. *Len Gittleman*

38. Peoples Savings Bank, exterior, side elevation, brick and water table detail. *Aaron Siskind*

39. Peoples Savings Bank, exterior, entry detail. *Aaron Siskind*

40. Getty Tomb, Chicago, exterior, front elevation. *Richard Nickel*

41. Getty Tomb, exterior, bronze gates detail. *Richard Nickel*

42. Martin Ryerson Tomb, Chicago, front elevation. *Richard Nickel*

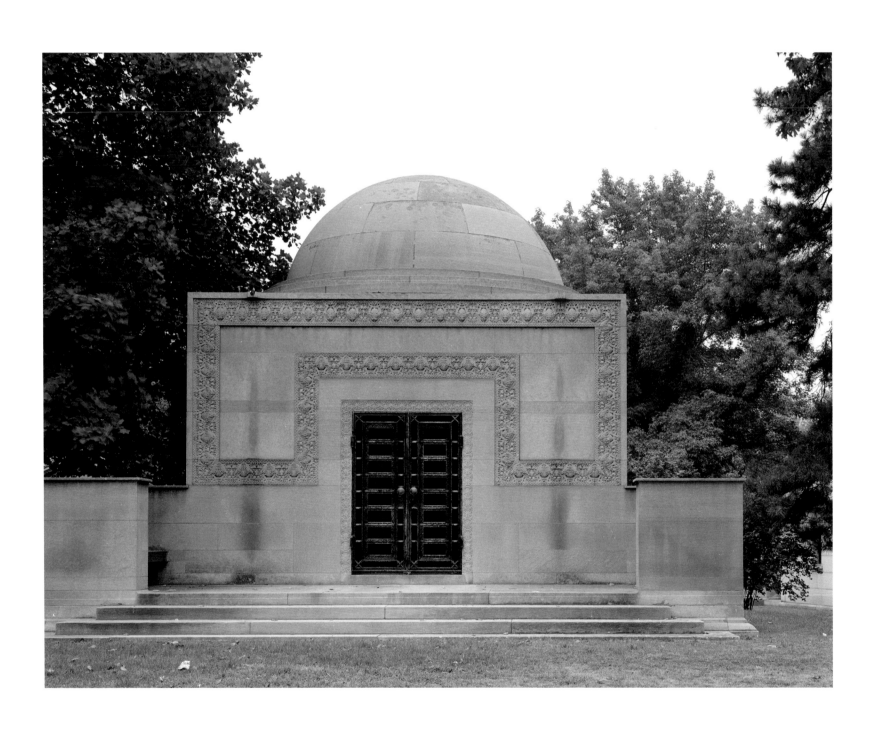

43. Wainwright Tomb, front elevation. *Aaron Siskind*

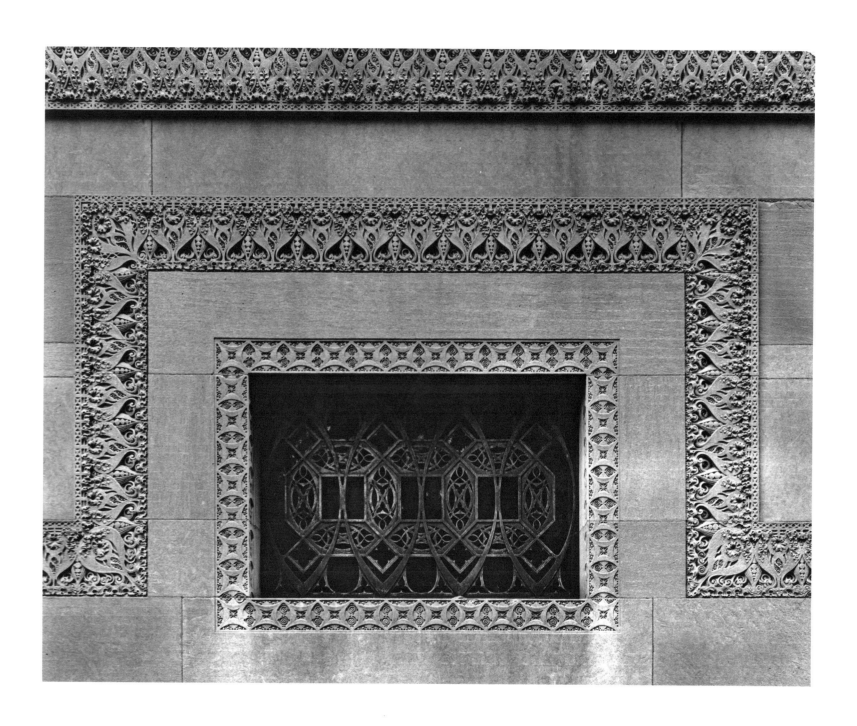

44. Wainwright Tomb, side elevation detail. *Aaron Siskind*

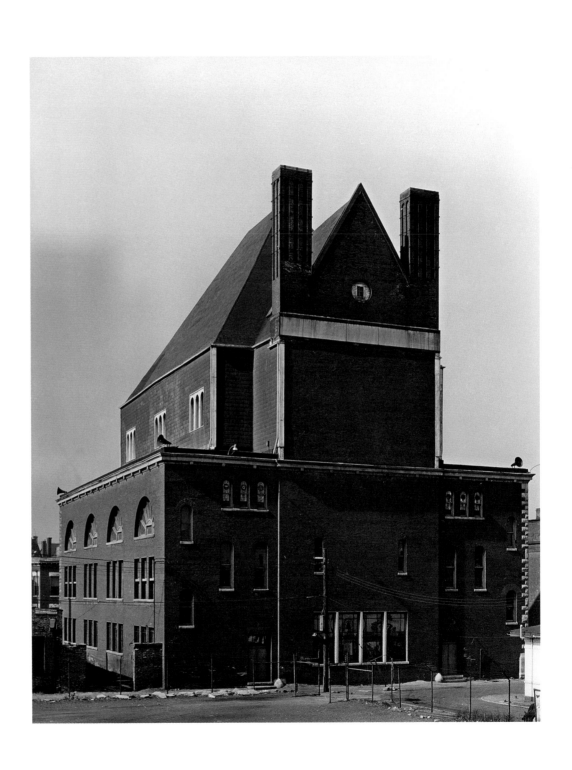

45. Kehilath Anshe Ma'ariv Synagogue, Chicago, exterior, east (rear) elevation. *Richard Nickel*

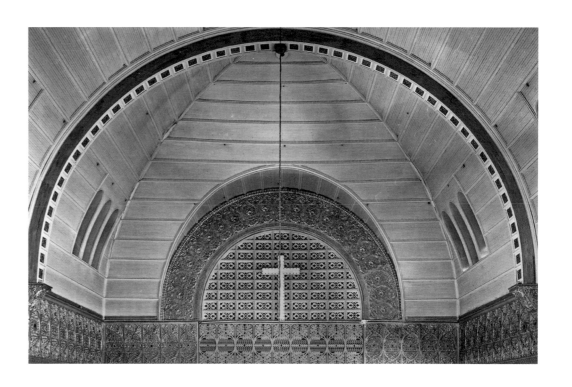

46. Kehilath Anshe Ma'ariv Synagogue, interior. *Casimir Estramskis*
47. Kehilath Anshe Ma'ariv Synagogue, exterior, west (front) elevation, entry detail. *Casimir Estramskis*

48. Kehilath Anshe Ma'ariv Synagogue, exterior, east elevation. *Richard Nickel*

49. Kehilath Anshe Ma'ariv Synagogue, interior, upper sanctuary, corner column ornament detail. *Casimir Estramskis*

50. Kehilath Anshe Ma'ariv Synagogue, exterior, west elevation, window detail. *Casimir Estramskis*

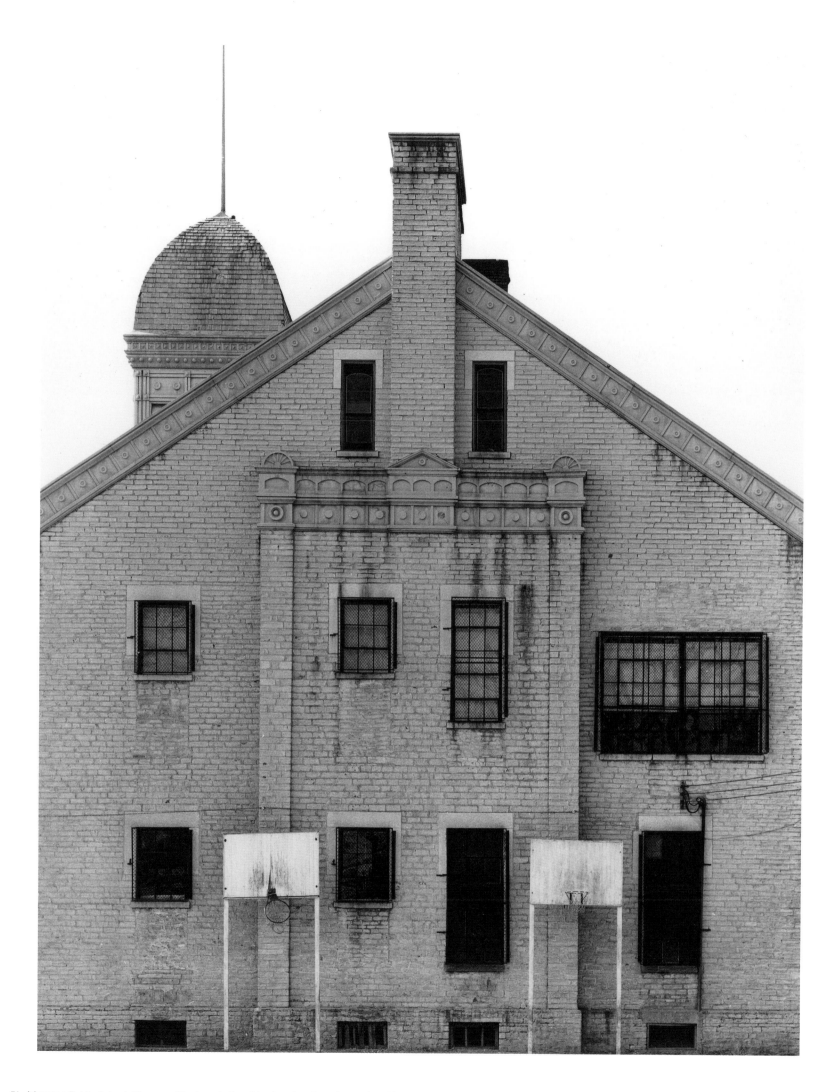

51. Marengo Public School, Marengo, Illinois, exterior, side elevation. *Leon Lewandowski*

52. Marengo Public School, exterior, side elevation detail. *Richard Nickel*

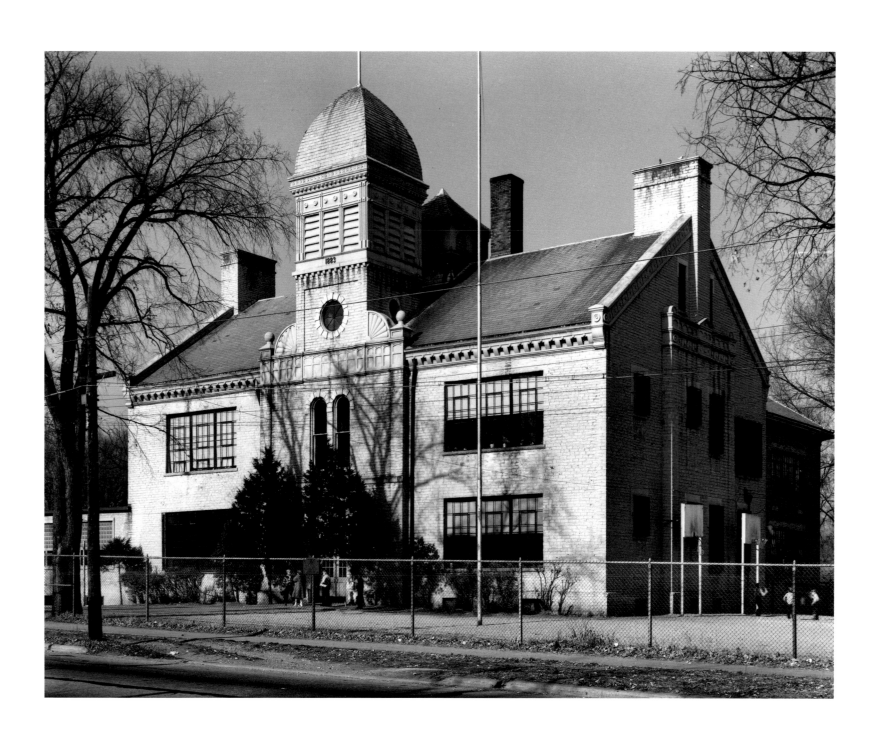

53. Marengo Public School, exterior, front elevation. *Richard Nickel*

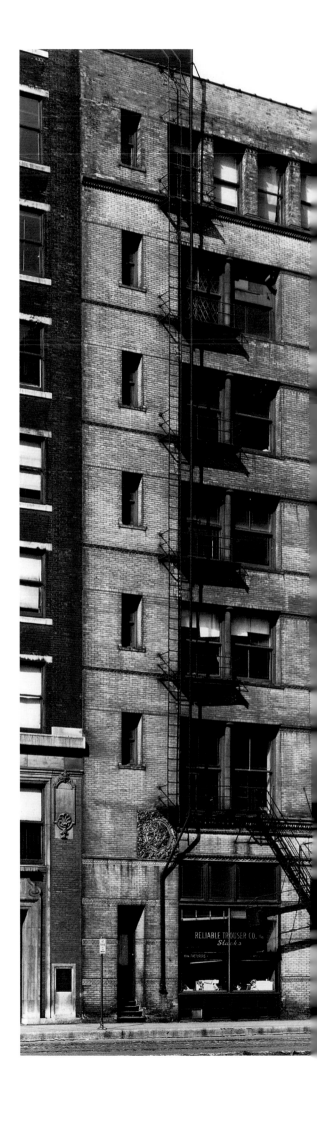

54. Meyer Building, Chicago, exterior. *Richard Nickel*

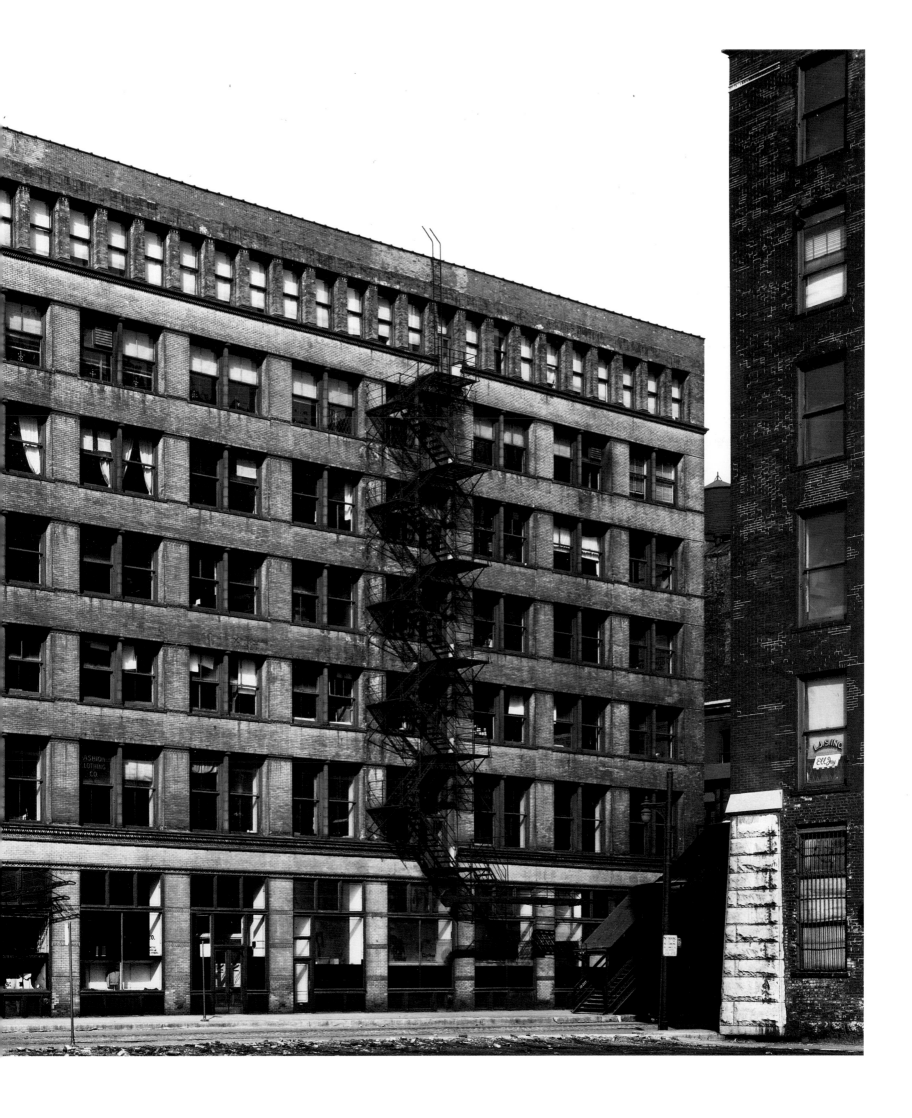

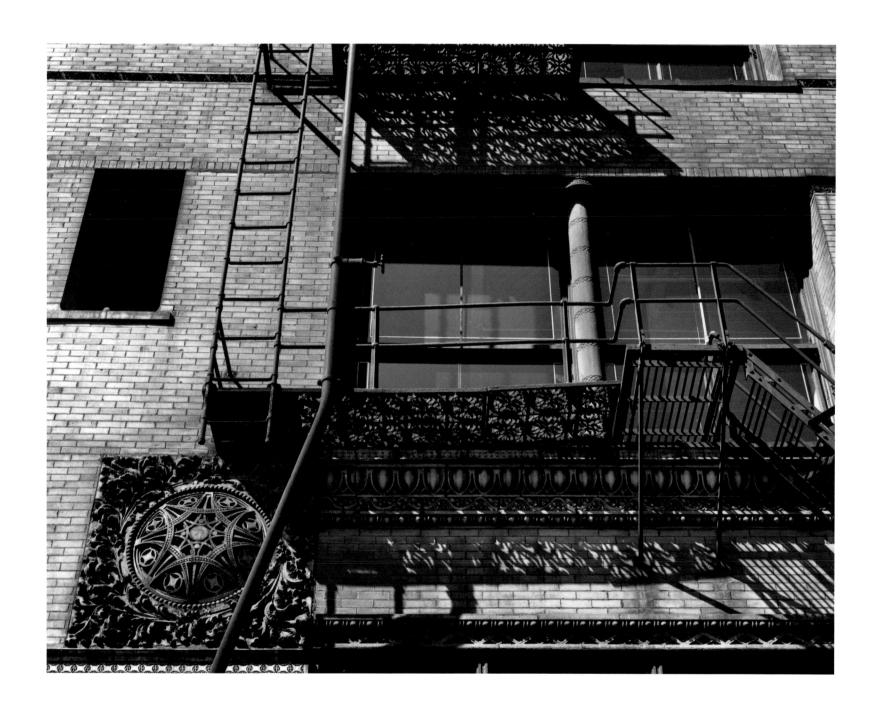

55. Meyer Building, exterior, medallion detail. *Richard Nickel*

56. Gage Building, Chicago, exterior. *Richard Nickel*

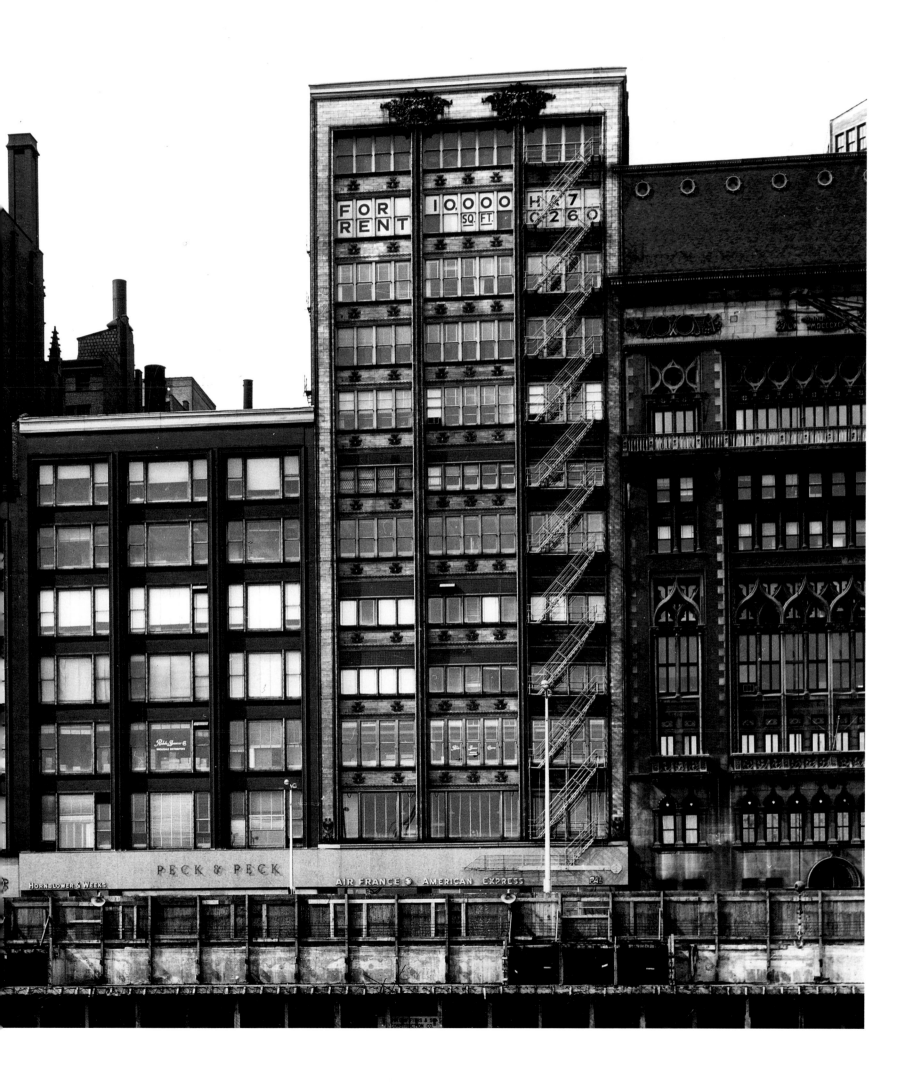

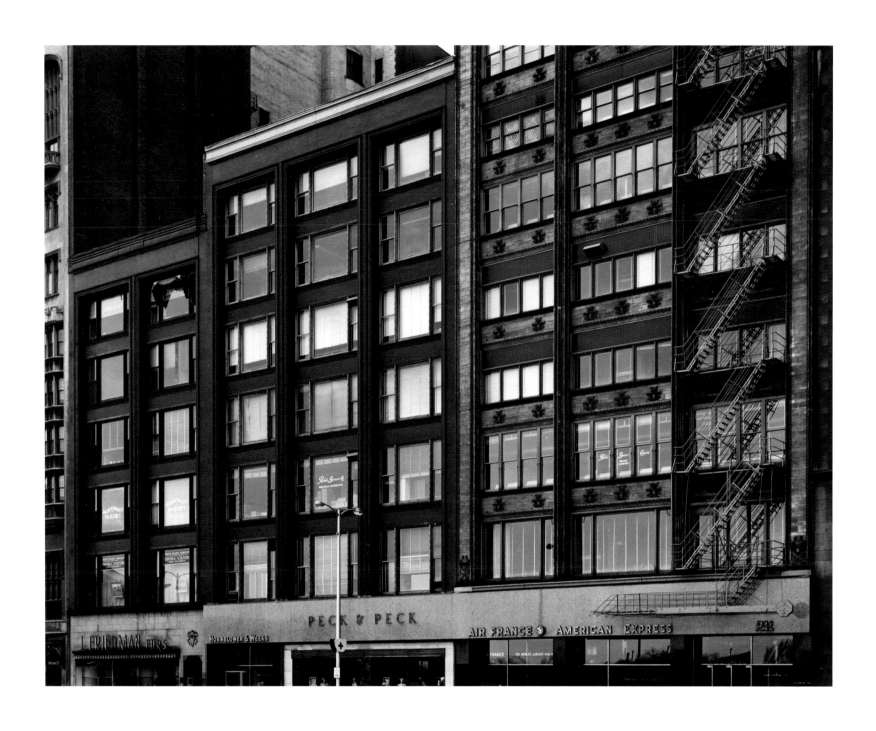

57. Gage Building, exterior detail. *Richard Nickel*

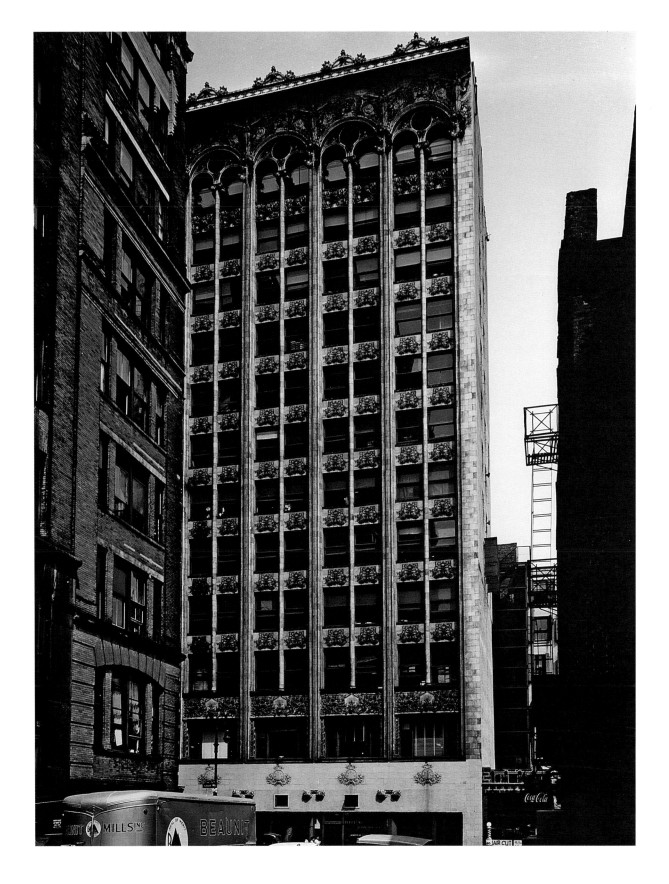

58. Bayard Building, New York City, exterior. *Aaron Siskind*

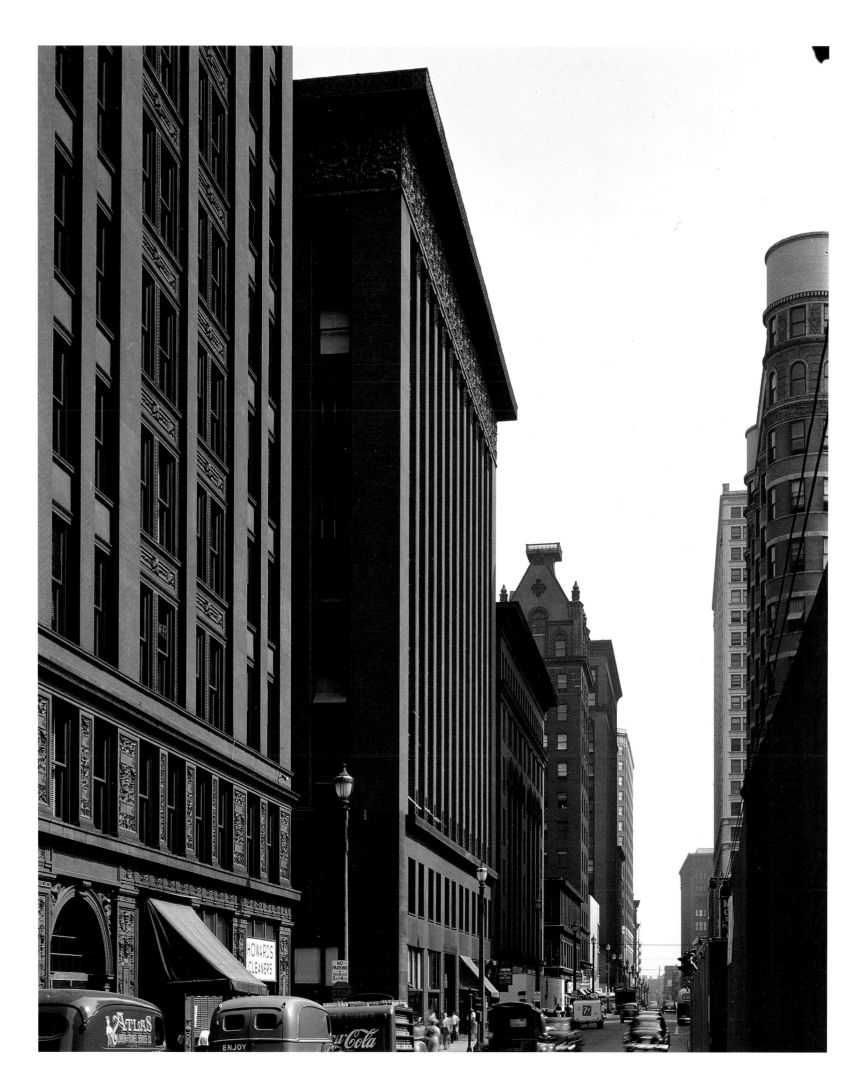

59. Wainwright Building, St. Louis, Missouri, exterior. *Aaron Siskind*

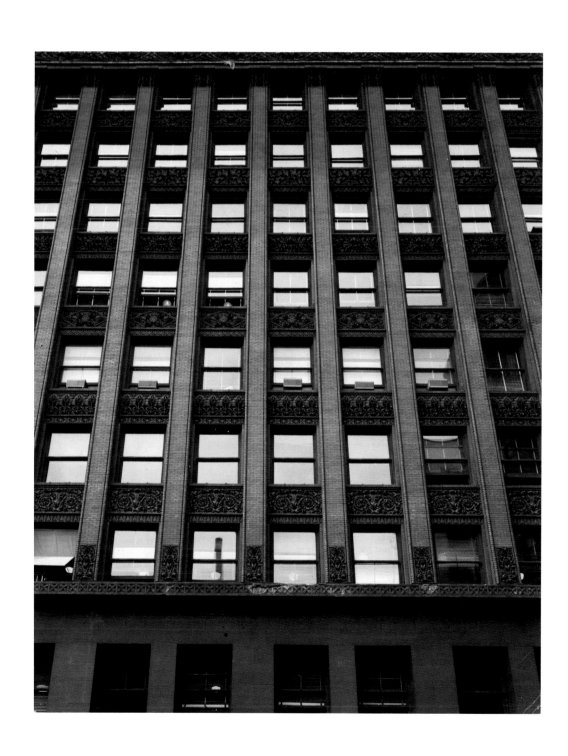

60. Wainwright Building, exterior, upper floors. *Aaron Siskind*

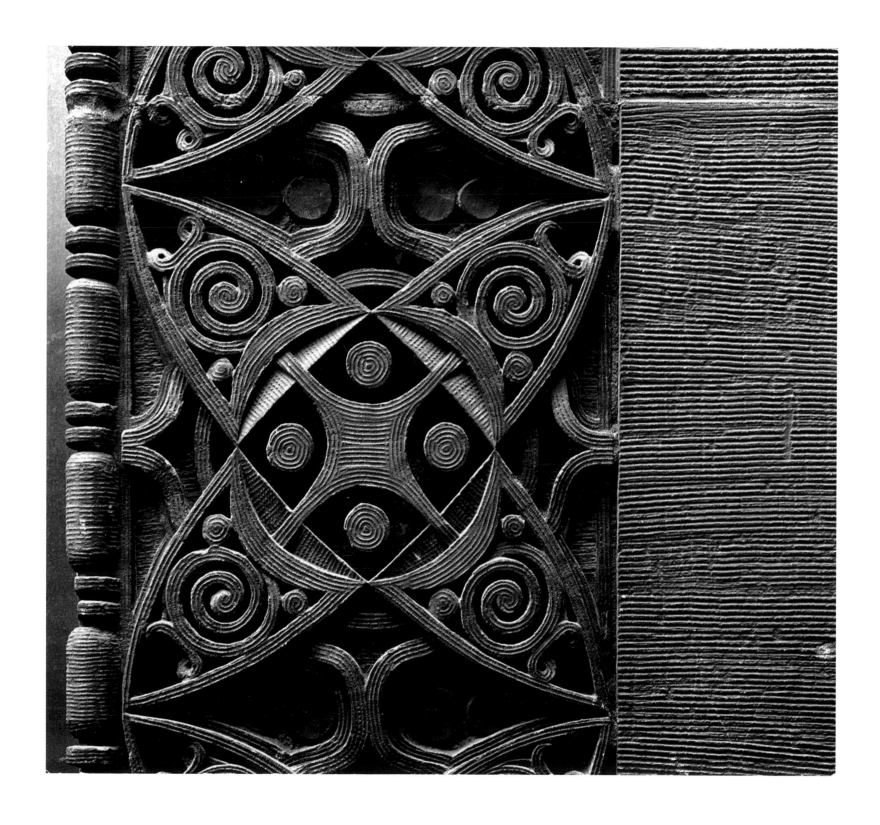

61. Wainwright Building, exterior, ornament detail. *Aaron Siskind*

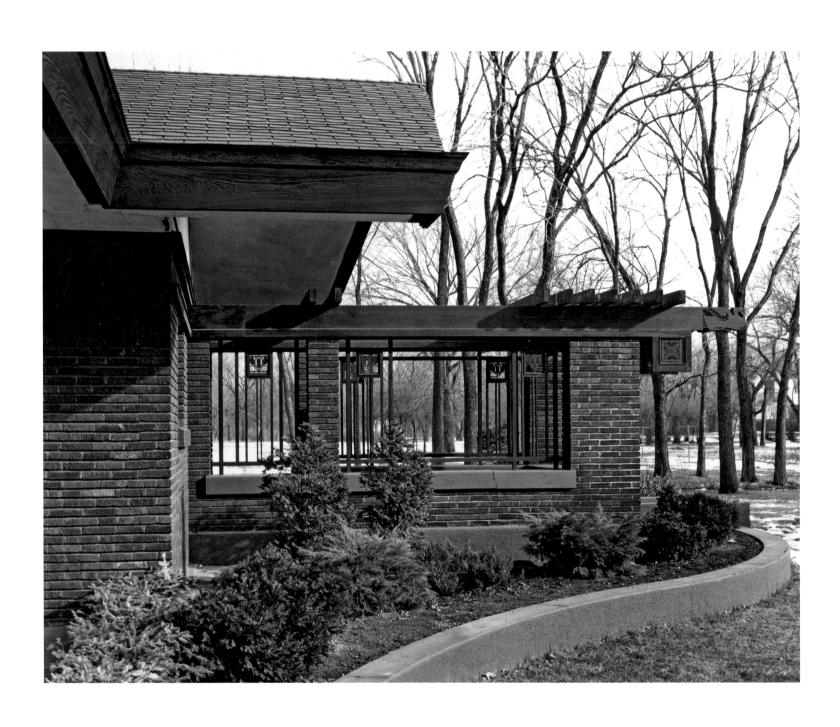

63. Babson Residence, exterior, porte cochere (George Elmslie addition). *Richard Nickel*

64. Babson Residence, exterior (Elmslie addition). *Richard Nickel*

65. Babson Residence, exterior, side elevation (Elmslie addition). *Richard Nickel*

66. Babson Residence, interior, alcove and niche. *Aaron Siskind*

67. Babson Residence, exterior, front elevation. *Richard Nickel*

68. Harold and Josephine Bradley Residence, Madison, Wisconsin, exterior. *Leon Lewandowski*

69. Bradley Residence, exterior, loggia. *Aaron Siskind*

70. Bradley Residence, exterior, drainspout detail. *Len Gittleman*
71. Bradley Residence, exterior, window detail. *Leon Lewandowski*

72. Bradley Residence, exterior, loggia detail. *Len Gittleman*
73. Bradley Residence, interior, settee (Sullivan design). *Leon Lewandowski*

74. Bradley Residence, interior, wall paneling and chair (Sullivan design). *Len Gittleman*

75. Bradley Residence, interior, second floor stairwell. *Leon Lewandowski*

76. Bradley Residence, interior, ceiling and chandelier. *Len Gittleman*

77. Max M. Rothschild Houses, Chicago, exterior. *Len Gittleman*

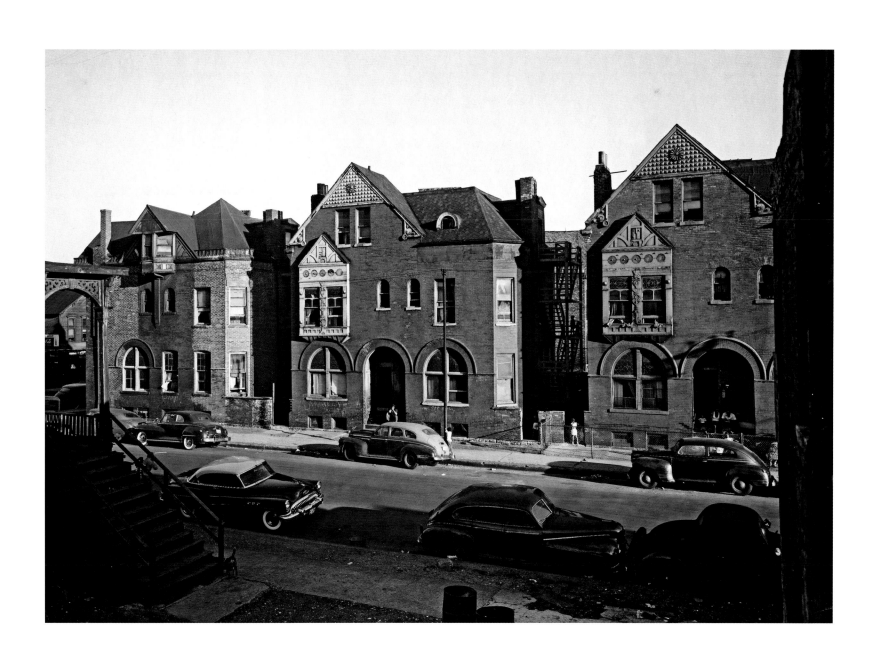

78. Rothschild Houses, exterior. *Aaron Siskind*

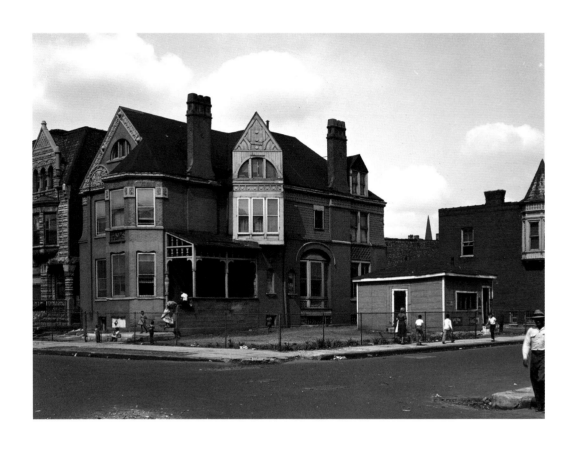

79. Martin Barbe Residence, Chicago, exterior. *Aaron Siskind*

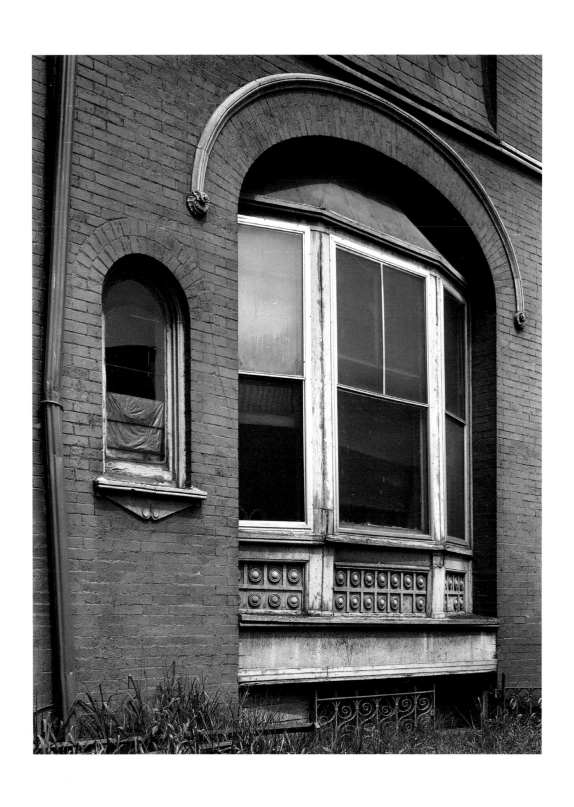

80. Barbe Residence, exterior, window bay detail. *Not attributed*

81. Dankmar Adler Residence, Chicago, exterior. *Not attributed; no original print or negative*

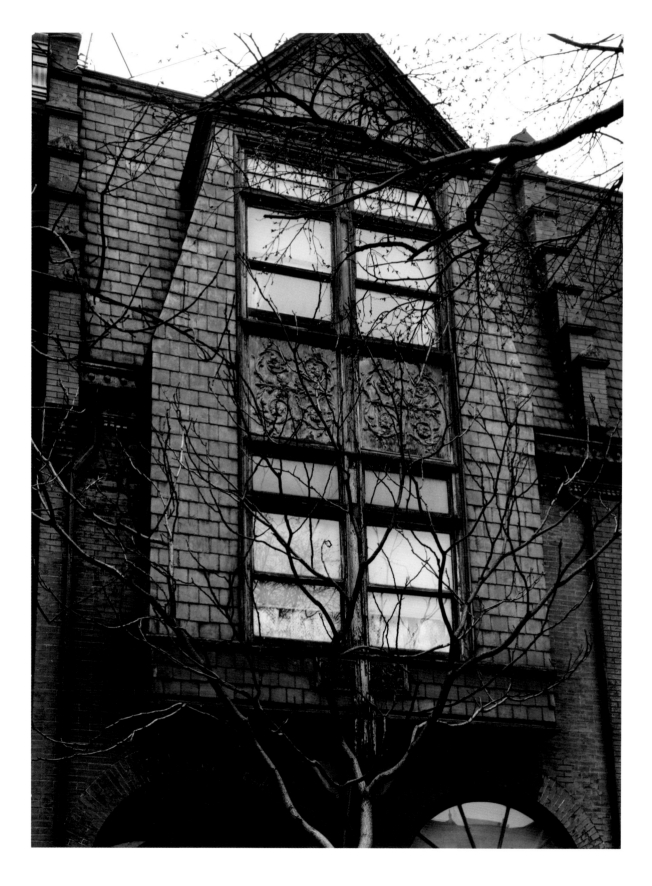

82. Adler Residence, exterior, upper floor window bay detail. *Aaron Siskind*

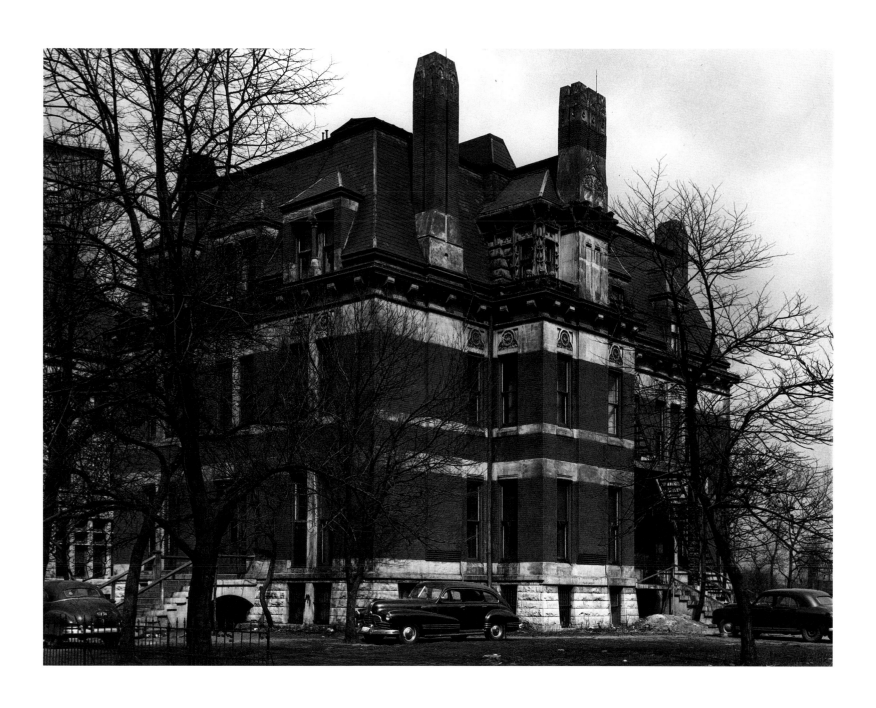

83. John Borden Residence, Chicago, exterior. *Richard Nickel*

84. Albert W. Sullivan Residence, Chicago, exterior. *Leon Lewandowski*

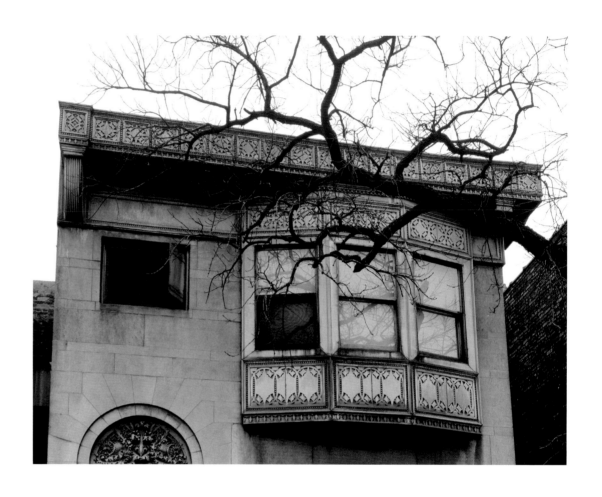

85. Albert W. Sullivan Residence, exterior. *Aaron Siskind*

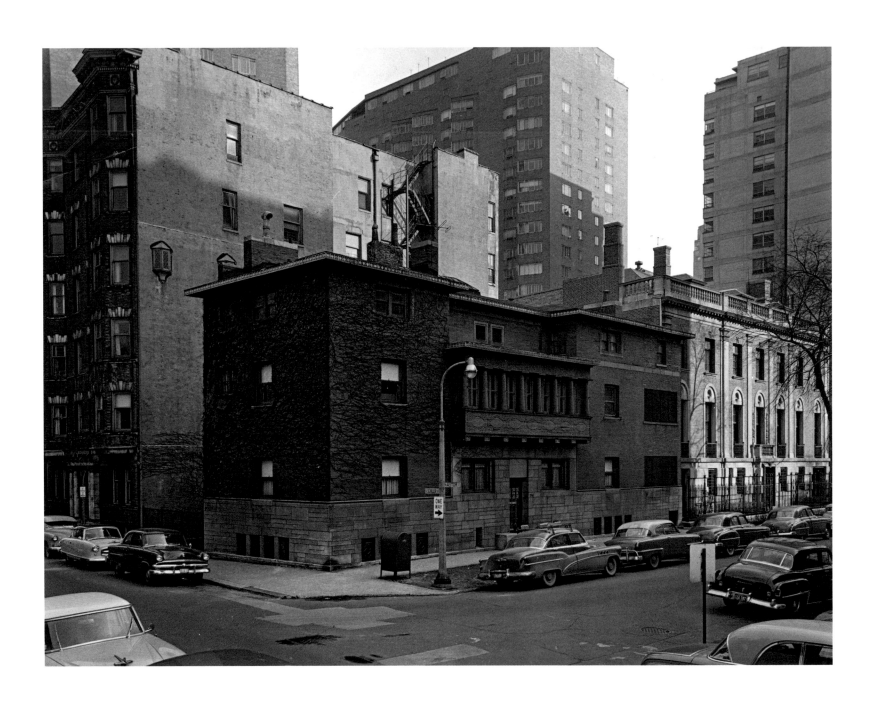

86. James Charnley Residence, Chicago, exterior. *James Blair*

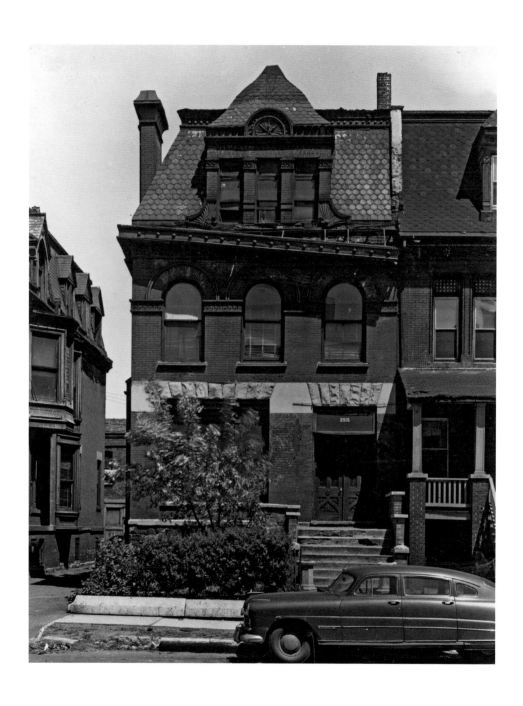

87. Henry Stern Residence, Chicago, exterior. *Not attributed*

88. Max M. Rothschild Rowhouses, Chicago, exterior. *Richard Nickel*

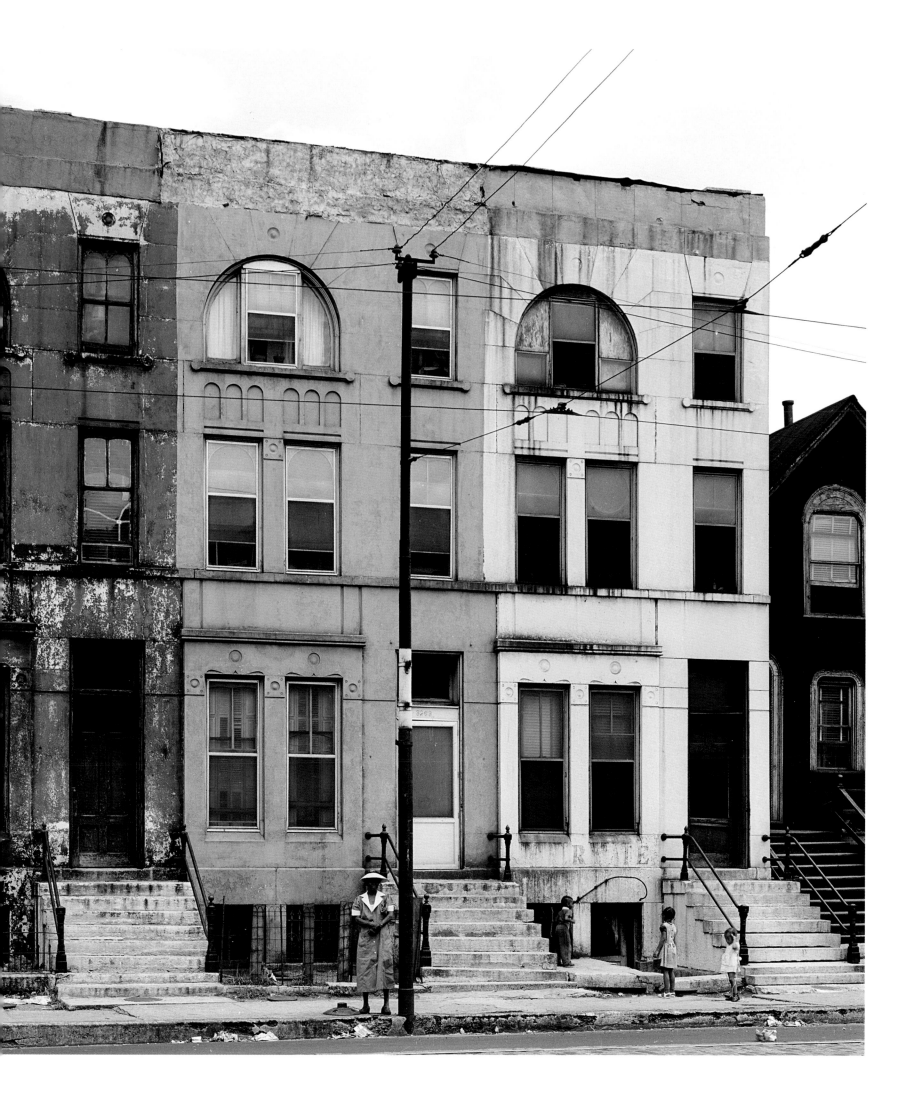

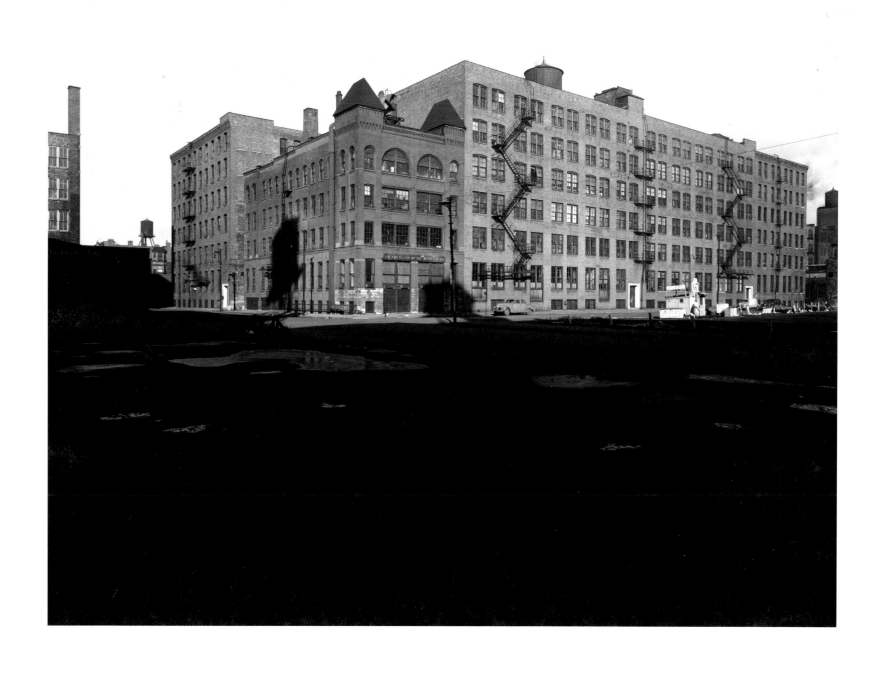

89. Brunswick-Balke-Collender Company Factory, Chicago, exterior. *Asao Doi*

90. Brunswick-Balke-Collender Factory, exterior. *Not attributed; no original print or negative*

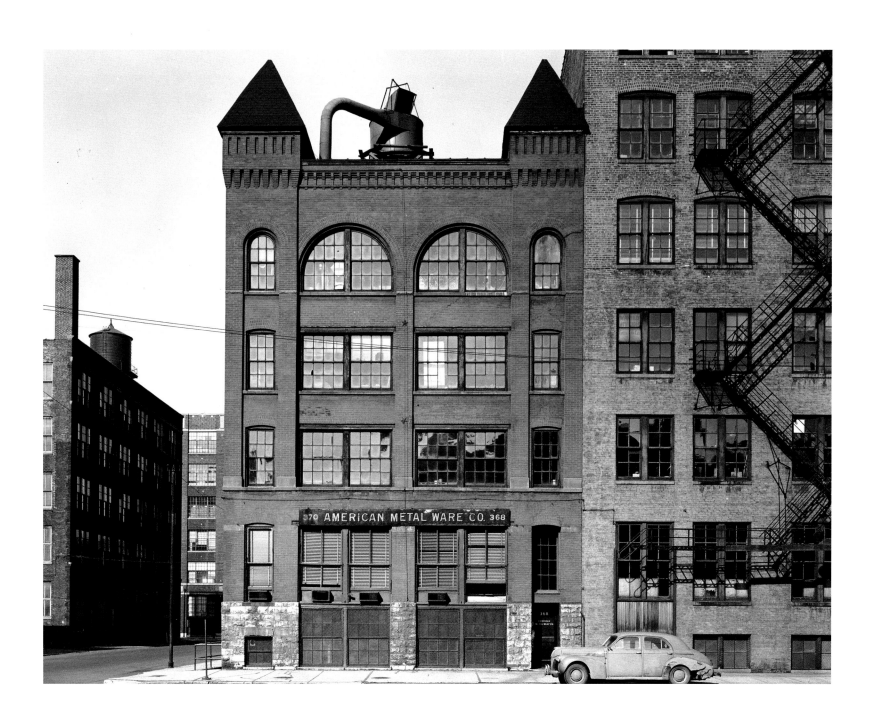

91. Brunswick-Balke-Collender Factory, exterior (not by Sullivan). *Asao Doi*

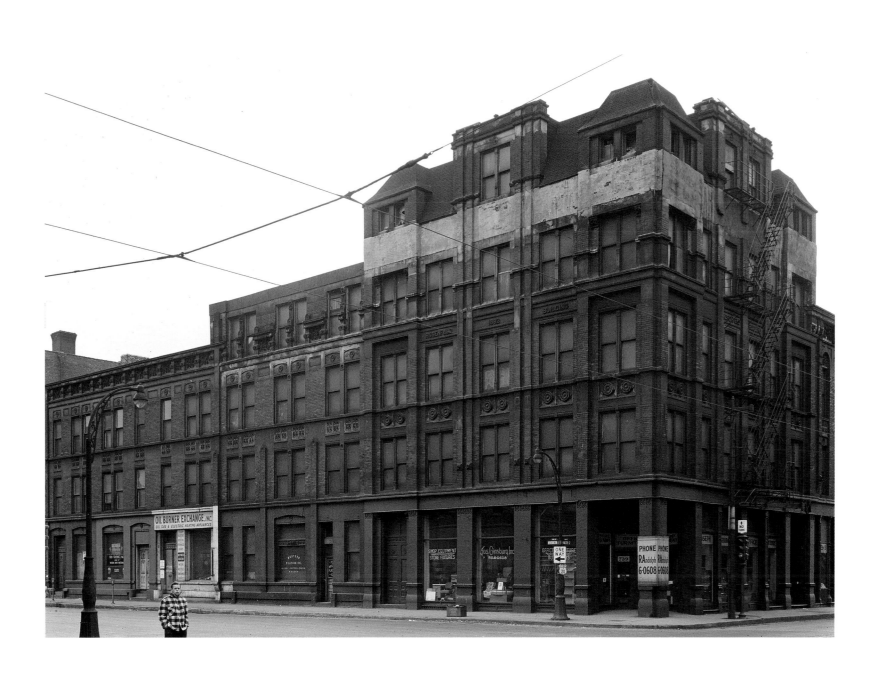

92. Rosenfeld Building, Chicago, exterior. *Richard Nickel*

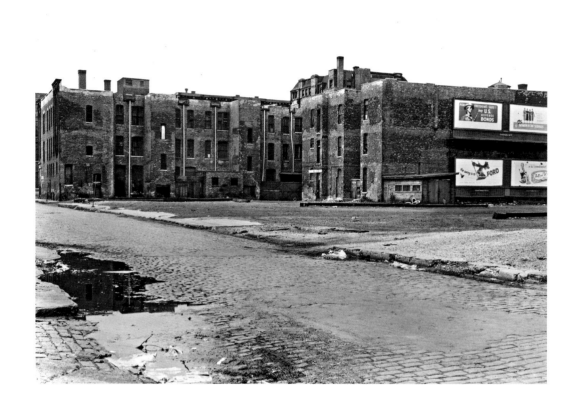

93. Rosenfeld Building, exterior. *Asao Doi*

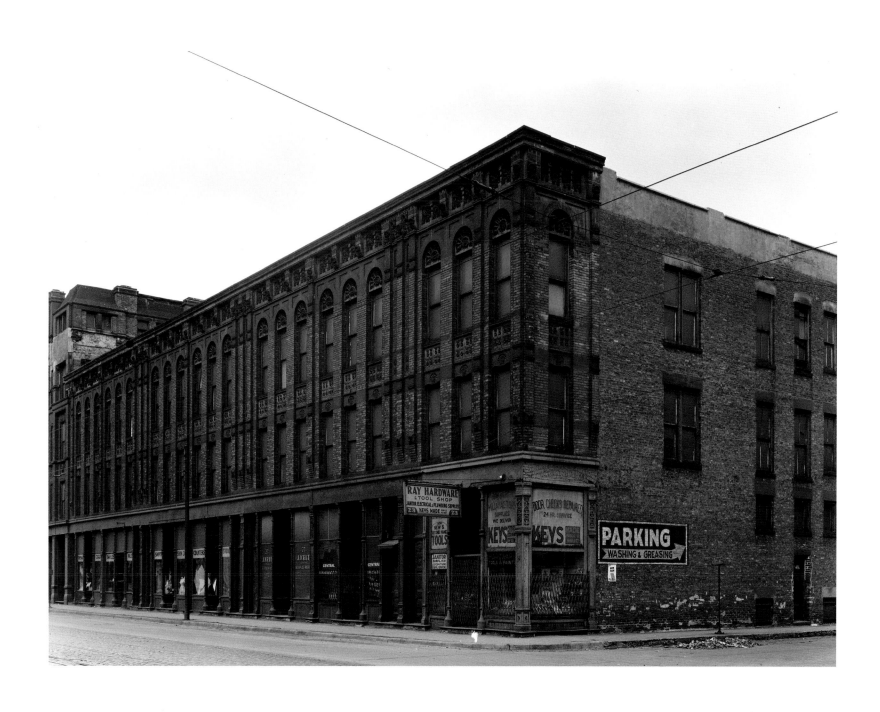

94. Rosenfeld Building, exterior. *Asao Doi*

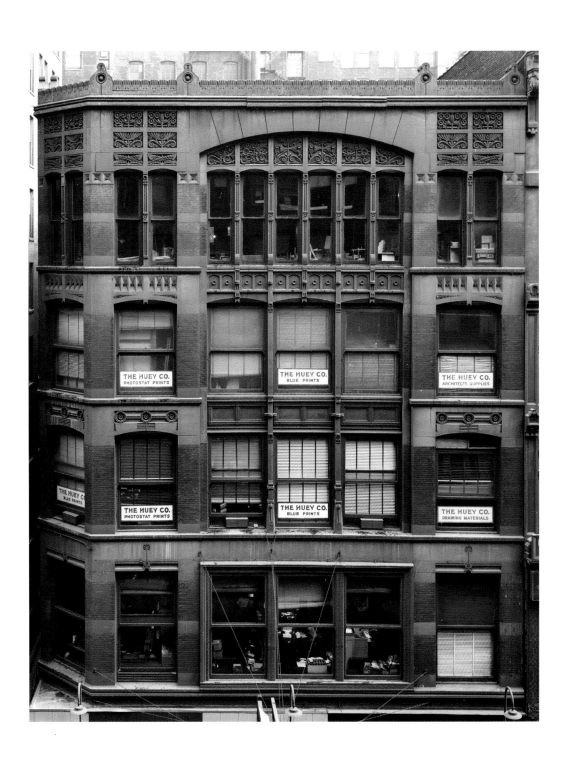

95. Jewelers' Building, Chicago, exterior. *Richard Nickel*

96. Jewelers' Building, interior, ceiling detail. *Richard Nickel*

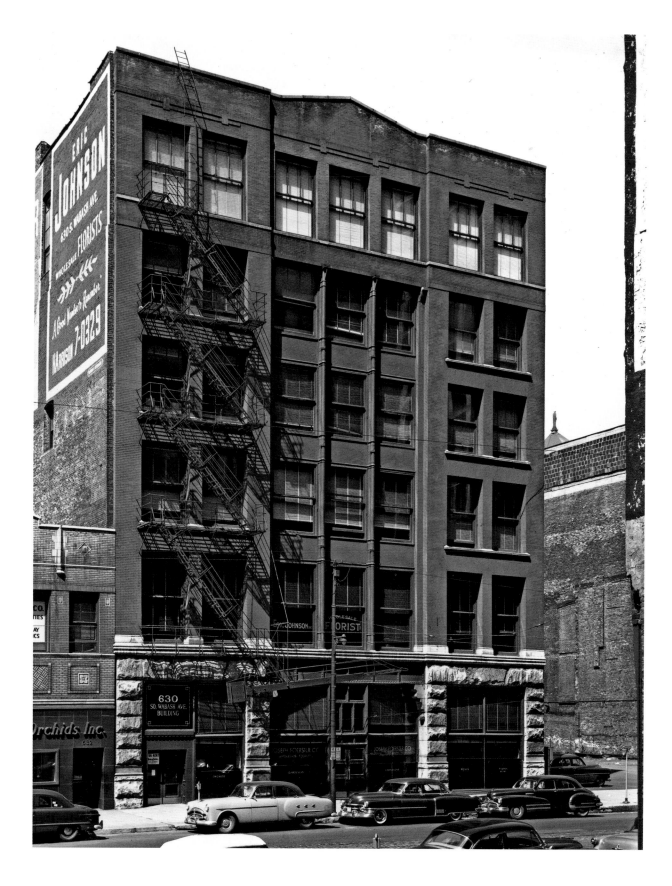

97. Wirt Dexter Building, Chicago, exterior. *Richard Nickel*

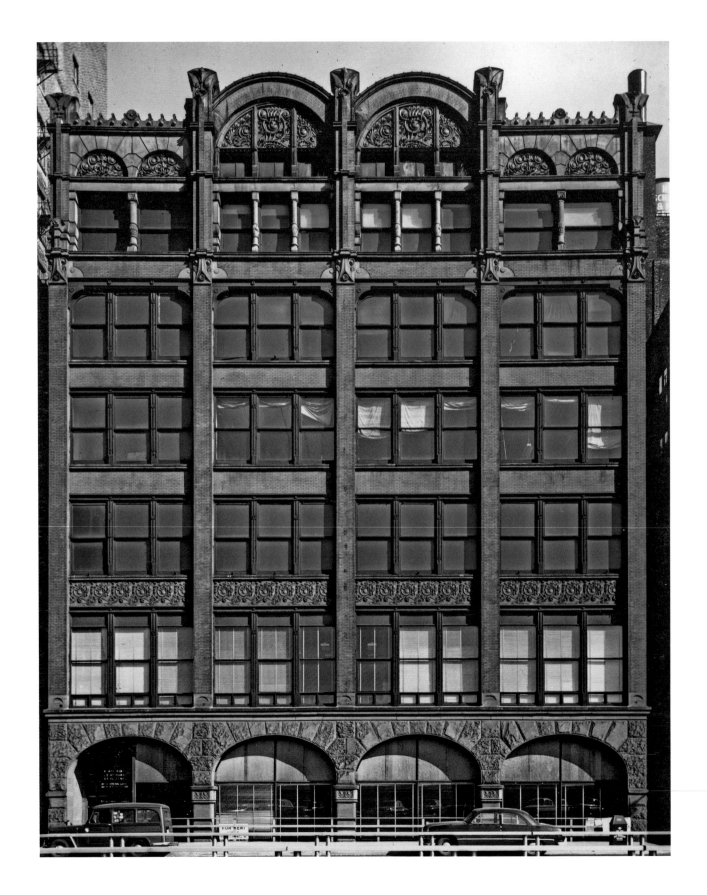

98. Troescher Building, Chicago, exterior. *Alvin Loginsky*

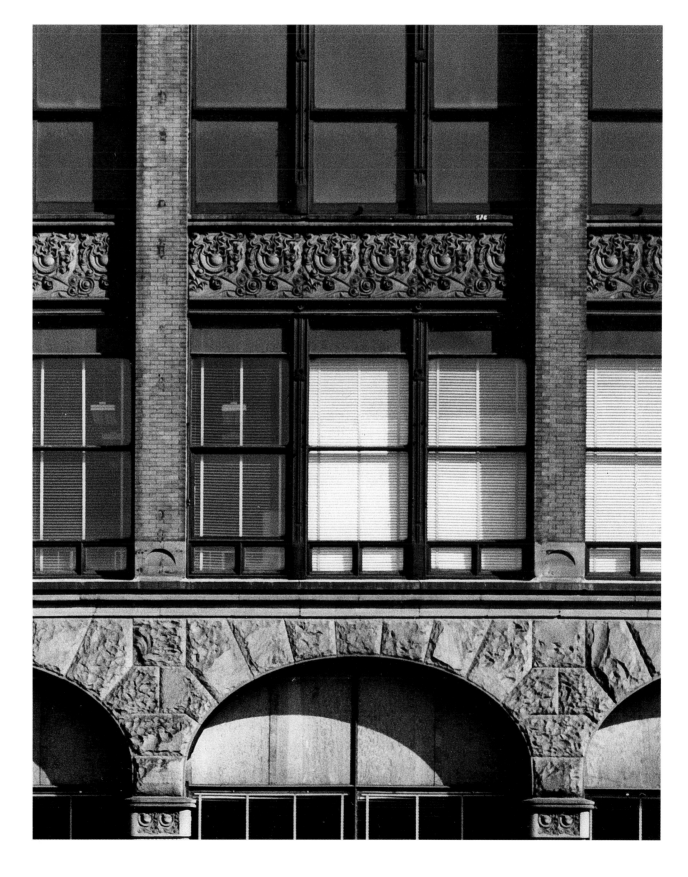

99. Troescher Building, exterior, center bay detail. *Alvin Loginsky*

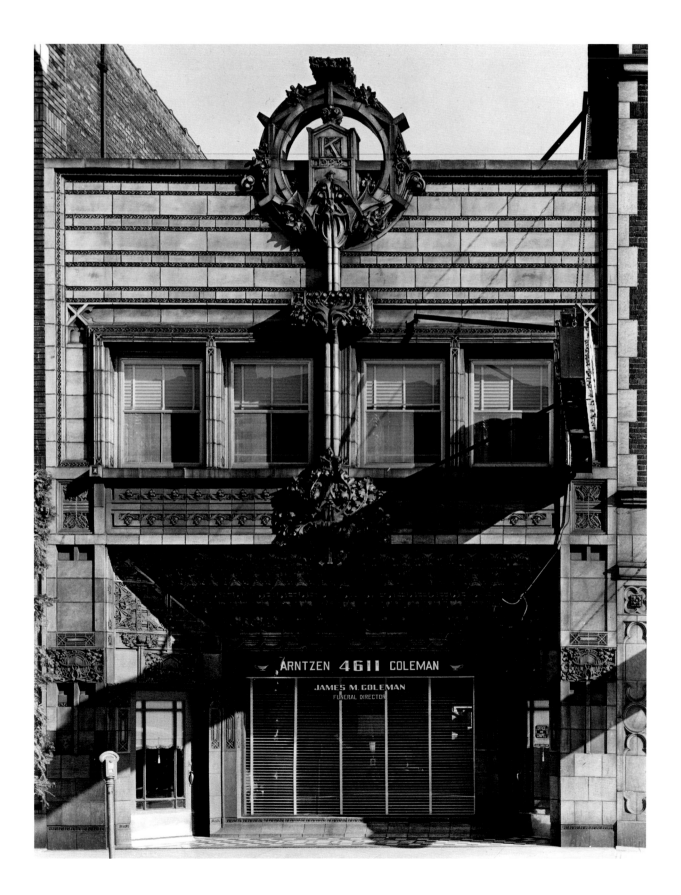

100. Krause Music Store, Chicago, exterior. *Alvin Loginsky*

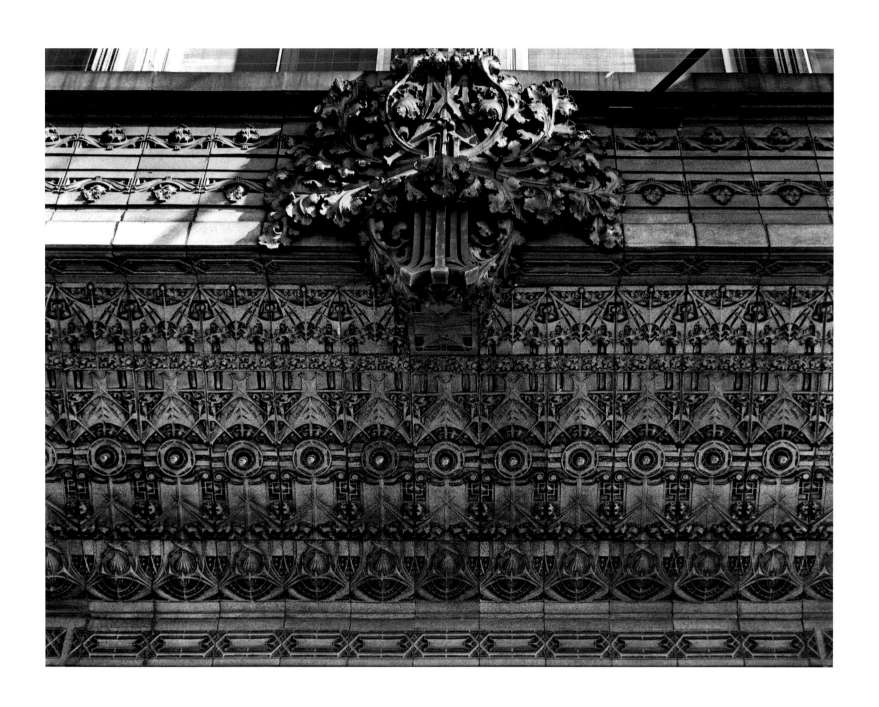

101. Krause Music Store, exterior, recessed entry. *Alvin Loginsky*

102. Garrick Building (originally Schiller Building), Chicago, exterior, upper floors. *Leon Lewandowski*

103. Garrick Building, exterior, tower and cupola. *Richard Nickel*

104. Garrick Building, exterior, loggia at second floor, ornament detail. *Not attributed*

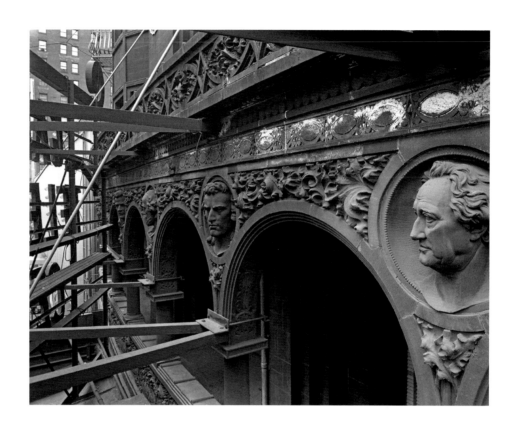

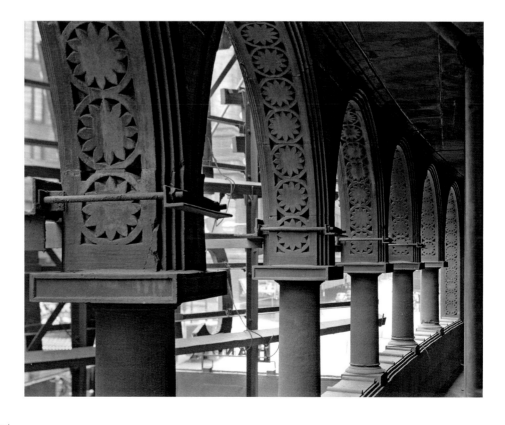

105. Garrick Building, exterior, ornament detail. *Richard Nickel*
106. Garrick Building, exterior, loggia. *Richard Nickel*

107. Garrick Building, exterior, side wing at eighth and ninth floors. *Alvin Loginsky*

108. Chicago Stock Exchange Building, Chicago, exterior, upper floors and cornice. *Richard Nickel*

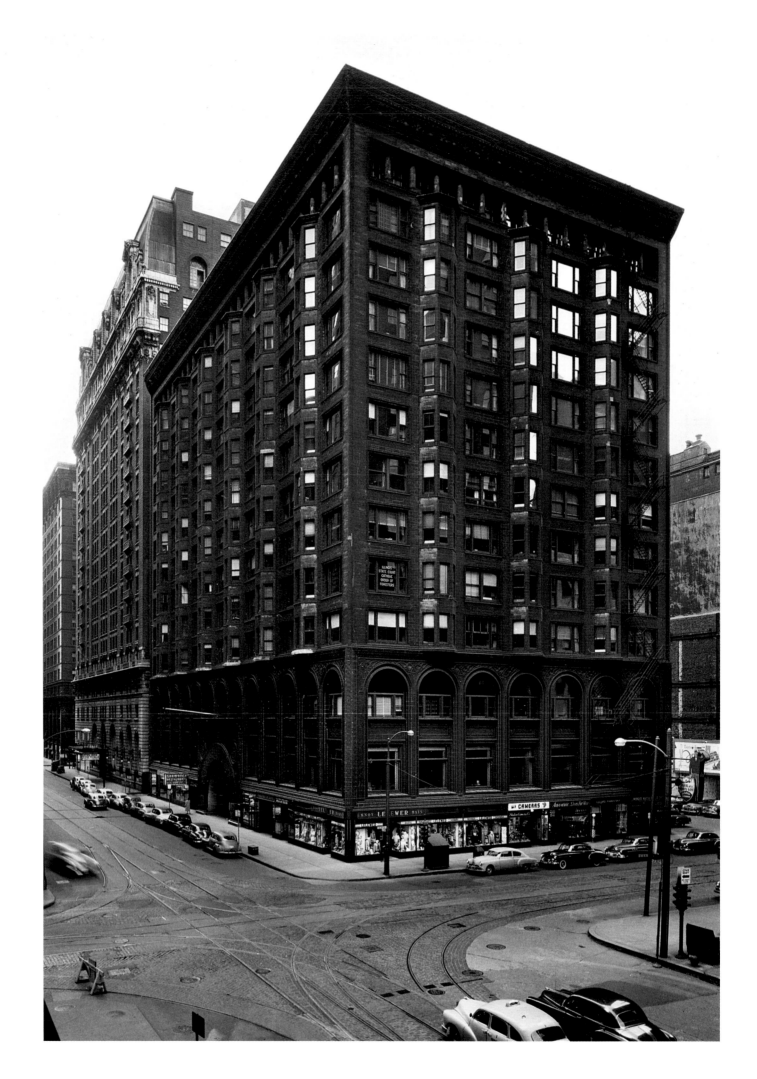

109. Chicago Stock Exchange Building, exterior. *Richard Nickel*

110. Chicago Stock Exchange Building, exterior, main entrance. *Asao Doi*

111. Chicago Stock Exchange Building, interior, elevator screen (upper floor), T-plate detail. *Asao Doi*

112. Chicago Stock Exchange Building, interior, elevator screen (lower floor). *Asao Doi*

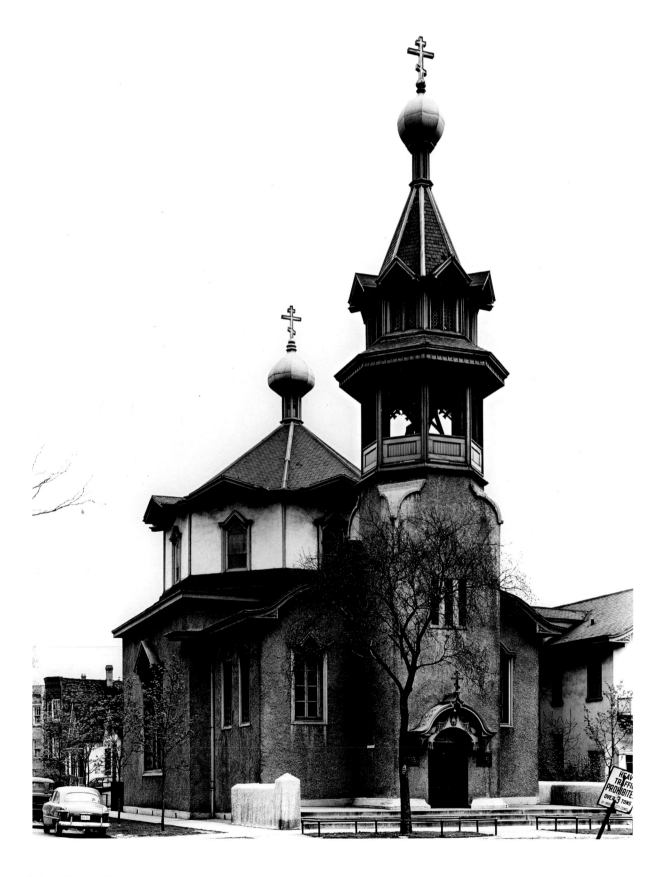

113. Holy Trinity Russian Orthodox Greek Catholic Church, Chicago, exterior. *Alvin Loginsky*

114. Holy Trinity Church, exterior. *Alvin Loginsky*

115. Holy Trinity Church, exterior. *Alvin Loginsky*

116. St. Paul's Methodist Episcopal Church, Cedar Rapids, Iowa, exterior. *Len Gittleman*

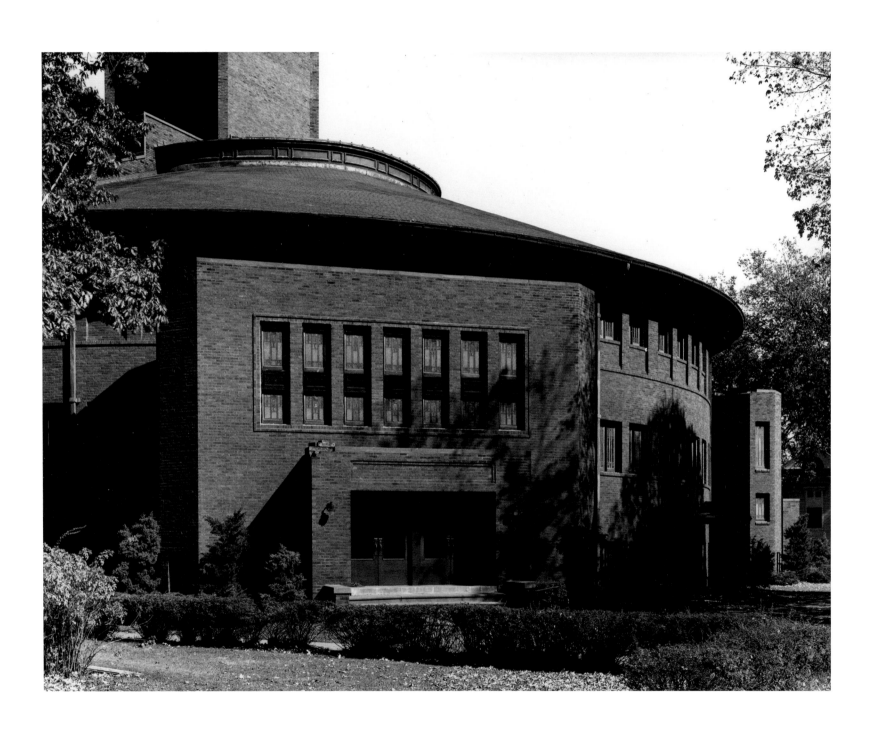

117. St. Paul's Methodist Episcopal Church, exterior, entry. *Len Gittleman*

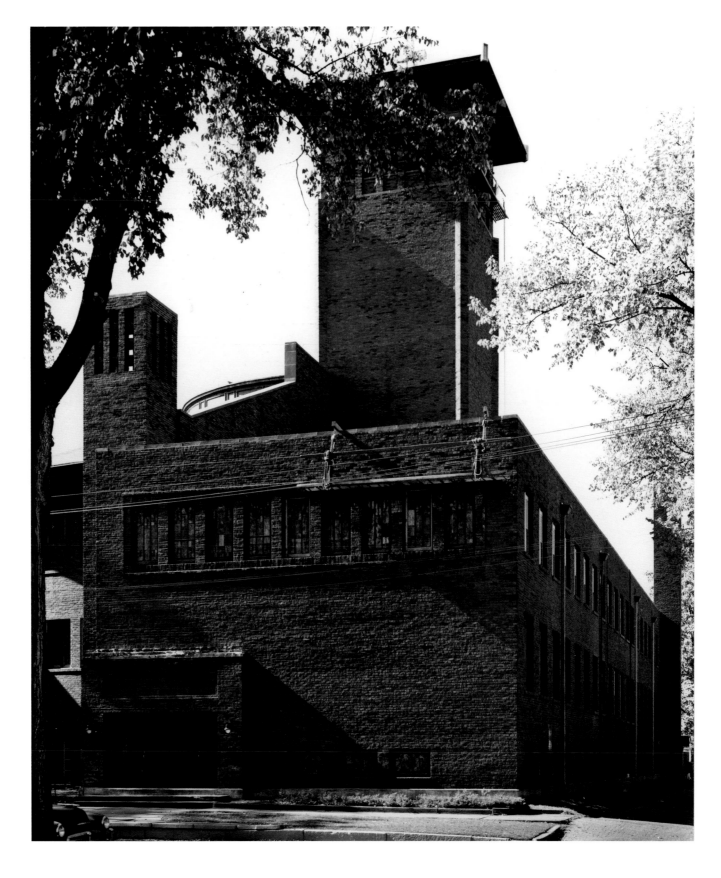

118. St. Paul's Methodist Episcopal Church, exterior. *Aaron Siskind*

119. Carson Pirie Scott and Company Store (originally Schlesinger and Mayer Department Store), Chicago, exterior, upper floors. *Not attributed*

120. Carson Pirie Scott Store, exterior. *Len Gittleman*

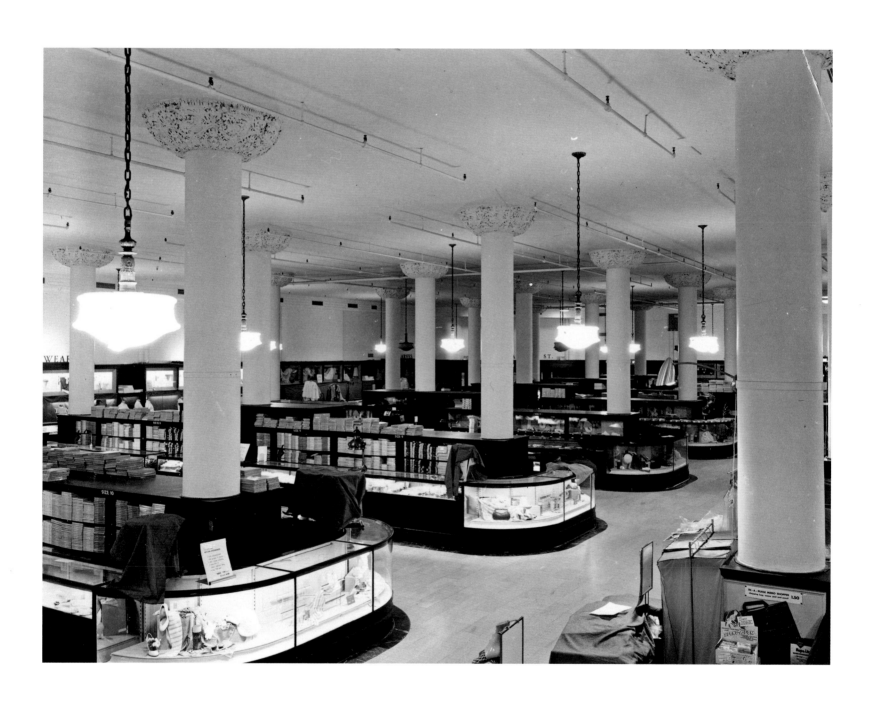

121. Carson Pirie Scott Store, interior, first floor (1930s remodeling). *James Blair*

122. Carson Pirie Scott Store, exterior, upper floors. *James Blair*

123. Carson Pirie Scott Store, exterior, upper floors. *Len Gittleman*

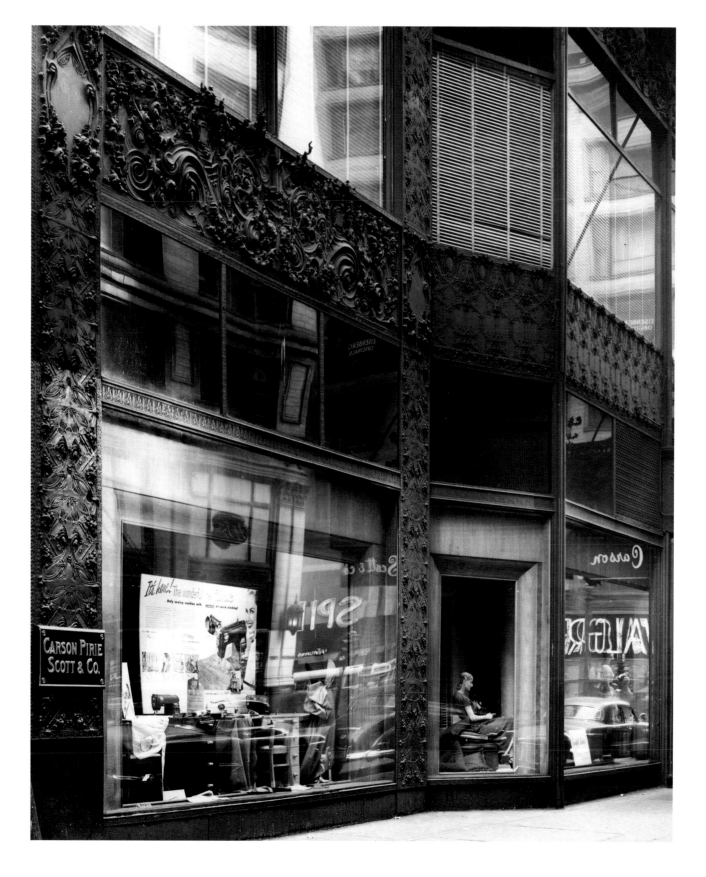

124. Carson Pirie Scott Store, exterior, ground floor, (1899 building with original cast iron ornament). *Aaron Siskind*

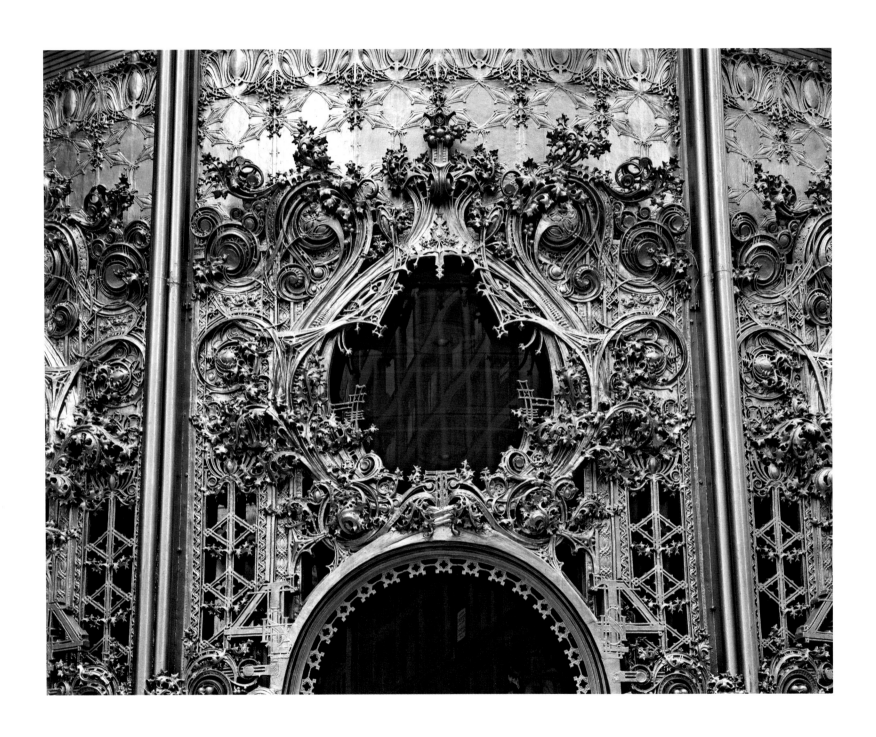

125. Carson Pirie Scott Store, exterior, rotunda entry, cast iron ornament detail. *Len Gittleman*

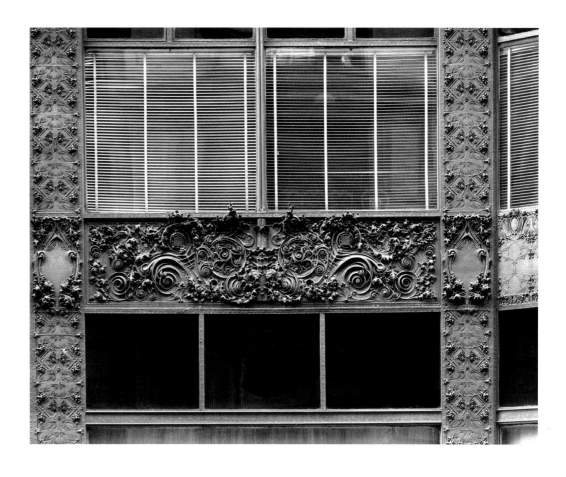

126. Carson Pirie Scott Store, exterior, first and second floors, spandrel panel, ornament detail. *Len Gittleman*

127. Dankmar Adler *(left). Not attributed*
128. Louis H. Sullivan. *Not attributed*

129. Dankmar Adler Tomb *(left). Richard Nickel*
130. Louis H. Sullivan Tomb. *Richard Nickel*

Appendix: The Production of Exhibit Photographs for Publication

For their exhibit photographs, Aaron Siskind and his students typically used 4 by 5 inch format Crown Graphic cameras and Panatomic-X or Super-XX Kodak black and white film. Prints for the 1954 exhibit were made by Siskind and the students at the Institute of Design darkroom, then directed by former Institute of Design student Art Sinsabaugh. Exhibit photographs were mounted on Masonite without borders or frames.

The Richard Nickel Committee Archive (RNCA) includes 74 prints made by Aaron Siskind, Richard Nickel, and other Institute of Design students from their negatives, as well as some original exhibit prints mounted on Masonite. The Art Institute of Chicago Ryerson and Burnham Archives (AIC) also has prints made by Nickel (after 1955) for several other exhibit photographs. We used these original prints to establish print standards for the exhibit prints reproduced here. Original project prints, including mounted exhibit prints, occasionally show very slight differences in cropping from the exhibit panel photographs, due to variations in printmaking or subsequent trimming. Whenever possible we used original prints for our reproductions, accepting the cropping differences in return for original print quality.

The RNCA prints were scanned by Gamma Photo Labs, Chicago, with a custom Scitext flatbed scanner (at 300 dpi, 10 by 12 inch scan size); Gamma then made new prints from these scans. Gamma also scanned original negatives for which there are no original prints and made prints using the RNCA and AIC original prints as our reference for print quality. Ward Miller and John Vinci (from the Richard Nickel Committee), Bruce Baker and Elaine Kobold (from Robertz & Kobold, Inc.), and the author subsequently reviewed each print for publication. Machine prints from scanned original prints or negatives do not capture automatically the tonal values achieved by the photographers in darkroom printing. (For a brief description of the role of darkroom work in the Institute photography curriculum, see Harry Callahan and Aaron Siskind, "Learning Photography at the Institute of Design [1956]," in *Aaron Siskind: Toward a Personal Vision, 1935-1955,* edited by Deborah Martin Kao and Charles A. Meyer [Chestnut Hill, MA, 1994], pp. 64-69).

Our large exhibit prints are produced through the tritone process. While no modern printing process can duplicate the manual creation of prints for an exhibit at a distance of over fifty years, we have taken great care to ensure that our reproductions of the exhibit prints consistently emulate the clarity and tonal quality of their originals.

Index

Italicized numbers refer to figures (photographer or subject); bold numbers, to exhibit photographs (photographer).

DATE DUE